The Photographer's Internet Handbook

REVISED EDITION

Joe Farace

ALLWORTH PRESS
NEW YORK

05 04 03 02 01 5 4 3 2 1

Published by Allworth Press
An imprint of Allworth Communications
10 East 23rd Street, New York, NY 10010

Cover design by Douglas Design Associates, New York, NY
Page composition/typography by Sharp Des!gns, Lansing, MI

ISBN: 1-58115-084-9

LIBRARY OF CONGRESS CATALOGING-IN-PUBLICATION DATA
Farace, Joe.
The photographer's Internet handbook / by Joe Farace.—Rev. ed.
p. cm.
ISBN 1-58115-084-9
1. Photography—Computer network resources—Handbooks, manuals, etc.
2. Internet—Handbooks, manuals, etc. 3. World Wide Web—Handbooks, manuals, etc. I. Title
TR11 .F37 2001
025.06'77—dc21
2001022046

Printed in Canada

I met Vern Prime when he was a camera repairman. When he moved onto building computers, we kept in touch and along the way became friends. I would be lost without Vern, not only for building the Windows computers I've been using since Jurassic times, but for technical assistance for all the things in this book that are PC-related. Whenever I have a camera or a computer problem, he drops everything to help. But sometimes a "thank you" doesn't seem to be enough for all of the help that he's given me over the years. That's why this revised edition of *The Photographer's Internet Handbook* is dedicated to Vern Prime. My wish for all of my readers is that someday you'll have a friend like Vern.

Contents

Acknowledgments .. vii

Introduction ... ix

1 What Is the Internet and Who Is Surfing It? 1

2 Getting Wired ... 15

3 Surfin' Software 37

4 The Internet: Now You're There 59

5 Web Sites You Shouldn't Miss 85

6 Promoting Yourself on the Web 109

7 Build a Home Page 117

8 Photographers Online 137

9 Open for Business 159

10 Cyber Theft ... 169

Afterword ...177

Appendix A: Glossary of Internet Terms 183

Appendix B: Some of the Companies Mentioned 201

About the Author .. 207

Index ... 209

Acknowledgments

Tad Crawford had the original concept for what became *The Photographer's Internet Handbook* and gave me his input on shaping the book's outline and content. I thank him for having the faith that I could bring form to his vision. Thanks, Tad, for also asking me to write the update.

To all of those wonderful people and companies that took some of the mystery out of the process and helped me with various sections of this book by providing technical support and allowing me to review copies of software and hardware, I would like to say a big thank you.

Here are a few individuals without whose help this book would never have been completed:

A big thank-you goes out to Dana Rudolph for originally introducing me to the free e-mail and Internet services provided by Juno Online Services. I also want to thank FileMaker's Kevin Mallon for his help with their HomePage Website creation software. Lastly, I would like to thank Susan Doering of Adobe Systems for keeping me up-to-date with the latest developments in Adobe Photoshop—including version 6.0.

There were also many photographers who helped shape other parts of this book. Foremost was photographer and good friend Barry Staver, who acted as a

sounding board for me not just for this book but also for many other book and magazine projects. Thanks, Barry, for your insight and friendship! A big thanks also goes out to those photographers who shared the agony and the ecstasy of going online. These include Gary Auerbach, a fine arts portrait photographer who creates images using platinum printing techniques; Len Kaltman, the most influential glamour photographer since Peter Gowland; Herman Krieger, who proves that black-and-white documentary is not only alive and well but has a sense of humor; B. Moose Peterson, the legendary wildlife photographer and genuinely nice guy; Tony Sweet, whose nature and landscape photographs transcend the genre; and Tom Zinn, a photographer of racing yachts whose images take you where no photographer has gone before.

Writing is a solitary business, and I could never have completed my first book and especially this one, without the love and devotion of my dear wife, Mary. She is my biggest fan and, for that, I'll always be grateful. Thanks, Mary, for just being you.

All of the wonderful folks listed here are responsible for all of the good things you will find between the covers of this book. Any mistakes, errors, or omissions that you discover are all mine.

JOE FARACE
Brighton, Colorado

Introduction

I use an electric razor and a color television. However, I hang back from computers. I'm afraid they would cut down on my production.

Isaac Asimov

Isaac Asimov wrote the above words in 1980, just before he became a spokesman for Radio Shack computers and started using word processing software to increase his already prodigious output of books and magazine articles. Nevertheless, Mr. Asimov probably didn't use the Internet—he passed away before the World Wide Web became widely popular—and he never embraced high technology as much as the characters in his science fiction novels did. Many photographers seem to feel the same way and have stayed with the traditional business methods of what photographer and writer Rohn Engh (*www.photosource.com*) calls the three Fs—Fax, Fone, and FedEx.

Their reasoning for not participating in the high-tech revolution seems to be that high technology is not necessary for success. After all, Mathew Brady built up what would eventually become a legendary photographic business before telephones even existed. Not so long ago, not many photographers owned a fax, but that's changed too.

The point is that not only have the tools of our profession—cameras, film, and lenses—changed, but so have the ways professional photographers communicate with clients and

URLs and You

URL is the Internet term for Uniform Resource Locator. This is the technical term for the actual electronic location of a home page on the World Wide Web. The first part of a WWW address is "http://" (HyperText Transport Protocol) and is the communications protocol that is used on the Internet—specifically the World Wide Web—to share information. Throughout this volume, I will sprinkle URL listings wherever the name of a person or Web site appears in the text. If you like, you can drop this book, launch your Web browser (if you don't know what a browser is, you'll find out later in the book), and get the latest information on that topic or that person. Generally, I will skip using "http://" when mentioning a Web site. For example, the URL for *Shutterbug* magazine's home page is *www.shutterbug.net*. However, when a Web site has an unusual address, I will use "http://" to show the entire address so that you won't get lost or confused. The first version of this book was in print for four years, which is a long time in Internet years. Having URLs appear throughout the book means that you can always find out what's new on a particular subject at any given moment in time.

potential clients. Most studios are small enterprises, and the most successful ones are those that have maximized the use of technology, especially communications, to maintain and grow their business.

Although computers have become popular in studios, they are most often used for word processing, desktop publishing, and database management. A savvy marketer like Mathew Brady would have used the Internet if it had been available, and the same has been true throughout the history of photography. The most successful photographers are those that have mixed their image-making creativity with technology to maximize their opportunities. If you feel that you are not getting the maximum productivity out of your studio's computer, this book is for you.

What's in This Book

In *The Digital Imaging Dictionary* (Allworth Press, 1996) I define the Internet this way:

> Originally developed by and for military use, the Internet is made up of thousands of interconnected computer networks in over seventy countries, connecting academic, commercial, government, and military networks for academic and commercial research. It is also used as a worldwide electronic mail system. The fastest growing part of the Internet is the World Wide Web (WWW), where thousands of companies are creating what might be called the real "Information Superhighway." Connection to the Internet is available through online services

such as CompuServe, Prodigy, America Online, and many, many local and national Internet Service Providers.

Your first reaction to reading the above definition may be, "Huh?" but don't despair. Like everything else in the world of technology, the Internet has developed its own language and buzzwords combining terms from the worlds of computing and telecommunications. So just relax. When any new terminology is introduced in the body of this book, it will be explained in as much detail as those who are less-than-technically inclined will be able to stand. Those impatient souls who want to know what a new term means right away can feel free to jump ahead to appendix A, which contains definitions of all of the Internet jargon used in this book. I've also included definitions on imaging-related terms, such as types of image-compression graphics file formats, that photographers plying the Internet may find useful.

When I wrote the first edition of *The Photographer's Internet Handbook*, the Internet was still new to many people, but now it has become part of the fabric of the world. In the United States, more than 40 percent of households have computers. Since every new computer constructed today has a built-in modem, this also means they have the potential for Internet access. If you don't have a computer or an Internet Service Provider, most libraries do, which means that anyone who wants to can have Internet access. As you will discover later in the book, you don't even need a computer to have an e-mail address. You cannot escape the fact that the Internet is here and that it's changing the way the world does business.

Much of the real action for photographers and everybody else is centered on the World Wide Web, sometimes called just "the Web." Some people confuse the Internet and the World Wide Web, assuming that they are one and the same, but that is not the case. The Internet is a large network that is comprised of many elements, most of which will be covered in these pages, and it includes other elements as well, such as e-mail. One of the most popular aspects of the Internet is the World Wide Web, which uses a set of conventions for publishing and accessing information that provides access through a graphical user interface. The user then interacts with the Web by pointing and clicking with a mouse. What this means, practically, is that the Web's technology provides photographers with the ability to treat visual data, like photographic images, as if they were text.

Although the Internet contains a wealth of information, the WWW contains everything you ever wanted to know about anything. There are Web sites that feature everything from cameras to film to digital imaging, and there is plenty of marginal information there too. As in the case of television, finding useful information can be a challenge. Since there's no *TV Guide* to help you, this book will save you time by finding many kinds of photography-related areas on the Internet and Web and showing you how to find more.

Who Should Read This Book

Shortly before I started writing the first edition, I attended a seminar on the World Wide Web conducted by a computer company. With me were Barry Staver and John Blake, two other Colorado-based photographers. Our reason for being there was simple: We had heard all the hoopla surrounding the Web and were there to find an on-ramp to the information superhighway.

We were no "babes in the woods." All of us had been using computers for our photography studios for some time. Although I had started with an Apple II computer when I was an in-house photographer, I began using an Apple Macintosh in 1984 after I started my own studio. The other two guys had similar experience. We also had online experience and had all been using CompuServe Interactive Services for communications and for a way to keep up to date with our computers and our photography studios. Yet we were unprepared for what we found.

The all-day session began with a barrage of acronyms that had us gasping for air. This was followed up by an introduction to the software bits and pieces we would need to add to (and tweak) our computers in order to access the World Wide Web. Something seemed horribly wrong. After four hours of listening to all this techno babble, Barry, John, and I decided to call it quits and left—the barrage of compu-speak still ongoing. Later, on our own, we discovered our own on-ramps and are now all three surfing the Net—no thanks to our Internet seminar leader. It is my intention in writing this book to spare you from a similar experience.

The purpose of *The Photographer's Internet Handbook* is to bring the power of the Internet to every photographer—amateur or professional. The goal of this book is to make it possible for the *average* photographer, not the digital gurus— *you guys know who you are*—to take advantage of the latest communications technology. Whether you're an advanced amateur trying to create new and exciting images, a commercial photographer doing advertising assignments, a portrait photographer creating family portraits and weddings, or a stock shooter communicating with clients around the corner or around the world, the Internet can help increase your sales by offering new, electronic means to market your company, studio, and images. This book is an introduction to the opportunities available for photographers to use the Internet to gain knowledge and, at the same time, increase their studio's productivity and profitability.

What Kind of Photographer Are You?

Don Feltner, in his audiotape *How to Make Money in Photography*, suggests that photographers, like skiers, can be classified into three distinct groups: Beginner, Intermediate, and Advanced. I would like to suggest that computer-using photographers fall into similar categories.

Here's my view of these three groups of computer-using photographers, which may help you see where you fit in: Beginners are advanced amateurs or aspiring professionals who work alone in a small or home-based studio, spend five hours a week or less at the computer, and use word-processing, spreadsheet, and graphics applications; Intermediate users often work at their computer for ten hours a week, using desktop publishing, scheduling software, and database managers; and Advanced, or Power, users spend more than ten hours a week, using process-specific software such as Adobe Photoshop. There are always exceptions, but most photographers fit comfortably into one or another of these categories.

All three groups will find something in *The Photographer's Internet Handbook* that they can use and apply at the levels where they are working. Intermediate and Power users will be able to put the advice immediately to work in their operations, but even if you're a photographer with a shiny, brand-new computer sitting on your desk, you'll find something you'll be able to use right away.

In creating this book I've made a few assumptions: The book is aimed at users of computers running Microsoft Windows as well as owners of Macintosh and Mac-compatible machines. These are the same kinds of computers you will find in the homes, offices, and studios of photographers all across the country. Amiga, BeOS, or UNIX-based machines are not covered for the simple fact that not as many photographers use this type of equipment. I've attempted to make sure that equal emphasis is placed on software and hardware products for both Windows and Macintosh working environments.

I've assumed that readers do have a working knowledge of how to use their computers and are familiar with its basic functions. If you don't know what a mouse is or how a menu works, this is not the place to learn it. Go back to your computer's manual or read one of the many excellent introductory books available for Macintosh and Windows computer users.

I've also assumed that you have a basic understanding of graphics (especially photographic) file formats and of the use of some image editing software. You may not be a Photoshop wizard—few people are—but I expect you to have a basic grasp of how image manipulation programs work and to have the ability to save images in various graphics file types. If you're a Beginner, don't panic! The most common graphics files used on the Internet will be explained early on in the book, so you'll have plenty of time to brush up on your image conversion skills.

In short, I've assumed that you are the average photographer who wants to see what all the hype about the Internet is and find out if you want to put it to use. I think that you will find that there are at least one or more aspects of the Internet and World Wide Web that you can use to increase your ability to make creative photographs—and make money at the same time.

A Few Technical Notes_____

For readers who are interested in this sort of thing, this book was written on a 300MHz Apple Power Macintosh G3 computer, using Microsoft Office 2001 software. Most, but not all, of my surfing was done on a 350MHz Prime-built PC, running Windows 98. Both of these computers have built-in modems. Currently, my Internet Service Providers are CompuServe Interactive Services and the free Juno Online Services (more about that later in the book). My browser software includes both Netscape Navigator and Microsoft's Internet Explorer. The original manuscript of the book was printed on an Epson Stylus Photo 1270 printer, but a copy was also provided to the publisher on floppy disk.

The method for producing the images on these pages is as follows: Photographic prints were scanned on an Agfa (*www.agfahome.com*) SnapScan Touch flatbed scanner and 35mm slides were scanned using Kodak's (*www .kodak.com*) PhotoCD Process. Screen captures for the Macintosh were made using Ambrosia's (*www.ambrosia.com*) SnapZ Pro and TechSmith's (*www.techsmith. com*) SnagIt screen-capture utility for programs running under Microsoft Windows 98. When necessary, all of these images were converted into grayscale form, saved as a TIFF (Tagged Image File Format) file, and tweaked using Adobe Photoshop before being placed on a recordable CD disc for the book's designer.

A Final Note_____

Although only four years have passed since the first edition was published and I started writing this new one, much has happened, and this new book reflects changes in both the Internet and in computing. Back then, there were no television commercials for "dot.coms," but now you cannot turn on a TV without being bombarded with ads for every kind of online service available, from stock portfolio management to pet food. The single biggest change that the Internet has wrought has to do with the fabric of time. "Internet years" are different from calendar years and have more in common with "dog years," which are supposed to represent eight years of human time. Instant access has increased demands on a photographer's time and on a pro's client expectations.

Some things that were new when I wrote the first edition are hopelessly outdated today, but some larger concepts have not changed, including the following.

The Internet is big. So big, in fact, that no single book can possibly contain "everything you always wanted to know" about the Internet. If your favorite software or hardware product or Internet Service Provider is omitted, it is not intentional on my part. An omission could simply mean that I was unaware of a product or service, in which case I apologize. On the other hand, it is more likely that I contacted the company and either its representatives refused to cooperate with me on this book or just ignored me. Many large companies—some that fill

A Surfing Caveat

When surfing the Internet to look for any of the Web sites mentioned in this book, I ask that you keep a couple of points in mind. None of the sites that appear in this department are affiliated with Allworth Press or with me, and their inclusion here does not constitute an endorsement by the publisher or by me. All of the software and Web sites that are featured are intended as examples of the kinds of products and home pages that are available for Web-surfing photographers. You may find that you have Web sites, programs, utilities, or plug-ins that you prefer, and the omission of one of your favorites does not mean that I do not like the product or site—only that I may not have been aware of it at the time I wrote this book, or that the site was published or went online after the book was written. I tried to double-check to make sure that all of the sites listed were online when this book went to press, but access to any site on the World Wide Web may occasionally be unreliable, and even the site's URL may have changed by the time you read this. Please accept my personal apology if you find any site unavailable when you try to find it.

your mailbox with demo and sample disks, for example—do not return writers' phone, fax, or e-mail messages.

The Internet is changing. I have tried to avoid using version numbers for any software that is mentioned in this edition. Newer versions of almost all of the software will, most likely, be available by the time you read this, so I decided not to add to the confusion that outdated version numbers can create.

The Internet is no panacea. It's easy to lose sight of the real advantages of having an Internet presence for yourself or your studio. Don't do it just because you think it's cool. You need to use common sense—and not everybody does. Pizza Hut spent millions of dollars on a Web site to serve the people of Santa Cruz, California, only to discover that people would rather order a pizza by the telephone instead of their computer. It's just as easy to overlook some obvious goals when planning your own Internet project. When discussing marketing plans, professional marketers always refer to a "marketing mix": a combination of different media and tools aimed at reaching existing and potential clients. Just as you wouldn't shoot all of your photographs with the same lens, don't put all of your marketing eggs in one basket. The Internet is just another tool in your marketing toolkit.

When working on your own Internet-related efforts, just remember one of Farace's Rules of photography: Success is hard, failure is easy.

What Is the Internet and Who Is Surfing It?

We are moving inextricably toward total non-silver-based imagery.
What we are seeing now is the first wave of changes in our industry,
in which computers, telecommunications, and entertainment will merge.

Joe Farace, *Photomethods*, February, 1987

In this chapter you'll be introduced to some of the Internet's technical definitions and descriptions that you will need to know in order to become a proficient surfer. For reasons that have been lost in antiquity, people who use computers to connect to the Internet—for whatever purpose—are said to be "surfing the Net." The real reason that people "surf" the Internet is probably based on the same rationale that says photographers "shoot" brides and children. Ya think?

What Is the Internet, Anyway?

If you are satisfied with the definition of the Internet found in the introduction, you can skip to the next major heading, but if you're the kind of photographer who likes details, read on . . .

The Internet is actually not a single entity; it is composed of thousands of interconnected computer networks that are located in many different countries. If you prefer to think of it in organic terms, the Internet is a limbic system connecting the gray matter of independent computers by a series of high-speed com-

munication links between major supercomputer sites located at educational and research institutions within the United States and throughout the world.

Like many successful enterprises, the Internet had rather humble beginnings. In 1969 the Advanced Research Projects Agency of the U.S. Department of Defense created a computer network, called ARPANET, enabling scientists doing research for the Department of Defense to communicate with one another. The original ARPANET connected just four computers, but by 1972 fifty different universities and research sites had access to it. During the late 1980s commercial restrictions were lifted, and what eventually became known as the Internet began to grow dramatically.

In 1991, $20 million a year in federal subsidies were awarded to the National Science Foundation to maintain a major chunk of the system through another network that was to be called, not surprisingly, NSFNET. The actual management of NSFNET is now handled by a joint venture of IBM and MCI called Advanced Network and Services, which links supercomputing centers and 2,500 academic and scientific institutions around the globe.

Commercial service providers of all kinds, including telecommunications giants like AT&T, connected to the system and provided links to subscribers like you and me. Eventually, all of these public and private networks were interconnected, allowing any computer on any one of the subnetworks to access computers anywhere else in the entire Internet. Want to see a map? Visit *www.mids.org/mapsale/world*. As I write this, there are 100 million adult (over sixteen years of age) Internet users, and traffic is doubling every one hundred days.

With many different kinds of computers connected on the Internet, engineers had to develop a method by which they could all speak to one another using a common language. In 1983 a communications protocol was developed, which ultimately became known as TCP/IP. Let's attack both of these terms in reverse order: "protocol" is a communications industry buzzword that defines a system by which the computers on both ends of a network connection are operating under the same set of rules so that it's possible for them to communicate without experiencing any problems. TCP/IP stands for Transmission Control Protocol/Internet Protocol (that's a big help, isn't it?) and is the official protocol for the Internet. (This is like Coke's being named the official soft drink of the NASCAR.)

It is the job of TCP/IP to make sure that the number of bytes that start out at one end is the same number of bytes when the data gets to the other end. TCP/IP was originally developed for UNIX computer systems but is now the communications standard for all Internet-connected computers, including the Power Macintosh on which I'm writing this book. For PC-compatible computer users, Internet software is installed in the form of Dynamic Link Libraries, or DLLs, to provide a common interface between TCP/IP and your Windows-based computer.

The closest thing to an organization that actually runs the Internet was the Internet Activities Board, now called the Internet Architecture Board (*www .iab.org*). The IAB is ostensibly the Internet's governing body. A subcommittee called the Internet Research Task Force (IRTF) investigates new technologies, which it then refers to the Internet Engineering Task Force (IETF), which provides specifications for new standards.

Telcordia Technologies (*www.netsizer.com*) estimates that on the day I write this sentence there are 81,179,000 *hosts* on the Internet. Check their site for the latest number. (When I wrote the original book in 1997, there were 2 million hosts on the Internet.) A host is a mainframe, minicomputer, or workstation that directly supports the Internet Protocol—the IP in TCP/IP. The Internet is connected to all types of computer networks around the world via gateways that convert TCP/IP into other protocols. Let's climb up the acronym ladder one more rung and mention that TCP/IP includes a file transfer capability called FTP for File Transfer Protocol. What's so wonderful about FTP? It's the protocol that lets you send and receive files on the Internet. If you don't already know why this is a cool thing, you will by the time you're finished reading this book.

And on just one more rung, another important feature of TCP/IP is SMTP, or Simple Mail Transfer Protocol. SMTP permits Internet users to send e-mail by allowing both sending and receiving computers to emulate a terminal connected to a mainframe computer. E-mail allows you to send a message electronically to another user who may be located anywhere in the world. Asking for an e-mail address is fast replacing the question "What's your sign?" at bistros everywhere.

The World Wide Web

The World Wide Web, WWW, or sometimes just plain Web, was originally designed by Tim Berners-Lee and his colleagues at the European Center for Nuclear Research as a way of linking various kinds of information—no matter where it might be located—on the Internet. The WWW was not designed as a physical entity but as a series of basic specifications for interchanging linked information. *The Digital Imaging Dictionary* defines the World Wide Web as follows: "One of the most popular aspects of the Internet, the World Wide Web has a set of defined conventions for publishing and accessing the information found on it using HyperText and multimedia." One of the reasons that the World Wide Web is popular is that documents on it can display text and—attention, photographic shoppers—graphic images.

Right away, we're in acronymville again. Let's start with HyperText and see where it ends. The term "HyperText" was originally used by computer visionary Ted Nelson to describe a method that would allow computers to behave in the same manner as people do when they're looking for information. HyperText

The Ukrainian-made Kiev medium-format cameras have attracted much attention from bargain-minded photographers. One of the places that you can purchase Kiev cameras and other Russian products on the Web, including KGB watches, is Russian Plaza at *www.russianplaza.com*.

accomplishes this the same way our brain does by linking related information together. Programmers using HyperText Markup Language, or HTML, create linked information on the Web.

Specific locations on the WWW are called home pages and usually contain links with other documents either locally or anywhere on the Internet. Sometimes a home page will be called a Web site. As is common in general usage, I will use these terms interchangeably in the book—although usually I think of a "home page" as the first screen or page of a Web site. *Internet Computing* magazine estimates that there are more than 325 million Web sites on the WWW. Right now, 50 percent of all U.S. companies have a Web site, and I have heard (although this is impossible to verify) that two thousand more are added each day.

What all of this jargon means in practice is that the World Wide Web uses "hot spots" on its home pages to link related information. If you're interested in

Upload versus Download

When any kind of data, including images, is retrieved from the Internet or WWW and saved on your computer, it is said to be *downloaded*. When data—text or images—is sent to a home page it is *uploaded*.

toy cameras, for example, a home page may contain links to sources to purchase cameras, like the inexpensive but eminently usable Ukrainian-made Kiev medium-format camera. The mere act of effortlessly moving, by just pointing and clicking, from Web site to Web site, country to country, and location to location is what I really think gave birth to the term "surfing the net."

In the not-too-distant past, the only way you could create your own home page was by writing actual HTML code. Fortunately, there are now much easier ways for nonprogramming photographers to produce their own Web site, and these methods will be discussed later in the book.

Multimedia Aspects of the WWW

Multimedia is another computer buzzword that has been overused. Multimedia is nonetheless the fastest growing aspect of the Web. On the most basic level, a Web site with multimedia can be any home page that mixes graphics, text, animation, movies, and photographs. Macromedia (*www.macromedia.com*) upped the multimedia stakes with the introduction of Shockwave. Shockwave is a software plug-in (or add-on) for Internet browsing programs that allows animation and movies to be viewed in real time. Later on in the book, the software and plug-ins needed for "browsing" the WWW will be introduced. In the meantime, the most important multimedia feature of the World Wide Web for readers of this book is that it's the place that allows photographs to be displayed and downloaded.

Graphics File Formats

Photographs on the Internet are usually displayed or saved in one of four possible graphics file formats: JPEG, GIF, PNG, or FlashPix.

JPEG is an acronym for a compressed graphics format created by the Joint Photographic Experts Group, within the International Standards Organization. Unlike other compression schemes, JPEG is what techies call a "lossy" method. By comparison, LZW compression (see below) is lossless—meaning that no data is discarded during the compression process. JPEG, on the other hand, achieves compression by breaking an image into discrete blocks of pixels, which are then

divided in half until a compression ratio of between 10:1 and 100:1 is achieved. The greater the compression ratio that is accomplished, the greater the loss of sharpness and color detail you can expect. JPEG was designed to discard information the eye cannot normally see.

GIF (pronounced just like the peanut butter) stands for the Graphics Interchange Format originally developed by CompuServe. It is platform-independent—that is, the same file created on a Macintosh is readable by a Windows graphics program. A GIF file is automatically compressed and consequently takes up less space on your hard disk than other graphics formats. Some image and graphics programs consider GIF files to be "indexed" color with a limited number of colors, so not all software read and write GIF files, but many do. When CompuServe originally developed the format, it used the Lempel-Ziv-Welch (LZW) compression algorithms as part of the design, believing this technology to be in the public domain. As part of an acquisition, UNISYS gained legal rights to LZW and a legal battle ensued between CompuServe and UNISYS, which in turn led to the creation of the Portable Network Graphics format.

Portable Network Graphics, or PNG (pronounced "ping"), is the successor to the GIF format widely used on the Internet and online services, like CompuServe. In response to the announcement from CompuServe and UNISYS that royalties would be required on the formerly freely used GIF file format, a coalition of independent graphics developers from the Internet and CompuServe formed a working group to design a new format that was called PNG. PNG's compression method has been researched and judged free from any patent problems. PNG allows support for true color and alpha channel storage, and its structure leaves room for future developments. PNG's feature set allows conversion of GIF files, and PNG files are typically smaller than GIF files. PNG also offers a more visually appealing method for progressive online display than the scan line interlacing used by GIF. PNG is designed to support full file-integrity checking as well as simple, quick detection of common transmission errors. All implementations of PNG are royalty-free.

As I was completing the first edition of this book, a consortium of companies, including Eastman Kodak, Hewlett-Packard, Live Picture, and Microsoft, announced a new, open standard for digital imaging called FlashPix. The format would use a hierarchical storage concept, allowing images to take less RAM (Random Access Memory) and hard disk space than previous image-based graphics files. This would allow users to work with many on-screen images at the same time without overloading the computer's memory or adversely affecting performance. Edits would be easier, especially nondestructive edits, such as rotation, scaling, and color and brightness adjustments. This means that users would be able to experiment with changes and quickly undo them, without destroying original image data. While FlashPix had many advantages and Kodak actually

digitized images onto FlashPix discs (I have one), the format never took off on a larger scale.

PNG and FlashPix have yet to catch on as a widely used Internet standard, and most images are still displayed on the Web as JPEG or GIF files. Knowing what file formats are Internet-friendly may not seem important right now, but it will be later on when you start building your own home page. How to get your photographs into one or more of these Internet-friendly graphics file formats will be covered in chapter 7. In that chapter, I'll give you some reasons why you may or may not want to use either file format.

The Internet and the Intranet

Sooner or later you're going to encounter the term "intranet." Before you become even more confused, note the following: An intranet (usually written with a small i) is a private computer network that has been designed to have the same look and feel as the World Wide Web and combines HyperText links with text-based information, animation, graphics, and video clips to allow its users to communicate. A Full Service Intranet system, a concept developed by Forrester Research in 1996, is a TCP/IP network inside a company that links the company's employees and information in a way that allows people to be productive, have access to information, and be able to navigate through the company's computing environment. A Full Service Intranet takes advantage of open standards and protocols that have emerged through development for the Internet. These open standards make possible applications and services like e-mail, groupware, security, directory, information sharing, database access, and management that are as powerful, and in many cases more powerful, than traditional systems, such as Lotus Notes or Microsoft BackOffice.

Why the Internet Is Important to Photographers

There are four major reasons photographers should discover and exploit the Internet. These four are not the only reasons why you should Surf the 'Net or Waltz the Web, but they represent the major areas where the Internet will be of value—no matter what your photographic specialty may be. As you become more experienced with the Web, and as new elements are developed for it, you may discover other uses that affect you and your studio on many different levels.

Access to Photographic Products and Services

All of the major camera companies have home pages on the Internet. If you're a Nikon user and you want to find out what's new with your favorite company,

Nikon's Web site (*www.nikonusa.com*) provides access to the latest up-to-date information about the company's traditional and electronic imaging products.

just visit their Web site at *www.nikonusa.com*. The Web also provides access to photo retailers so that you can order a new 400mm lens or ask a technical question while visiting a retailer's home page. The WWW also lets you find hard-to-get items, such as an all-plastic Holga camera or film for your old and now-obsolete Kodak "Party Time" instant film camera. You can also buy new and used photo equipment at Web sites such as KEH Camera (*www.keh.com*), or even get involved in online auction of cameras and lenses on sites such as *www.ebay. com*. Later on, in chapter 5, I'll introduce you to many photography-related Web sites that you won't want to miss.

One of the newest features of the World Wide Web is that photographic labs and photofinishers are providing online delivery of digital images from processed or unprocessed film that you send them. The specifics of how one of these services work, along with a step-by-step download of actual digital images, is covered in chapter 4.

Nonphotographic Products and Services

Photographers do not live by digital imaging alone. They've got a business to run, too, and they require assistance for everything from travel planning to demo-

Using Web sites like Travelocity.com can save time and money when making travel arrangements. Once when a client told me that she only had a limited budget for travel, I was able to find a hotel/airline combination on the Web site for within four bucks of that budget. It was a win-win situation for both of us.

graphics to information about government regulations regarding photographing assignments on public land or national parks. Web sites such as *www.travelocity.com* not only let you make travel arrangements including telephone, hotel, and rental cars but can save you money, too. Glamour photographer Len Kaltman (*www.glamourportfolios.com*) told me that for his last shoot in Mexico, he made all of the travel arrangements, including booking the models, over the Internet.

The World Wide Web contains information that can help you in business planning, but one of the biggest problems is how to find it. The main tools for finding information on the Web are search engines that look up Web sites based on keywords that you supply. Chapter 4 includes a look at popular search engines and includes information about the strengths and weaknesses of each of them.

Worldwide Marketing

Although not all Internet users are potential buyers for images or services from professional photographers, the Internet is clearly becoming as much a business tool as the fax machine and cellular telephone. Having your own Web site gives a single photographer, working alone, the same *online* marketing clout that General Motors has. It's this democratization that empowers individual photographers, limited only by their creativity, to have the ability to market images and photographic assignment capabilities to buyers across the country or around the world.

Never in the history of art and commerce has this kind of marketing tool existed that allows a small studio to compete with the "big boys." If you have a studio in Spearfish, South Dakota, you may not be able to open an office in New York or Los Angeles to sell your work, but having a Web site on the Internet gives you the equivalent of an international office—with few of the costs normally associated with opening another studio location. In this way, the Internet is truly the great equalizer. When someone lands on your home page, he or she will judge it by its design and the quality of images that are displayed—nothing else.

Communications

One of the most practical aspects of the Internet is the ability to communicate with people, no matter where they may be located, electronically. For the cost of a local phone call, you can send electronic mail to a company in Germany, order camera parts from a firm in Canada, or correspond with a photography professor in Haifa, Israel. One of the first things you will notice is that e-mail, like Web sites, has a distinct format for an address. For those readers who have been wondering what all those acronyms and symbols mean, I've prepared the following overview of e-mail and Internet addresses.

E-Mail

Sending electronic messages, or e-mail, is much easier than writing a letter on your computer, printing it, addressing an envelope, licking a stamp, and dropping it into a mailbox. An e-mail message is usually delivered in minutes, and the cost of sending a message to Toledo, Spain, is the same as sending one to Toledo, Ohio. E-mail allows photographers to communicate with friends, colleagues, clients and potential clients, as well as suppliers around the world for very little cost, and it provides access to international photographic markets that were once the exclusive province of well-heeled shooters.

To send e-mail, one of the first things you'll need is an Internet address. This happens when you sign up with an Internet Service Provider (ISP) and is covered in more detail in the next chapter, including how to get free e-mail or a

portable e-mail address. Most ISPs allow you to pick your own e-mail address within the basic format of *"name@ISP.domain."* As I write this, most ISPs let you pick your own name as long as nobody else has it. At the moment, for example, my e-mail address is *jfarace@juno.com*.

When selecting an e-mail address, avoid the temptation to get cute. Instead of using *"spankme@trallop.com,"* use something that indicates there really is a person behind the address. This will help the person receiving your messages to take you seriously.

If the name is the first part of your "electronic" address and the ISP is your service provider, you may be wondering what the domain stuff is. Here's a quick overview of some of the most common Internet domains:

- **.com** is a business or commercial Internet domain, and photographers using CompuServe, America Online, or Prodigy usually have a *.com* domain.
- **.edu** is assigned to educational and research users at colleges or universities. Student photographers or photography professors may have a *.edu* domain in their Internet address.
- **.gov** is used by government or military agencies. If you're an in-house photographer for a government agency or a Photographer's Mate in the Navy, your address will end with *.gov*.
- **.net** is used by gateway or Internet host sites. If you want to send a letter to the editor at *Shutterbug* magazine, the address is *editorial@shutterbug.net*.
- **.org** is used by nonprofit organizations, like National Public Radio, as well as many of the quasi-governmental organizations.

More to Come

The above domains are the most common, but the Internet Corporation for Assigned Names and Numbers (ICANN) has indicated that it might be expanding some of these choices. Here are a few possibilities that, although they weren't firm as I finished this book, may be in place when you pick it up.

- **.banc** or **.shop**: These have been suggested as domain names for financial Web sites and for e-commerce—stuff that you buy, such as the current *www.landsend.com*.
- **.nom**: This domain would be used for Web sites created by individuals. I hope that by the time you read this, *www.joefarace.com* is online, but it might be a candidate for the *.nom* domain.
- **.union**: Dedicated for accredited labor organizations.
- **.Web**: A possible supplement for the ubiquitous *dot.com*.

- **.sex**: Would be dedicated to pornographic Web sites (that some people believe make up 80 percent of all Web sites) as a means of both segregating them and making them easier to control through "nanny" software and filters.

Internet Relay Chat

Internet Relay Chat, or IRC for short, is a system that allows users to interact in real time with other people connected to the same channel. Some pundits have likened IRC to Citizens Band Radio, and for many years the Citizens Band Simulator on CompuServe has been a popular area for its subscribers. A variation on this theme is Instant Messenging. This is a system that lets you know when specific users (you have to provide a list) go online. You can then communicate with them directly by sending and receiving private text messages.

Emily Post in the 21st Century

In the next chapter, you'll discover how to get the hardware and software needed to actually begin sending e-mail. In the meantime, here's a short overview of the basic language and etiquette, sometimes called *netiquette*, that you will need to know before communicating electronically.

When corresponding via e-mail or in newsgroups where more than one person may read a message you send, certain levels of civilized behavior are expected by the people reading your messages. Instead of having an Internet Emily Post, people reading your postings will try to educate you in the proper forms of written behavior. One of the most common mistakes newcomers make is typing everything in CAPITAL LETTERS. This is considered a breach of netiquette because the writer is considered to be shouting—and it's hard to read, too. If you get too loud or profane (sometimes called "flaming"), expect a stern warning from the Webmaster or others in the group. You may even find yourself banned from future participation.

After you read a message, you might want to reply to it as soon as you can. This seems an obvious rule, but it's one that is gradually disappearing. The golden rule applies here, I think.

Part of the problem with the growing volumes of e-mail is that some of it is misdirected. That's why it's a good idea to routinely double-check the "To:" field whenever you send a reply. This can keep you from replying to more people than you intend.

As you will discover, e-mail is no panacea; some problems are best resolved with a telephone call. Want to know more? Visit Albion.com's Netiquette section (*www .albion.com/netiquette*).

America Online, CompuServe, ICQ, Microsoft, and Yahoo! all currently offer this service, which requires that you download specific software. Some of the software, such as Yahoo! lets you use audio equipment, not just text, to communicate. As of this writing the software is only available for Windows computers, not the Mac OS, although the technology would not seem that difficult to port.

USENET Newsgroups

USENET is yet another form of information gathering that gives Net surfers access to a worldwide bulletin board with well over ten thousand special interest categories, allowing users to read and post messages as well as download articles on many different topics, including photography. It was established in 1979 as a bulletin board between two North Carolina universities and has grown to its current size through the use of volunteers only.

All of the news that's found on the Internet is called "NETNEWS," and a newsgroup is a place where users have running conversations on a particular topic. Although the topics can include photographic art, science, and commerce, they are just as likely to include something silly as well. If you would like know more about this topic, visit *www.geocities.com/ResearchTriangle/Lab/6882.*

Getting Wired

She has an ultra-high-speed modem connection, I guess, since Internet stuff pops up the moment she hits the return key.

Roger Ebert writing about Sandra Bullock's character in the movie, *The Net*

To get connected to the Internet you will need two things: hardware and software. The first section of this chapter looks at hardware—modems, in particular—and the second section introduces you to software browsers that make communications over the Internet possible. No matter what combination of hardware and software you end up using, nothing can shield you from the reality of the Internet as I write this in the middle of 2000: accessing information on the Internet can still be slow. According to Macintosh guru Henry Norr, writing in *MacWeek*, "the main problems have nothing to do with the [band]width of your local pipe; the real issues are backbone bottlenecks, overcrowded servers, and insensitive [home] page design." There are always alternatives to using conventional modem technology, and this chapter will look at Internet options including digital networks and cable TV (yes, the same cable that brings you *The Sopranos* on HBO).

Hardware: Modems

Your hardware ticket to the Internet is a modem. The word "modem" comes from a compound of two words: "MOdu-

Do You Have a Modem?

When I wrote the first edition of this book, not every computer-using photographer owned a modem. Nowadays, every new computer, with very few exceptions, has a modem already built in. The discussion of internal versus external modems may seem moot, but not every reader of this book has a brand-new computer. Some have entered computing via the purchase of a used computer, which is an excellent way to get into digital imaging and Web surfing for little cost. Some used computers may not have a modem built in or may have an older, slower model. Just as one of Farace's laws of computing states that you should always buy the fastest computer *that you can afford,* the same is true of modem speeds.

late-DEModulate." That's what a modem does. Since the current telephone system across most of America is analog, computer data must be converted from digital form into analog form for transmission over telephone lines. At the receiving end, the data is then converted from analog back into digital form. Most online services are connected by telephone lines to a central computer, known as a "server." The server is similar to a digital warehouse that's full of information. When you want to retrieve some of that information, you send a command to the server and the server fulfills the order, sending back the requested data to your computer. On a commercial online service, such as America Online or CompuServe, telephone lines move the information from the server to your modem, which passes the information into your computer at a speed that varies according to the modem's design. These speeds vary from 2,400 bps (bits per second) to approximately 56,000 bps.

A traditional modem, when used with the appropriate software, can also dial up an online service, answer a call, and control transmission speed, which currently ranges from 300 to 56,000 bps. Although modem speeds have continuously been raised through a horsepower race between manufacturers, all this conversion back and forth does limit the actual speed of data transmission.

Two Flavors

Modems come in two basic configurations: internal and external. These names indicate exactly what they're like. Internal modems are mounted on circuit boards and plugged into a slot on your computer's motherboard. Any discussion of the advantages, disadvantages, and installation procedures for internal modems may be more relevant to computers running the Microsoft Windows environment and not Apple computers. All currently produced Power Macin-

The built-in modems on Apple G-series Power Macintosh models have a separate slot for the modem and therefore don't grab the all-too-scarce expansion slots. Courtesy Apple Computer.

toshes, iMacs, and PowerBooks have modems built in directly at the factory. This was a result of Steve Jobs's decision to have Apple focus on the Internet. There are some internal modems available for older Macintosh models; two of the best sources for this hardware are Small Dog (*www.smalldog.com*) and Shreve Systems (*www.shrevesystems.com*).

Internal modems cost less than external models because they don't require a separate housing and because they use your computer's built-in power supply instead of requiring their own. Internal models don't require additional desktop space, something that for most digital photographers grows scarcer every day. One downside of an internal modem is that it takes one of your slots and, depending on your motherboard design, that may or may not be a problem for you.

External modems, on the other hand, are separate boxes containing their own power supply and circuitry and are connected by a cable to your computer's modem or serial port. That's as difficult as they are to install. You plug in a cable to the computer, insert the power cord into a wall socket, plug in the telephone line, install the software, and (if you're lucky) you're ready to go online. It doesn't always happen that way with Windows computers, and sometimes there are problems with COM (communications) ports, but each new version of the operating system has made such problems less likely.

What Do Those Blinking Lights Mean?

One of the advantages of external modems is that they usually have a display of LED indicator lights that indicates what they are doing. Some modem users think these lights are an essential part of the modem experience, while others (I'll raise my hand on this one) could care less. Above and below these lights a two-to-three-letter code is usually printed, indicating what's going on. Here's a crash course in what these indicator light codes mean:

AA: Auto Answer
CD: Carrier Detect
EC: Error Control
MR: Modem Ready
RD: Receiving Data
SD: Transmitting; Sending Data

CA: Compression Active
TR: Terminal Ready
HS: High Speed
OH: Off Hook
TM: Test Mode

One of the major advantages of the external configurations is that you usually have some kind of LED (Light Emitting Diode) display on the front of them that indicates the progress of your connection with the Internet or host computer. My old Supra (*www.supra.com*) Fax/Modem has a panel that actually displays English words. When the modem is turned on—but not in use—it displays "OK." External modems are getting smaller, too. Because external modems have a separate power supply and external case, they are necessarily more expensive, but not too much more. As I write this, a 56K external modem from Global Village (*www.globalvillage.com*) costs under $100.

The ultimate decision of whether you choose an internal or an external model may boil down to how difficult it is to install an internal model. In the past, installation of internal modems in the typical Windows-based computer was—let's be honest—a pain in the you-know-where. The further implementation of the plug-and-play concept of Microsoft and Windows 98 now extends to all hardware and software, including modems, making the installation of an internal modem a matter of plugging in the modem in an available slot and double-clicking the Add New Hardware control panel. This procedure launches one of Microsoft's Wizard sequences, guiding you step-by-step through the rest of the process. (Macintosh users have had this same plug-and-play capability since 1984, but that's a topic for another book.)

This same procedure is not as easy to accomplish in Windows 3.1 and older versions. Therefore, installing an internal modem in a computer using these older operating systems is best left to those technically inclined photographers

Modem on a Stick (OK, Card)

A subset of the internal modem category is the PC Card modem. PC Card is the current euphemism for PCMCIA. PCMCIA is an acronym for Personal Computer Memory Card International Association. A PCMCIA, or PC, Card is a small, credit-card-sized module that is designed to plug into standardized sockets of laptop and notebook-sized computers.

To date, there are three PCMCIA standards: Type I, Type II, and Type III. The major difference between these types is the thickness of the cards. A Type III card is 10.5 millimeters thick, Type II is 5 millimeters thick, and Type I is 3.5 millimeters thick. Most laptop computers will take a combination of the different types and, if a modem is not already built in, will have slots that can accommodate two Type I or Type II PC Cards, or one Type III card for the installation of a modem.

who like to take things apart. Keep in mind that you don't have to do it yourself. Many computer and electronic superstores now include free installation of computer hardware items that you purchase from them.

Internal and external modems are produced by many different manufacturers, and most today are 56,000 bps modems (more on what these numbers mean later). As the price and performance of all modems steadily improves, a modem's serviceability or warranty becomes less of an issue when deciding which kind or brand to buy. The chances are that if—and that's a big if—your modem ever fails, you will want to replace it with a newer, faster model. And chances are good that this new modem will cost less and have more features (like fax or voice mail) than the one you currently own.

Which type of modem is best? I have internal modems in both my desktop computers and my laptop. I prefer the internal style because my work area tends to be messy, and the fewer peripherals that I have grabbing desktop space and power-strip space, the happier I am.

How Modems Work

Techie alert: This next section gets into the basics of how modems work and of what the technical specifications of a typical modem are. Reading this later information can be just as important as checking out the technical specs for a new camera or lens. However, just as not all photographers care about resolution charts, not all photographers care about modems. All some of you want is for the two different devices to work. If that describes you, skip ahead to the next section.

A traditional modem's job is simple: It takes the digital information stored in your computer and converts it into audio frequencies that are compatible with the analog telephone system. The modem, along with the appropriate software that we'll get to in a bit, will dial the phone number for your Internet connection. The speed of transmission for a modem is measured in bits per second. Not so long ago, 2,400 bps modems were the norm; this quickly escalated to 9,600; then 14,400; then 28,800; and now 56,000 bps is considered *de rigueur* for Net surfing. Make no mistake about it, surfing the Net can be slow—slower than you may think—and having the fastest modem you can afford will make cruising the Internet less painful.

To control the modem, most companies use the Hayes AT command set of machine instructions. Hayes Microcomputer Products was one of the early pioneers in data communications and, up until they created the Smartmodem 300 in 1981, most modems were passive devices used in dedicated data transmission systems such as private data networks purchased or leased from telecommunications companies. The Smartmodem created and understood a language of modems that other manufactures quickly adopted as a standard. When buying a modem, you want to make sure that it is 100 percent Hayes-compatible.

Standards for data communications devices are created and approved by the International Telecommunication Union (ITU), whose Web site address is *www.itu.org*.

For a while, there were two competing standards for 56K (56,000) modems, but that ended when the ITU established the V.90 standard on February 6, 1998. Many industry experts expect this to be the last analog standard before we finally go fully digital and end all that analog-to-digital-and-back translating. Using the former V.34 standard, transmission speeds were limited to a theoretical 35K bps with analog connections at both ends. The V.90 standard assumes that one end of the communications link is purely digital and can produce transmission speeds up to a maximum of 54K bps—not 56K, as the modem speed suggests—due to a Federal Communications Commission ruling on maximum permissible power during download transmissions. A typical Internet caveat applies here too: Actual data transmission speeds will vary depending on online conditions and the speed of the server that you ultimately connect to. Some are faster than others; some are more overloaded than others. More information on the V.90 standard can be found at *www.v90.com*.

Many modems offer faxing capabilities in conjunction with their data and Internet features. Fax modems often incorporate DSPs (digital signal processors) that allow the device, when used with the appropriate software, to become a digital fax machine capable of sending and receiving Class I and Class 2 faxes at 14,400 bps. A Class I fax is a series of Hayes AT commands that can be used by fax software to emulate and communicate with a fax machine or another

Looking for More Details on Modem Technology?

Photographers who love to know what's behind the scenes, can visit the following Web sites for more technical details:

- Lucent Technologies: *www.lucent.com/micro/K56flex/about.html*
- 3Com: *www.3com/technology/tech_net/white_papers/500659*

fax/modem. Class 2 was developed in 1991 to allow a modem to handle all of these functions directly through the hardware itself. This standard allows a fax/modem to establish the connection, but it places the burden on sending and receiving image data on the host machine's processor. Having a fax that can work with both Class 1 and Class 2 modes gives computer users the greatest flexibility in selecting the fax software they would like to use with their computer. You're not sure if you need fax capabilities? Read on.

Finding the Right Modem

The next two sections contain information that could rightly be called "what to avoid and what to look for" when shopping for a new modem. Consider it a highly opinionated look at the modem marketplace.

What to Avoid

Unless you are extremely knowledgeable about computers and modems, beware of closeouts at the discount computer store. At the end of the next section, you will discover Farace's Internet Rule #14. I won't spoil it for you now, but it tells you that there are few real bargains in older or used modems. Often these closeouts offer used or demo models of older and slower models. As I have mentioned, the Internet can be slow—annoyingly so, on some days—and if you buy a slow modem, you will not be happy with your "good buy" when it takes an hour to download a large file.

On the other hand, used state-of-the-art modems are available at the kind of used computer stores that are springing up everywhere. The best of these stores will guarantee the equipment, and you can pick up modems at better-than-bargain prices. Why are these used modems available? Part of the problem is that the Internet has been oversold to a large part of the general population as a panacea for everything from a kid's poor grades in school to your declining stock portfolio. Some people quickly realize that they are not really happy Net surfers and dump their hardware—usually at a big loss.

When shopping for a modem with fax capabilities, make sure it can handle

both Class 1 and Class 2 faxes, so that you can use whatever brand or type of fax software you want without being limited by the hardware design.

Don't cut corners when shopping for a modem. It will be one of the least expensive peripheral purchases you make, so now is not the time to scrimp. You didn't wince when you purchased that 600mm lens. If you're serious about taking advantage of the Internet, you need to make the same kind of financial investment as you made in your photographic equipment—besides, the cost of the most expensive modem will be much, much less than any long lens for your Nikon, Canon, or Minolta.

Buyer's Check List

Here are a few things to keep in mind before heading out to the computer superstore with your credit card or breezing through the pages of *Computer Shopper* magazine looking for bargains.

Hayes-compatibility. If you've read the section about Hayes Microcomputer Products and their creation of the original, *de facto* modem standards, you now know that spending money on a modem that is not 100 percent Hayes-compatible is a waste of money.

Configuration—internal or external. It's a good idea to go shopping with a specific kind of modem in mind. Don't just buy it because it was on sale. Because photographers tend to have more peripherals than the average user, I would like to recommend you get an internal modem. For example, I have a flatbed scanner, an APS tape drive (for backups), color printers, an Iomega 250 Zip, and a CD-ROM drive connected to my Power Macintosh G3. I'm not bragging, just pointing out the minimum, typical peripherals a digital photographer might have. When you add a modem to that menagerie of hardware, it makes for a cluttered desktop, and in an age of ever-expanding work, space is always at a premium.

Telephone capability. More and more modems are coming equipped with telephonic abilities. New software and Web sites, such as *www.visitalk.com* and *www.dialpad.com*, allow users to use the Internet as a real-time voice telephone to call anywhere in the world with no long distance charges—just your normal Internet connection fees. Some modem software packages provide a combination speakerphone, voice mail, fax, as well as Internet features. The package includes microphone and speakers to provide hands-free speakerphone and telephone capabilities along with voice mail features. While "touch 1 to speak to the photographer" may be a cliché, business voice messaging is a fact of business life in this new century. Your clients will not be offended, and it might even upgrade your studio's image a bit.

Fax/modem. Because I tend to send few faxes, I'm less excited about fax capabilities for modems, but many of my photographer friends swear by them. Having a modem that offers voice, fax, and Internet capabilities is much less expensive

Internet services, such as Visitalk.com provide both voice and video conferencing services from your computer to phones anywhere in the world with no long distance charges.

than you might think and triples the use of a single office or home office telephone line. As noted about internal modems, combining multiple capabilities in a single package of hardware and software helps save you money and desktop space—something the typical photographer can always use more of. Think about it.

Finally, let me reiterate Farace's Internet Rule #14: Always buy the fastest modem you can afford, because the day after you buy it, someone will introduce another modem or new technology that will be twice as fast and for half the cost. Being king-of-the-hill in the computer world is a short-lived experience, and nowhere is that more true than in the fast-changing modem marketplace.

The ISDN Alternative

The dream of an all-digital network that would eliminate the need for all that modulating and demodulating has been a reality for some time. The problem, at least in the United States, has been implementing it. In the following sections,

I'll introduce you to several ways to avoid the analog telephone network and go digital all the way.

ISDN (Integrated Services Digital Network) is the international standard for transmission over completely digital circuits and lines of voice, data, and video at 64,000 bps. Access to this network doesn't require new telephone wiring. ISDN converts your existing copper wire into a powerful communications pipeline by sending digital signals at high speeds over multiple pathways. ISDN enables voice, data, video, and graphics to be sent over a single, ordinary telephone line at speeds up to fifty times faster than typical analog voice line capabilities. A new generation of ISDN called Broadband ISDN (BISDN), which is built on fiber-optic technology, increases the potential top data transmission speed to 155,000,000 bps.

One of the concepts that ISDN is built upon is removing all of the signaling that accompanies standard telephonic practices, placing them on a separate path called the "D" channel that operates at 16,000 bps. This leaves another channel called the "B" channel that can operate at 64,000 bps, which can be used for voice and data. Unlike telephone lines that carry a single analog voice channel, ISDN is typically offered as a multichannel package called Basic Rate Interface (BRI), which includes three separate channels—two B channels and one D channel—as standard. This means that you can be talking on your telephone and surfing the Internet—at the same time. You will, however, require an ISDN telephone set for your voice conversations, and while such sets are even available at Radio Shack, they aren't cheap.

Since data from your computer is already digital and doesn't have to be converted into analog form (and vice versa), ISDN lines don't require modems. They do, however, require a terminal adapter to provide an interface between your computer and the ISDN line. ISDN terminal adapters, sometimes called Network Termination Devices, provide the basic interface between the ISDN line coming into your home, office, or studio. Recognizing that the whole world is not going ISDN overnight, some companies have developed hybrid modem/terminal adapters that will function with traditional telephone lines and ISDN.

My old friend, Gene Jones of Bell Atlantic, introduced me to ISDN in 1986 when the first call was placed in Phoenix, Arizona. What, you may be asking, took so long? All is not rosy and perfect in the land of ISDN. The biggest barrier seems to be costs. The cost to the consumer is reflective of the cost that telephone companies have to expend to upgrade their central office switching equipment and outside plant facilities. In Britain, as in the rest of Europe, ISDN has been a practical reality for some time; the cost of analog and ISDN lines, except for a slightly higher quarterly charge, are identical. In the "good ole U.S.A." prices tend to be higher.

Most forecasts predict that ISDN will gradually become more affordable for

More Data, Please!

As I write this, here are some of the best online sources for more information about Integrated Services Digital Network:

- *www.isdn.zone*
- *www.isdn4me.com*
- *www.microsoft.com/windows/getisdn/whatis.htm*
- *www.nationalISDNcouncil.com*
- *www.ralphb.net/ISDN*

the average user. One thing that might motivate some photographers to go ISDN sooner—instead of later—is that the increase in performance may be worth it. BT North America performed several comparison tests and found that a file that took twenty-three minutes to send through a standard modem took only twenty-five *seconds* over an ISDN BRI line.

Cable TV and the Internet

If you think that ISDN has telecommunications well poised to be the provider of choice for Internet access, watch out! The cable television industry has its sights set on the same goal and for good reason. Like the Bell Regional Operating companies, commonly called "Baby Bells," cable TV firms already have an enormous infrastructure in place—some including fiber-optic cables. The acquisition of TCI Cable by AT&T was specifically to get into the cable modem business via the company's @Home cable-based digital network. You can visit their site at *www.@home.com* for more information.

Because cable firms already carry video signals through channels used for television, their cables have the potential for moving data at faster speeds than either conventional analog telephone lines or ISDN lines. And cable companies already have access to content providers who can deliver a wide range of services to their users—including local and national news, shopping, sports, weather, as well as information about local entertainment and activities, schools, government, and libraries.

A cable modem is different and is both faster and better. How fast? According to studies made by CableLabs using a 500MB image file as a test, a 28,800 bps modem took six to eight minutes to download the file, while a cable hook-up took approximately one second.

How do they accomplish these high speeds? Using a fiber-optic cable coupled to a coaxial cable (the typical cable television wiring), the connection from the

company's servers to the cable modem can deliver information at speeds that are one hundred times faster than a dial-up connection. You get the information you want much more quickly and you don't have to wait for dialed connections to be made. This also means that your phone line isn't tied up. This kind of service has a single monthly fee and you can use it as much as you want.

Digital Subscriber Line

As I write this, the hottest form of digital Internet connection is provided by Digital Subscriber Line (DSL) technology. This is a system that provides high-speed access over traditional copper telephone lines. A DSL line simultaneously carries both data and voice signals, and the data portion is always "hot." DSL installations began in 1998, but problems with installations that have not been able to keep up with demand have created some service bottlenecks. Most industry observers expect DSL to replace in many areas and to strongly compete with the cable modem, but ultimately, who wins this race depends on who delivers what and where and for how much. There are some variations of DSL that are explained in the sidebar "Types of DSL."

The key to having DSL installed in your home or business is the distance that your location is from a telephone company (where all the local and toll switching equipment is housed) that offers DSL service. So there really are two aspects to actually having DSL available to your home and office: DSL service must be offered in your area, and you need to be close enough to take advantage of it. Some telephone companies and DSL service providers have sections of their Web sites that let you check to see if you are within range to subscribe to the service.

DSL lets you receive data at rates up to a theoretically possible 8.448 Mbps per second, which enables transmission of video, audio, and even 3-D effects. Most companies offering DSL service offer different speed ranges at different prices. Quest (*www.quest.com*), for example, offers six levels of what they call their MegaBit service, starting with 256 Kbps (Kilobits per second) up to 7 Mbps for intensive business users.

Digital Satellite

Some people live in areas that may be serviced by local telephone service but are not offered Digital Subscriber Line. Their cable TV company may not find it economical to put in fiber-optic cables to bring them cable modem service. Their last choice for high-speed Internet access is digital satellite. One of the companies that offers this service is DirecPC (*www.direcpc.com*), a division of Hughes Electronic Systems. DirecPC provides data transmission speeds up to 400 Kbps, which is three times faster than ISDN and fourteen times faster than a 28.8

Types of DSL

ADSL: Asymmetric Digital Subscriber Line is the most familiar for home and small business users. It's called asymmetric because most of its two-way or bandwidth is devoted to sending data to the user—often called downstream in the lingo of DSL. Using ADSL, up to 6.1 megabits per second of data can be sent downstream, while up to 640 Kbps can be sent upstream, or uploaded. A portion of the downstream (or download) part of the connection can be used for voice communications, so you are really getting two lines for the price of one: one for data, one for voice.

CDSL: Consumer DSL is Rockwell's (*www.rsc.rockwell.com*) trademarked version of DSL that is somewhat slower than ADSL. It provides 1 Mbps downstream, and something less upstream, but it has the advantage that additional hardware, called a *splitter*, doesn't have to be installed at the photographer's location.

FreeDSL: is the name of a company (*www.freedsl.com*) that offers free ADSL hardware and setup with no monthly charge for service. In exchange users must agree to provide personal information and to have a small navigational bar containing advertising that's visible while you're connected. More information on how this freebie service works can be found at their Web site.

G.Lite: Sometimes known as DSL Lite, this is basically a slower version of DSL. It's officially ITU-T standard G-992.2 and provides a data rate from 1.544 Mbps to 6 Mbps downstream, and from 128 Kbps to 384 Kbps upstream.

HDSL: High bit-rate DSL was the earliest version of DSL and is symmetrical, in that an equal amount of bandwidth is available in both directions, which means that the maximum data transfer rate is lower than for ADSL.

IDSL: This service is more similar to data rates and service at 128 Kbps than to the much higher rates of ADSL.

RADSL: Rate-Adaptive DSL is an ADSL technology in which software determines the rate at which signals can be transmitted on a phone line and adjusts the delivery rate accordingly.

SDSL: Symmetric DSL is similar to HDSL, using a single twisted-pair telephone line, carrying 1.544 Mbps in the United States and Canada or 2.048 Mbps in Europe. Data transfer rate is the same in both directions.

VDSL: Very high data-rate DSL is a new technology that promises higher data rates over short distances, and a number of standards organizations are working on it.

x2/DSL: The name of a modem manufactured by 3Com (*www.3com.com*) that is designed to support modem communications but is software upgradeable to ADSL.

modem, using a satellite dish similar to those used for transmission of television signals. You will need to have a Windows-based computer, a modem, and certain minimum system requirements that can be found at the company's Web site. You will also need to have an Internet Service Provider (DirecPC provides only the hardware and connection) to make it all work, although they will provide you with one. Once you've paid for the dish the cost of the service is comparable to many high-speed services and for some users may be the only way to get speedy Internet access. DirecPC is sold in many computer and electronic retail outlets.

Finding an Internet Service Provider

Finding an Internet Service Provider, or ISP, is much easier than finding a local telephone company. It's even easier than, believe it or not, finding a long distance company, and the competition is not to the point that ISPs are calling you during dinner to ask you to switch to their service—at least not yet. Since there are many small, local ISPs, this section of the book will only look at a few of the popular national companies that provide Internet access.

America Online

America Online, Inc. was founded in 1985 and is based in Dulles, Virginia. With more than 23 million members AOL is the world's biggest provider of Internet services—if you didn't already know it. For many years, they were more famous

Buzzword of the Chapter: Browser

You can't talk about the Internet without the word "browser" coming up. (And note that although some of them may be dogs, the term is not "bowser.") Although the next chapter of the book goes into more detail about how they function, analyzing different browsers from different companies now is as good a time as any to introduce the concept. When I use the term "browser," I am specifically referring to a class of software known as *Web browsers*. A Web browser is a program that allows computer users to locate and access documents on the World Wide Web. Sometimes you will hear browsers referred to as "client" software. While this sounds like a simple function—and it is—the differences in browser designs vary from the utilitarian to the feature-laden. Like everything else in Net surfing—and real surfing too, for that matter—finding the browser that is right for you is a matter of smart shopping and research.

for stuffing everyone's mailbox full of AOL CD-ROM discs, but I haven't received one in a long time, so their marketing blitzkrieg must be limited to television advertising with all of the other dot.coms.

AOL also owns CompuServe Interactive Services and Netscape—the people who make the browser software that will be covered in the next chapter. What AOL and similar services offer is quick, easy, and inexpensive Web access for a majority of computer users. Everything you need to get launched onto the World Wide Web can usually be found on a single CD-ROM disc: Insert it into your computer and within minutes you can be surfing your favorite camera manufacturer's Web site. But AOL is not without its critics, who find that some of its polices amount to censorship, and sites such as Web Vengeance (*www.segasoft. com/Webvengeance/endex.html*) have sprouted up using AOL as target practice. Nevertheless, for many photographers and people just interested in going online, America Online provides easy entry.

AT&T WorldNet

It took them awhile, but late in 1995, AT&T announced plans to provide its 90 million business and consumer customers with access to the Internet. Its goal, and one that should have seemed obvious, is to make online services as easy to use as telephone service. To accomplish this task AT&T created three new businesses: First, AT&T WorldNet Services is designed to make the Internet accessible to individuals and businesses; second, Hosting and Transactions Services will provide businesses with a range of services to help them reach more customers, promote their products, publish electronic catalogs, and handle secure sales transactions through the Internet; and third, a content services business will also package content within broad interest areas.

Information about WorldNet can be found on the AT&T WorldNet Services home page on the Internet at *www.att.com/worldnet*. It provides all of the information you need to get started and software to download.

CompuServe

CompuServe Interactive Services, with its more than 2.7 million members, is one of the oldest online services and is often referred to simply as CompuServe and sometimes as CIS. CompuServe is now part of America Online, though for the time being it is being operated as a separate entity. Formerly, CompuServe offered it's own dedicated software that was a model of efficiency and dependability, but the company gradually went over to an Internet-based format that seems decidedly Windows-biased. Macintosh owners, myself included, have suffered long and hard under bug-ridden software and connections that cut you off in the

CompuServe Forums, such as the legendary Photographer's Forum, are one of the main sources of attraction to this online service.

middle of a long download. And even though CompuServe had a great monthly magazine for a long time, it was one of the first things to go when the company encountered financial troubles. Some photographers I know have left CIS, but others have switched to the new CompuServe 2000 system, which is both Mac and Windows compatible but seems as fraught with problems as previous versions. Several experienced Windows users that I know have reported few problems with that version, while Mac OS users looking for relief from software crashes and system cut-offs did not find it. All the same, the Forums—areas of special interest—on CompuServe are legendary, including the Photographers, Photographers and Models, and Pro Photo Forums. Providing a source of sound advice and wise counsel, these Forums are the main reason I have stayed logged on with CIS since 1984.

EarthLink

MindSpring swallowed NetCom and was in turn swallowed by EarthLink (*www .earthlink.net*) to create one of the fastest-growing ISPs around. EarthLink serves approximately 3.5 million individuals and businesses every day from its head-

quarters in Atlanta. Like other similar services, EarthLink provides you with free Web site space, and while you may not have a URL like *www.hotphotog.com*, the 6MB capacity is a great way to get started with your own home page. (There will be more about building a Web site in chapter 7.) The service has a simple "Click-n-Build" home-page builder that will have even the most novice photographer bragging about his or her new Web site in no time at all. EarthLink also offers a bimonthly print publication called *bLink*, which is a great way to communicate with its members.

Microsoft Network

Whether it is part of Bill Gates's plan to conquer the world or just part of Microsoft's business plan, Microsoft Network (*www.msn.com*) started out life as an AOL clone but quickly switched to a Web-based model that also houses the company's free e-mail service—HotMail. In addition to all of the stuff you might expect, such as free Web sites, MSN also offers Sidewalk, an online service that combines elements of the yellow pages, buyer's guides, entertainment guides, and city guides. A check for my little town—I just plugged in my zip code—showed a listing of some of the hot spots, including one homey little restaurant that took me four years of living here to find. Sidewalk found it with a click of the mouse. A look at what was happening in nearby Denver showed a cornucopia of cultural and culinary delights.

Prodigy

This online service was originally a partnership between IBM, Sears, and some other high-rolling corporations who wanted to cash in on the Internet revolution with a low-cost online service. Now, Prodigy is on its own and is carving out its own niche. Prodigy employs an access network covering approximately 750 cities in all fifty states, allowing 85 percent of the U.S. population to access Prodigy's services with a local telephone call. Freed by a dedicated software interface that parades ads for different products, Prodigy is another player in the online sweepstakes. One way that it, as well as MSN and some others, is carving market share is by giving sizable (sometime $400) rebates on low-cost, start-up-style computers, making the cost of the machine almost zero. Many people bought the computer, got the rebate, and are happily surfing Prodigy. Prodigy has expanded into products and markets, such as Prodigy en Español, the only fully-bilingual Spanish Internet service in the United States, aimed at 28 million Spanish-speaking Americans. Prodigy users can switch instantly between Spanish and English home pages—each page has a mirror image in the opposite language.

While a free ISP may seem too good to be true, it is true with Juno Online Service. The service is supported by on-screen advertising, but the ad (such as this one for Dodge minivans) can be dragged anywhere and placed wherever you want on your screen.

Juno and Other Free ISPs

How much do these ISPs cost? Nada, nothing, bupkis. If you've been wanting to surf the World Wide Web but have been unsure about how much it may cost, check out *www.juno.com*. I first became aware of Juno's free e-mail service while writing the first edition of *The Photographer's Internet Handbook*, when I saw an interview with the company's CEO on television. At that time Juno provided— and still does—a free e-mail service that was different from those offered by HotMail, Yahoo!, and others. (More about free e-mail in chapter 4.)

You don't need Internet access to make Juno work. Instead, all you need is a Windows-based computer, a modem, and Juno's software, which can be obtained by asking a friend to download it from their Web site or by calling 800-TRY-JUNO. There may be a small service charge (less than $10) to mail a CD-ROM disc to you, but that will be your only out-of-pocket expense. Juno's software is easy to install, and you get to pick your own e-mail address along with a password. The e-mail address is *yourname@juno.com*, but you're on your own for the password. Whatever you do, don't use "password."

Over time Juno's free e-mail service became free Internet access, and the company now offers three levels of service.

1. Juno's basic service provides you with free Internet access, as well as Juno's signature free e-mail. You pay nothing: no monthly charges, no hourly billing, no start-up or membership fees, and no costs of any kind. In most areas, local telephone numbers provide access.

2. Juno Web is a premium (that means you have to pay for it) Internet access service that provides features and benefits that are not included in their free basic service. This includes priority access to Juno's network, more local access telephone numbers, and free, live customer service and technical support. (Members of the basic service must pay $1.95 per minute to speak to a live Juno representative, but I've never needed to call them.)

3. Juno Express, using what appears to be a DSL connection, is the company's highest level of service and offers all of the features of Juno Web at super-fast speeds that are at up to fifteen times faster than a typical Internet connection. As I write this, Juno Express is being tested in selected markets and is expected to roll out nationally sometime this year. No price details for the service were announced as I was finishing this book.

To be sure, nothing is really free, and Juno makes a profit by displaying ads for different products and services while you surf the Web. Some of the ads feature products aimed at your demographics, which you provide at the time you install the software. If you've ever filled out a warranty card for a computer or VCR, you'll recognize the information you provide for what it is: market research. None of the questions seemed intrusive to me, but at the time that I signed up, they wanted to know my annual household income and how many stock or bond

Freebie ISPs

Juno is not the only "free" Internet Service Provider. One that is Macintosh-friendly is FreeInternet.com (*www.freei.net*), but as of this writing, Barry Staver, my co-author on *Better Available Light Photography*, has reported that it is "the slowest connection since the caveman Web-surfed." Mac users might be advised to check it out as an alternative to Juno and see if access has been improved over the Jurassic levels that my colleague reported to me. Another Mac OS alternative is FreeLane (*http://freelane.excite.com*), but as of this writing, access is limited in some areas, including where I live, just twenty-two miles north of Denver, Colorado. These days it seems that everybody, including K-Mart, seems to be getting into the act, but be sure to read the fine print as to what comprises "free." It could be more expensive than you think.

More Buzzwords—SPAM

Internet legend has it that junk e-mail was named spam after the Monty Python sketch in which the only food that a restaurant served was Spam. Over time it came to be synonymous with junk e-mail, although in due respect to the famed Hormel canned meat product it should be spelled with a small s.

trades I had made over the past year. This might bother security-minded readers out there, and I leave it to you to decide if this might be considered an invasion of privacy. If you're worried about being buried by junk e-mail, note that I get significantly less spam on my Juno account than on CompuServe. If you'd like to know how to minimize and maybe even eliminate spam from your incoming mailbox, chapter 4 will provide everything you need to know about how to avoid receiving unwanted e-mail.

Choosing the Right ISP

Just as finding the right commercial photographic lab can be grueling, choosing an Internet Service Provider that provides the best combination of price and service can be a trial-and-error proposition. One of the best places to start your search is in the pages of the growing number of regional computer publications such as *ComputerUser* (*www.computeruser.com*), which is published in regional issues that contain advertisements from local ISPs along with their phone numbers and URLs. If you don't have access to such a publication, you might want to visit *Boardwatch Magazine*'s (*www.boardwatch.com*) Web site, which includes a "find a local ISP" function. It's a good place to start your search.

Although on the surface finding an ISP may seem identical to picking a long-distance telephone company, there is one important difference: Your telephone number stays the same no matter who provides your long distance services, but your Internet e-mail address is tied to your ISP. On CompuServe, my current e-mail address is *joefarace@compuserve.com*, but for the short time I was on (pre-EarthLink) NetCom, my address was *jfarace@netcom.com*. Your e-mail address is just as important as your voice telephone number, and making changes—because of the cost of printing new business cards and so on—can be expensive; so only change your ISP when you have a good reason.

Selecting an ISP is personal, so be sure to use the same network resources you would when purchasing a new camera system or lens. Talk to your photographer friends and ask them what service providers they're using. Better yet, join a user's group for your specific computer. Nowhere else will you find a larger

group of people willing to share information—though sometimes contradictory—about every aspect of computing. In the end the decision is yours, but when making that decision, ask yourself the following questions:

- Will I be a heavy user? If so, consider using an ISP that has a flat monthly rate. Nothing is worse than getting your first ISP bill and seeing numbers that would make even the most avid 900-number users blush.
- Will you be a light user? If so, look for an ISP that offers an "occasional" user rate. Some have a rate under $10 for people who go online only an hour or two a month.
- Is software provided for free or extra cost? When analyzing costs, be sure to include everything that the ISP may be including. Be sure to add any extras that are included in the package.
- Is there a rate difference that varies depending on the speed of your modem? Some ISPs charge more for faster access. They can usually justify this with techno babble, but I think—and this is a highly personal opinion—that the rate should be the same regardless of the modem that you use.

Surfin' Software

Let's go surfin' now, everybody's learnin' how, come on a safari with me.

Brian Wilson

The World Wide Web is a big place. I have heard estimates—perhaps overly optimistic—stating that two thousand Web sites are added each day. No matter how many home pages are out there, even a cursory cruise around the WWW will convince you that you'll need some kind of help in finding your way through the Internet maze. Since this is the world of high-tech communications, you probably will not be surprised that there are solutions to finding your way to the Emerald City, right there on the World Wide Web itself.

Browser software is your ticket to the Internet and World Wide Web. It provides the gateway to Web surfing, e-mail, and all of the other aspects of the Internet that have kept you reading so far. There are two terms you need to be familiar with when looking at browsers: *client* and *server*. Within the context of the Internet, a client is software that requests information. A WWW browser is often referred to as client software. A server is a shared computer on a local area network (or the Internet) that interfaces with a client in the form of Internet software or hardware. A server acts as a storehouse for data and may also control e-mail and other services. Got it? Now let's move on.

The now-current version of Netscape Navigator provides all of the tools that most users need to get the most out of the World Wide Web.

Unlike your choice of ISP, your selection of a Web browser can be more causal—more like your personal choice of a word-processing program. If something better comes along, don't be afraid to make a switch. Sometimes an ISP will provide a browser, sometimes not. Nevertheless, you're going to need one, and the good news is that the most popular ones are free. No category of software is updated and revised faster than Internet browsers; the pace can be dizzying for both the companies and the consumers. That's why this section is not intended to be a comprehensive analysis of all of the browsers available, and if I've omitted your favorite, it is unintentional. Instead, think of this section as an overview of the category of browsers with some specific examples given. What you'll find here is a look at browsers and how to find the one that best fits your needs.

How It Works, What It Does

A browser has a simple function: you type in a URL, and your browser takes you to that location on the World Wide Web and displays a home page—text, photographs, video clips, animations, and whatever else the Webmaster wants to throw at you. In many ways a browser is a lot like Microsoft's original MS-DOS;

it does its job without a lot of muss and fuss but relies on your memory and skills to maximize its efficiency. For many surfers all that's needed is a Model T browser, while others might prefer a Jaguar.

A Web browser's main function is to connect you to your ISP and take you to a common home page that serves as a jumping-off point for your Web explorations. The first time most users encounter a browser, they are disappointed; they expect more. Unlike a starting screen for the CompuServe or America Online services that provide a cornucopia of information pointing to different parts of their services, browser home pages are full of self-promotion—or nothing. You need to know where you are going or, at least, what you are looking for.

What To Look for in a Browser

One of the most important things a good Web browser can do is serve as a spring board (surf board?) to finding what you are interested in on the Web and where it is. This boils down to one simple feature: convenience. *How convenient* (as the Church Lady used to say) a browser is to use is the first measure of its usability.

Bookmarks

This convenience first shows up in how a browser manages bookmarks. These are the digital equivalents of the *Wishbone* bookmarks that your kids gave you for a holiday gift, providing a way for you to mark your place in your copy of *The Long Good-Bye*. When you find a home page that you want to visit, your browser should provide a convenient way to digitally tag the site so that you won't have to remember the cryptic URL. Microsoft's Internet Explorer has a command at the top of its "Favorites" menu items that says "Add to Favorites," which then places the Web site in the Favorites menu. Instead of typing, *http://www. hyperzine.com/writers/joef.html* (my old home page address), you can just select it from the Favorites menu. Since this is a feature that you will use constantly, check out the Bookmark feature of your prospective browser to see how easy it is to use—especially when you accumulate more than twenty-five bookmarks.

Java

Whatever browser you choose, you should get one that is Java-aware. Sun Microsystems' Java is an object-oriented programming language that utilizes the features of other languages and that was originally created to produce software for systems for the consumer electronics market. It began as a subset of the C++ programming language but is different from traditional C-based languages because it is portable. That's the aspect of Java that makes it useful for Web site

Bookmark Me!

While I was giving my feet a break from abuse at the annual COMDEX trade show, I bumped into one of my readers. One of her questions surprised me: She asked me to e-mail her my bookmarks. "You can learn a lot about a person from his bookmarks," she told me. I'm sure my bookmarks do say a lot about me. In addition to the inevitable photographic sites (*www.minoltausa.com/cokin*, for example) my favorite sites serve pastimes that range from daydreaming (*www.ferrari.it/home1.html*) to everyday reading (*foldoc.doc.ic.ac.uk/foldoc/idex.html*). If you're wondering why the author of *The Digital Imaging Dictionary* has the Free Online Dictionary of Computing as a bookmark, I can only admit that I try to learn one new thing each day. When it comes to new buzzwords, FOLDOC is the first place I start.

and browser designers. Java enables Webmasters to write small applications (applets) that can be embedded in a home page using standard HTML, then enabling them to transfer these applets from a server to a user's Web browser, where they can be viewed on-screen. On the most basic level this means that

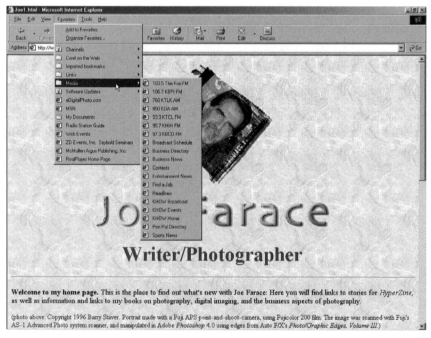

Microsoft's Internet Explorer browser software includes both menus and submenus of "Favorites" that lead you quickly and easily to Web sites that you visit on a regular basis.

Search Engines and Portals

In the last edition of this book, I spent lots of time talking about search engines, which are now called portals because they are often the first page your browser is set to display, and because they do lots more than just search. Since the actual number of Web sites on the World Wide Web is getter bigger everyday, finding the Exacta Collectors (*www.exacta.org/homeb.html*) home page would be impossible without a way to search for the word "Exacta." That's the function of portals: You type in a word, or words, and a list of Web sites whose descriptions contain those keywords appears.

type can be designed to scroll or move around a Web site. This may be cool and fun, but it has little to do with gathering information. It does, however, have a lot to do with selling the sizzle—and that's what marketing, photographic or otherwise, is all about.

Access to Portals

One of the first things you should do after installing a browser is go to the Preferences menu and set a portal site as your default starting page. This will be the first Web page that your browser goes to when it launches. Don't use the default that almost always takes you to a site that the browser company wants you to see. Having the default set to your preferred portal not only provides you with your favorite search engine, but also provides news and weather reports that can be customized by you so that you can see what the weather is like in Brighton, Colorado or Brighton, New York.

As part of its access to portals, your browser should be able to keep track of sites that you have already visited. Typically, this is handled by displaying previously accessed sites in a text of different color, but you may need to set the color by changing the preferences. By flagging previous Web sites, you can either remember if they were worth visiting (in which case you would have already added them as a bookmark) or not worth visiting. This can save time when the search engine produces over a thousand matches in response to your request. Tagging previously visited sites may seem like a small thing, but the more you use search engines, the more you will come to appreciate this feature in a browser.

Navigation Tools

Your browser should include a toolbar or simple commands enabling you to navigate back and forth through the many Web sites that you may visit during a ses-

Opera Software's (www.opera.com) Opera browser, seen here in its beta form of version 4.0 visiting www.amazon.com, provides an alternative to offerings from Netscape and Microsoft.

sion. I prefer buttons on a toolbox because they're a fast and more natural way of surfing the Net, but everyone's taste is different—that's why they make more than one kind of camera—so pick one that has an interface that feels "comfy" to you.

The obvious buttons (or commands) are "Backward" and "Forward," but the "Stop" button is important, too. Often you will encounter a Web site that as it draws itself on your screen turns out not to be what you were interested in. You can always click the Back button to back up to where you were last, but a safer way to operate is to hit the Stop button to stop the screen draw before clicking the Back button. (Browsers are like VCRs: You can hit the rewind button while a video tape is playing and after some moaning and groaning the tape will start going backward. But it's better to hit the stop button, then the Rewind.)

One button you'll discover to be indispensable is Reload. The Internet and browser software are not perfect, and often a home page being displayed will hit a glitch or two and stop. (A good browser will also display some kind of status bar indicating how the download is proceeding, at what speed, and whether there are any errors.) Or, if you inadvertently hit the Stop button and would really like to see the entire Web site, you can click the Reload button and reinitialize the home page being displayed on your screen.

Netscape versus Internet Explorer _____

Although the term "Netscape" is often thrown around by some users in a generic way, the company doesn't make just one product. It produces a family of products, including its flagship browser package, Netscape Communicator. Its major competitor is Microsoft's Internet Explorer. Most computers these days come with one or both of these browsers, and here's a quick look at each of them according to the different qualities that would appeal to the average photographer.

Netscape Communicator

The original Netscape Navigator has grown from a browser software package to a virtual suite of Internet communications software that includes the Navigator browser module along with Messenger and Composer modules. As of this writing the software is free, but unless you have a DSL or cable modem setup, it is a long 20MB download. You may find the latest version of the Windows or Mac OS on a CD-ROM included with many magazines. I always get the latest Mac OS version of Netscape's Communicator software from the disc that *Mac Addict* (*www.macaddict.com*) includes with its monthly magazine.

The current version of Netscape Communicator is version 4.73 (which is similar for both Mac OS and Windows), but the company is currently allowing downloads from its Web site (*www.netscape.com*) of what they are calling Netscape 6 Preview Release. Since some versions of this new browser will, most likely, be what is being used when this book is published, I want to take a look at the future, not the past.

One of the problems with browsers is that, over time, they have become "bloatware," engorged with so many features that they have become slower and less responsive to users, especially when used on a dial-up basis and not with the high-speed access that the developers probably had in mind when they designed the software in the first place. Downloading Communicator 4.73, for example, took me over ninety minutes using CompuServe and a 56K modem. That's one reason why browsers like Opera were developed. It is supposed to be smaller, lighter, and more responsive than the competition. Netscape has decided to answer that challenge with Netscape 6.

Netscape 6 is small in size, leads the industry in standards compliance, and can run across a wide variety of platforms from traditional desktop computers to new computing devices—Personal Data Assistants such as the Palm Pilot (*www.palm.com*), for example. Netscape 6 offers innovative functionality in several areas.

Download size and speed: It took me less than 30 minutes to download Netscape 6. The company claims that Netscape 6 was developed to be as small

as possible while still providing a rich feature set. The Installer is less than a 300K download and allows you to customize your installation with just the components you want. The entire browser is just a 7.5 MB download, about 30 percent smaller than a comparable installation of Microsoft's Internet Explorer. A typical installation is only 9.5 MB, which is about 25 percent smaller than a comparable installation of Internet Explorer 5.

Standards support: Netscape 6 uses the company's Gecko Technologies, which were developed as an open source project and which provide the basis for the program. The browser provides full support for XML, CSS (Cascading Style Sheets) level 1, and DOM Internet standards across a variety of desktop platforms, including Windows, the Mac OS, and Linux.

My Sidebar: Located on the left side of the Netscape 6 interface, My Sidebar gives you a convenient place to keep track of the things that are important to you, such as the KEH Camera Brokers (*www.keh.com*) Web site. You can use this feature to read the latest news, set up a stock portfolio tracking, check your Buddy List for instant messaging (more on this next), track camera auctions on eBay (*www.ebay.com*), or listen to music. With over four hundred tabs available from Netscape and third parties, My Sidebar is Bookmarks on steroids and is your connection to the sites and people that you care about. The Instant Messaging Buddy List tab lets you keep track of your friends and colleagues and communicate with them in real time. The sidebar's Open architecture lets Website developers create tabs and link them from their sites.

Real-time messaging integrated throughout the browser and mail. After e-mail and browsing, some pundits think that instant messaging is the third "killer app" on the Internet. I find e-mail less intrusive and remain a little skeptical about the efficiency of the new messaging for most professionals and serious amateurs, but since there are over 40 million users of instant messaging, there's more than a strong possibility that I may be wrong on this one. You can use the browser to manage multiple e-mail accounts, communicate with friends who use AOL's Instant Messenger service, and automatically collect contact information from the people you communicate with in the Netscape 6 address book.

Fully integrated Search function: Netscape 6 includes a search field in the main toolbar, which means that at any time you can type what you want and click Search. You don't have to load a special search page or open a frame. This search field doubles as the Web address field, so whether you have a Web address or a word or phrase to search for, all you have to do is enter it in the search field to get what you want. The Search service is powered by Google (*www.google.com*) and Netscape Open Directory Project, but you can customize with your choice of Search services, including the ubiquitous Yahoo! All search results are opened in My Sidebar, allowing you the flexibility to check multiple results without return trips to a search engine.

Internet Explorer

Next in the freebie browser sweepstakes is Microsoft Internet Explorer (IE). The current version is Internet Explorer 5 and was initially available for Windows 98, Windows 95, Windows NT® 3.51, Windows NT 4.0, Windows 3.1, Sun Solaris, and HP-UX operating systems—later versions made it compatible with Mac OS, too. The Windows version is available for download from *www.microsoft.com /windows/ie*. The Mac OS version can be found at *www.microsoft.com/mac*. With a 56K modem this represented a forty-five-minute download for me. Internet Explorer 5 has a new rendering engine and provides support for Web standards, and it sports a redesigned interface that highlights the design found on Apple's iMac and G-series computers. The earlier version, Internet Explorer 4.5 offered a feature called "Forms AutoFill," which automated the process of filling out the forms people can encounter online. Using Forms AutoFill as a base, Microsoft developed Auction Manager for Internet Explorer 5 to handle all online auctions at eBay, Amazon.com, and others. IE 5 also has a Media Toolbar that supports Apple's QuickTime as well as MP3 audio (more on these formats later).

I have used Internet Explorer on and off since it was introduced, but I have never stayed with it because I have found it to be too unstable and crash prone—especially with the Mac OS version—until version 5.0. Don't let this book's Netscape Navigator screen shots make you think that I've given up on IE. Oh, contraire! It's now my Mac OS browser of choice. Although I wrote almost this entire book on a G3 Power Macintosh, most of my surfing was done on a Windows computer—so I could write and surf at the same time. One appealing feature of Internet Explorer is its ability to download Mac OS formatted files. As I write this on my Power Macintosh G3, my Windows computer is downloading the latest Mac OS version of Internet Explorer. When I try this with Netscape Navigator, it just sits there and does nothing and refuses to allow me to save files onto my Windows PC's hard disk. This is just one reason why you may need more than one brand of browser software.

Challengers and Browser Clones

Right now the biggest challenge to the Big Two in the browser wars is Opera (*www.opera.com*). Opera is small—only 1.8MB without Java—and fast and will run on older computers such as the 486 box you can't bear to throw out. Now may be the time to turn it into a browser box for someone in the family. Opera's big claim to fame is that it requires little memory, so you can open multiple windows without running out of memory, or open documents in the background without destroying your search engine result listing. Unlike the other browsers, however, you actually have to pay for Opera; I leave it to you to decide if it's worth the cost.

Microsoft's Internet Explorer 5 for the Mac OS, shown here visiting Dave Hall's Glamour Models on the Web, looks great and runs great too. You'll meet Dave and learn about his site later in the book.

Opera is customizable. If you'd like to customize the look and feel of your toolbar, you can do it. If you don't like cookies (and I'm not talking about *www. mrsfields.com* here; more about cookies later), one click turns them off. Advanced cookie filtering allows you to specify which cookies you will or will not accept.

With Opera you can retrieve and view multiple documents at the same time. The documents are loaded faster, and you need not wait for a single document before browsing in another window. Opera also has a special download window with items like Download Résumé and a Rescue file just in case your machine crashes; when you restart, the browser picks up where you left off. If this has piqued your interest, visit their Web site for a complete list of features.

Opera is available for many different operating systems, including Windows 95/98/2000/NT 4.0, and it has a beta version for the BeOS, EPOC, a technology preview of Linux, and the Mac OS version that is expected to be available soon.

CompuServe Information Manager version 3.0 and later were designed to

make the Web a basis for how users interact with the online service. Until these Web-based versions were developed, CompuServe Information Manager was the software I felt that others should be measured against. It was dependable, intuitive, and sturdy. However, version 3.02 for the Mac OS is unstable at best, as long sessions on either CIS or the Web via CompuServe Dialer are almost impossible. It is common to be cut off when you are typing an e-mail message or just browsing the Forums. The Windows version 4.0x is much more dependable.

CIS is trying to move all of its users to a lower-cost service called CompuServe 2000. The Windows version of the software is available, and based on anecdotal evidence from talking to users, it is providing excellent service for them. The Mac OS version, on the other hand, is still in beta version and, like most beta software, has proven itself problematical to users I have spoken with. Yet I remain sanguine: I continue to use CompuServe because I still find it the simplest, easiest way to get onto the World Wide Web. Macintosh users will have to put up with the daily crashes, but Windows users will find that the service is both transparent and dependable.

America Online provides a similar browser clone interface for its service but seems immune to the software problems that plague the Mac OS version of CompuServe software. All of the AOL-using photographers whom I know are happy with the service.

Browser Plug-Ins

Plug-ins are small, sometimes not-so-small, software applications that can be used to customize and to increase the functionality of and to customize off-the-shelf programs such as an Internet browser. A popular analogy and an overworked cliché is that plug-ins are similar to blades or tools found in a Swiss Army knife and that McGyver never went anywhere without *his* Swiss Army knife.

One of the main features of plug-ins is that they are easy to use and easy to install. All plug-ins are installed in the same way: They are simply copied into the "Plug-in" directory or folder of a particular program. Sometimes, as in the case with such graphics software as Adobe Photoshop, they appear as menu items in that program. They are, in effect, "plugged into" the software and after installation become an integral part of it.

Plug-ins shouldn't be confused with the "Helper Applications" used by some browsers. Helper Applications are a class of software that permits you to access almost every type of file that you are likely to encounter on the Internet. Most helper applications are over-the-counter programs, but some are shareware or freeware and can be found at various archive sites. When your browser encounters a sound, image, or video file, it hands off data to a helper application to run or display the file.

Plug-Ins: The Back Story

In 1986, a Macintosh program called Digital Darkroom from Silicon Beach Software set a new trend in software design by integrating what the designers called the "DD Pouch." Add-ons that broadened the application's capabilities were stored inside this pouch, one of whose folders was called "Plug-ins." When Photoshop was introduced in 1990, Adobe Systems expanded the plug-in concept and made it an integral part of the program's design. Third-party developers were able to create new and exciting add-ons, quickly allowing Photoshop to become the de facto image-enhancement program for the Macintosh. Netscape added plug-in capability to Navigator 2.0, allowing third-party developers to add support for new file formats, among other things. In doing so, Netscape created a plug-in standard, much as Adobe had done six years ago, and most Navigator plug-ins are also supported by version 2.0 or later and by Microsoft Corp.'s Internet Explorer. Netscape used to call them "in-line" plug-ins, but they are inconsistent in that usage. A *plug-in* is a plug-in is a plug-in.

If you're not already familiar with browser plug-ins, you should be. Plug-ins extend the browser's capabilities, giving computer users, for example, the ability to play audio samples or view video clips. But what happens when you run into a Web site that requires a plug-in you don't have? If you are using some versions of Netscape Navigator, you'll be taken to the Plug-in Finder page. You'll have arrived there because you loaded a page that contains information that can be viewed only with the help of a specific plug-in—and you don't have it. Navigator will show you a list of plug-ins that can be used to display the missing audio, video, or text information. You can choose the plug-in you want to install, click the Download button, then follow the instructions to download and install the software to your system. When you're done, you'll have to relaunch Navigator and reload the Web page you wanted to view. Plug-ins are available in cross-platform versions but, as you will see, sometimes they are developed for specific operating systems.

Plug-in Tip

If you have more than one browser, you don't need to have a complete duplicate set of plug-ins for each one. Just create Aliases (Macintosh) or Shortcuts (Windows) for all of your favorite browser plug-ins and place them in the other browser's plug-in folder. Viola! Whenever you launch a browser, it will have access to the other browser's plug-ins.

Software companies are developing plug-ins at warp speed, and generally they fall into several categories, including 3-D and Animation, Audio, Video, Business and Utilities, Image Viewers, and Presentations. Here are just a few plug-ins in each of these groups that will provide an introduction to what browser plug-ins do and how they work. Many of them are freeware or shareware, some are beta versions, and others may be demos. Here's a look at them in alphabetical order.

Adobe Acrobat (*www.adobe.com*)

The free Adobe Acrobat Reader allows you to view, navigate, and print Portable Document Format (PDF) files across all major computing platforms. PDF files are extremely compact, platform-independent, and easy to create. They offer design control, print-ready documents, and an endless array of authoring applications. Acrobat Reader is the free viewing companion to Adobe Acrobat and to Acrobat Capture software. This is a must-have plug-in, since many photographic manufacturer's Web sites display new hardware specifications as PDF files.

Ad Banner and URL Filter (*www.nit.mk.ua/adiefltr/adiefltr.zip*)

If you are somewhat new to the World Wide Web, you will notice that many home pages are bedecked in advertisements called "banners," some of which seem to take an unnecessarily long time to load. (This may, in fact, be by deliberate design so that you sit and stare longer at the ad while its being displayed instead of just scrolling past it.) One way to eliminate these banners is by using filter software that won't allow them to be displayed. Ad Banner and URL Filter is a plug-in for Microsoft Internet Explorer 4.0 and later. Because it's a plug-in, it is fully integrated into the browser and works in the background, unnoticed by any user. You can use it on your home computer to protect your kids from sites that show adult material, or in your studio to prohibit employees from visiting those sites that are not directly related to their work. In general, you can configure the program to allow access to everything except specifically prohibited sites, allow access only to permitted sites, or most importantly to turn off all banner advertising.

Calendar Quick Plug-In (*www.logicpulse.com/calquick/cqplug32.exe*)

The Calendar Quick plug-in allows you to view files created with Calendar Quick embedded in a Web page. It works with Netscape Navigator 2.0 or later, Internet Explorer 3.0, and other plug-in–compatible Web browsers, such as Opera. It displays monthly, weekly, and daily calendars, as well as timelines and planning

grids. Other features include a full-featured print output and Web browser–style schedule navigation.

Columbine Bookmark Merge (*http://myWeb.clark.net/pub/garyc*)

CBM is a plug-in for the Netscape, MSIE, Mosaic, and Opera Web browsers. It permits you to merge Netscape bookmark files, MSIE favorites files, Mosaic Hot List files, Opera Hot List files, or Netscape e-mail address book files together without producing duplicates or unwanted bookmarks. Columbine Bookmark Merge enhances your browser's built-in bookmark editor by letting you edit bookmarks, create or delete bookmarks, create or delete folders, or drag bookmarks from one folder to another. Columbine Bookmark Merge is free, but you are asked to contribute to the Frank J. Cramblitt Memorial Fund for the furtherance of elementary school education.

Go!Zilla (*www.gozilla.com*)

Go!Zilla's main function is to help you recover from download errors and resume failed downloads, manage and categorize files to download later, and get those files from the most responsive site. You can also gather links to files that you want to download by simply dragging them from your favorite Internet browser. You manage and categorize your files using an Explorer-style interface that allows you to see file sizes, estimated download times, and network connection performance. You can even add as many different locations for a single file as you can find or let Go!Zilla do the work by quickly searching FTP archives. Then Go!Zilla retrieves the file for you. When you do, it checks all available locations and delivers the fastest possible connection. Go!Zilla will also intelligently switch between mirror sites to meet your minimum transfer speed requirements.

IPIX (*www.ipix.com/download.html*)

An IPIX file is an interactive, spherical image offering users a complete field of view, from earth to sky, floor to ceiling, horizon to horizon. You will need this plug-in to view these images, which are gradually becoming a de facto Internet standard for immersive imaging.

QuickTime (*www.apple.com/quicktime*)

QuickTime is the Apple technology that makes video, sound, music, 3-D, and virtual reality come alive for Macintosh and Windows. If you have a Macintosh browser, chances are there's already a QuickTime plug-in in the plug-in folder,

but Windows browser users may need to install the plug-in so that they can see what all the fun is about.

RealPlayer (*www.real.com*)

RealPlayer is a free plug-in that's another de facto standard for playing audio and video on the Web. The company also offers an inexpensive upgrade—RealPlayer Plus (for $29.99)—that supplements video with picture controls and offers improved audio with graphic equalization, access to 2,500 radio stations, and free access to the Sports Illustrated Swimsuit Video.

Shockwave (*www.shockwave.com*)

Macromedia Shockwave Player and Macromedia Flash Player are both free Web players from Macromedia. Shockwave by Macromedia is available for Windows 95, Windows 3.1, and the Mac OS. Together, they bring users the best rich-media content on the Web. Each has a distinct purpose. Macromedia Flash Player displays Web application front-ends, high-impact Web-site user interfaces, interactive online advertising, and short- to medium-form animation. Macromedia Shockwave Player displays destination Web content such as high-

Downloading the Shockwave plug-in is an interactive experience. First you download about a four-minute bit of software, then you launch this small program, which in turn relaunches the browser and continues the download. While doing this, you'll see this screen.

performance multi-user games, interactive product simulations, online enter-tainment, and training applications. Through Xtras, Shockwave Player is also extensible to play back custom-built applications. A Flash Player is automatically included with any download of the Shockwave Player. If you don't already have a copy of Shockwave (check your browser plug-in folder first), go online and download a copy.

If you would like to search for new plug-ins, check out the Web page that you use to download the latest version of the browser that you are using. If the site has a search function, enter the key words "Plug-in" and see where it takes you. Another place to try is *www.download.com*. It may be different when you read this, but the easiest place to find plug-ins is: *http://download.cnet.com/downloads /0,10151,0-10068-106-0-1-3,00.html?tag=st.dl.10013.dir.10068*. Yeah, I know it's a keyboard-full, but you can always go to *www.download.com*, click on "Internet," and then click on "plug-ins." The longwinded URL takes you directly there.

While trying out new plug-ins, keep in mind that some conflicts may develop, and some plug-ins may not get along well with others. Remember that old computer user's axiom: back up, back up, and back up. Happy plugging!

Web Utilities

Once the Internet browser became a basic part of everybody's hard drive, many utilities sprang up to enhance the surfing experience. I will confess to *currently* using few utilities for online use, although in the past I have used many differ-ent plug-ins and utilities to prepare images for use on the World Wide Web. I contacted several photographers and asked them what kind of Web utilities they were using and collected them in this section. Many of these utilities are for Windows, some are for the Mac, and some are cross-platform. Readers who have the first edition will notice that none of the software mentioned in that book made it into this one. Some of these may not make it either, so you need to visit the Web sites noted, download the files, and give them a try. If they're available and you can use them, enjoy.

AcqURL (www.acqurl.com)

GT Technologies offers AcqURL, a $35 Windows utility for bookmark manage-ment and file launching. AcqURL lets you assemble collections of Internet URL bookmarks organized by topic or by project, as well as local programs and files, and launch them with a single click. Using a book-like interface with unlimited tabbed pages and up to eighty links per page, AcqURL makes it possible to import bookmarks from Internet Explorer and Netscape. A single click on any bookmark

instantly opens the associated Web page, program, or file. AcqURL can include the Web site's icon with each bookmark, or you can associate other icons or image files with each bookmark. You can also print your bookmarks, save them as a Web page, send them to Internet Explorer or Netscape, or e-mail them to a friend. You can search your bookmarks, as well as color-code, verify, alphabetize, import, and export them. The program stores your personal contact information, saving you time when filling out an Internet Web form by letting you drag and drop information from AcqURL onto the Web page.

AcqURL saves each URL as both a DNS (Domain Name System) address and an IP (Internet Protocol) address, allowing you to bypass the lengthy DNS lookup process when you revisit the Web site. When you type a URL from a magazine or television, AcqURL will access the site's Web icon and description before you visit it with your browser. AcqURL lets you password-protect your bookmarks, pages, and entire files of bookmarks. You can even access multiple Internet search engines with a single click.

AcqURL version 4 runs under Windows 98/95/NT 4.0/2000 using Internet Explorer, Netscape, Opera, or any standard (non-AOL) Internet browser that supports DDE (Dynamic Data Exchange).

Babylon Translator and Converter (*www.shareware.com*)

This program is a single-click translator, dictionary, and converter that translates any on-screen words and expressions from English into the language of your choice. It now features an instant currency, time zone, and metric converter, along with the option of using a calculator and a text-to-speech add-on feature. You can also hear the English pronunciation of the word, phrase, or value you are translating. Every time you use Babylon while connected to the Internet, the program will determine if you have the latest version of this ever-growing database. The program resides in your system tray, and by clicking any word, you can get an instant and accurate translated definition. After translating a word, the program also allows you to search for that term on one of several online search engines or online encyclopedias.

Copernic 2000 (*www.copernic.com*)

Copernic 2000 is intelligence that can search the Web, newsgroups, and e-mail simultaneously, using more than thirty information sources. The utility offers a flexible, user-friendly interface that displays a history of your searches so that you can quickly find past search results. Copernic 2000 can also generate search reports in Web-page format, allowing you to easily browse results, remove duplicate matches, eliminate all invalid document links, and more. Special features

for Internet Explorer include a replacement for Internet Explorer's default search window or search bar that can be accessed directly from the browser toolbar. You can search using Copernic from any Web page within Internet Explorer 4.0 or later by highlighting a term and choosing a pop-up menu option. This program also features online shopping search categories for hardware and software, with more than twenty engines available. Copernic 2000 allows you to search for English, French, German, Italian, or Spanish content.

Download Accelerator (*http://download5.speedbit.com/dap3908.exe*)

As you might guess from its name, this utility is a download manager software that's designed to accelerate downloading files from the Internet. Some of the key features of the program include its ability to accelerate downloading files in FTP and HTTP protocols up to 300 percent, pause and resume downloads, recover from a dropped Internet connection, and show advertising banners while down-loading. The acceleration is done by using more than one connection for the same file, for single or multiple servers. Download Accelerator Plus will also make a mirror search for downloading from best performance servers. After you install Download Accelerator Plus, it will automatically activate itself when you download any of the following: EXE, ZIP, MP3, ARJ, RAR, LZH, Z, GZ, GZIP, TAR, BIN, AVI, and MPG files.

LuraWave SmartCompress Lite (*www.luratech.com*)

As part of a campaign to encourage adoption of the wavelet-based image com-pression that's part of the JPEG2000 standard, LuraTech, Inc. released its free LuraWave SmartCompress Lite software. LuraWave uses compression technology similar to the proposed standard, allowing digital imagers to test the compres-sion and other features behind JPEG2000. The software uses wavelet technology that compresses digital images at extremely high rates into files using the LuraWave Format (LWF), which is a proprietary format offering higher quality and smaller file sizes than the current JPEG standard, making it easier to trans-fer image files across the Internet. LuraWave is a scalable, multiresolution image format that offers a number of features and flexibility over current standards, including the ability to perform lossless or lossy compression within the same mode. LuraWave's multiresolution format (à la the late, lamented FlashPix) allows images to be scaled at different sizes without having to create separate files. On the Web, a user progressively downloads sharper versions of an image. Initially, a low-resolution version of the image appears and more resolution and details are filled in as the data stream continues. The format's flexibility is also valuable for handheld devices, which have different imaging requirements than

standard Web pages and need ways to draw only small amounts of data from the original image.

Plugsy (*www.digigami.com*)

What do you give the surfers who have so many plug-ins that they don't know what to do with them? Easy—a plug-in that lets them manage their plug-ins. Plugsy is the only solution for eliminating conflicts among Netscape Navigator plug-ins. Easy to install and simple to use, Plugsy gives power users and system administrators the unique ability to manipulate Netscape Navigator's plug-in configuration. You'll be able to mix and match third-party multimedia players, as well as Navigator's own built-in players, by individually assigning each multimedia format (MIME) type to either a plug-in or helper application.

Quick View Plus (*www.jasc.com*)

JASC Quick View Plus is a file viewer program that opens almost any file or e-mail attachment. Quick View Plus 6.0 (the current version as I write this) offers users a fast, easy way to view graphics, documents, spreadsheets, databases, presentations, zip files, and more, and it includes support for over 200 Windows, DOS, Macintosh, and Internet file types. Quick View Plus instantly displays virtually any file, whether you have the associated program on your computer or not. The software also makes it easy to find the files you need fast, without having to launch program after program in searching for a specific file. Quick View Plus 6.0 is available for Microsoft Windows 95, Windows 98, Windows NT 4.0, and Windows 2000 for $59. A free evaluation copy may be downloaded from JASC Software's Web site.

Sherlock (*www.apple.com*)

Sherlock is a personal search "detective" that Apple introduced in Mac OS 8.5, and it has many built-in plug-ins that allow fast searches of popular Web sites such as CNN Interactive, CNET, Amazon.com, Barnes and Noble, Music Boulevard, and Rolling Stone, in addition to Internet search engines such as Alta Vista, Excite, HotBot, Infoseek, and Lycos. Sherlock's "find by content" feature also includes the ability to search the content of PDF and HTML files stored on your hard drive. Each search engine that Sherlock uses is represented by a plug-in file that describes the formats that the engine expects for queries and produces in its responses. These files are stored in the Internet Search Sites folder in the System Folder. The "Search Internet" feature in the Sherlock application also allows users to perform Internet searches using one or more Internet search engines.

Apple Computer's Sherlock has been part of the OS since version 8.5, but it was the second genera-
tion of this search technology that really made the utility must-have. If you haven't already upgraded to
OS 9 or later, do it today.

Software developers can create a new plug-in to add a search engine to
Sherlock's repertoire if they know how to interpret the HTML files that underlie
search engine Web pages, and if they're proficient with tools such as BBEdit, a
flexible text editor available from Bare Bones Software and ResEdit, a free utility
that's available from Apple.

Stufflt Deluxe (*www.aladdinsys.com*)

There are millions of files on the Net that are stored in one of several compressed
archival formats. (An archive is a single file that acts like a container, holding
one or more files or folders.) These files are often compressed to take up less
room on a diskette or hard drive and to save time when transmitted over net-
works and modems. Stufflt Deluxe lets you decompress the contents of archives

from the most popular compression formats found on the Macintosh and some for Windows as well.

Some browsers automatically install a copy of the free StuffIt Expander, which will expand files encoded in BinHex format that are commonly found on the Internet. Aladdin Systems offers both Macintosh and Windows versions of StuffIt Expanders for a free download. I keep StuffIt Expander on my desktop right under the icons for my hard disk and removable drives. Since the program features drag-and-drop operation, all you need to do is drag a compressed file into the icon and watch it decompress. You can also configure StuffIt Expander to perform periodic checks on the contents of a specified folder (called a Watch Folder), and expand any new files that it finds. That way you can set StuffIt Expander to expand groups of files in the background while new ones are being downloaded. StuffIt Expander is the simplest, most efficient way to expand any compressed file you download from an online service or bulletin board.

The Internet: Now You're There

Sometime in 1989, you stopped asking people if they had a fax number. In 1996, you stopped asking people if they had an e-mail address.

Michael Kinsley, editor of *Slate* (*http://Slate.msn.com*)

Compared to online services like America Online, CompuServe, or Prodigy, the Internet as a whole may appear disorganized and even chaotic in structure. To make the Internet work for you and your personal or professional photography needs, you'll need more than a good browser and a few utilities and plug-ins. For openers, you'll need to understand about the other, older aspects of the Internet and how they can help you maximize your online productivity. These include tools and other uses for the Web beyond the obvious information gathering and marketing uses. In this chapter, you'll be given an introduction to these other items in preparation for the creation of your own Internet presence.

Other Sides of the Web

There's more to the Internet than the World Wide Web, and even the Web has some uses other than the obvious. In this chapter, we will look at other aspects of the Internet that photographers may find useful. Here's an introduction to a few other areas that photographers may want to know about and

to how they may be able to take advantage of what these areas have to offer. As the Web has grown both in complexity and sophistication, some of these technologies and terms have become extinct. Nevertheless, you may run into some of these terms (much as you might see the word "Triceratops") and in case you are interested in what it means and what it meant, now you'll know.

FTP

If you've been keeping track of Internet acronyms, you already know that FTP means File Transfer Protocol. Nitpickers may point out that it also means File Transfer Programs. Another usage of the term FTP adds the word "site." An FTP site is any computer system on the Internet that maintains files for downloading. FTP sites are great places to get public domain software. A site address will look like the following: *ftp.fhru.com*. Most accept anonymous log-in, which means that you use the word "anonymous" as a login ID and your e-mail address as a password.

The most famous of online databases is called "Archie" (more on this in a bit) and contains a list of software available from anonymous FTP sites. Archie is less popular than it was when I wrote the first edition, and many sites have been closed. One of the few left can be reached at *http://archie.emnet.co.uk/form.html*. Sites like this are some of the best places to get shareware and freeware programs. Online services such as EarthLink Network offer FTP sites to download software. You can reach the EarthLink site at *http://ftp.earthlink.net*.

That's not to say there aren't already lots of places to download software on the Web—there are plenty—but without the bells and whistles overhead of a Java-enabled Web site, an FTP download will be simpler, more straightforward, and, more importantly, faster. All of these advantages may be outweighed by newer browsers using acceleration utilities, such as Download Accelerator (see chapter 3) and logging onto Web sites such as 5 Star Shareware (*www.5star-shareware.com/main.cgi*).

Telnet

Telnet was originally developed for ARPANET and is part of the TCP/IP communications protocol. It's a tool to allow you to log onto remote computers, access public files and databases, and even run applications on the remote host. When using Telnet, your computer acts as if it were a terminal connected to another, larger machine by a dedicated communications line. Although most computers on the Internet require users to have an established account and password, many allow you access to search utilities, such as Archie or WAIS (more on these terms later). You usually don't have to purchase any new software to access the Telnet

Looking for shareware and freeware? Go to the 5 Star Shareware to get the scoop and download the products.

function, since many programs seamlessly integrate e-mail, FTP, and Telnet into Web browser functions.

Gopher

This is a document-retrieval system software that enables you to browse Internet resources. It was developed by programmers at the University of Minnesota—home of the *Golden Gophers*—and features a menu that allows you to "go for" items on the Internet, bypassing any complicated addresses and commands. You can navigate the Internet using Gopher by selecting desired items from a series of lists until you locate the information you are seeking.

While Gopher is a software program, Gopher sites are often simply called "gophers." (Yes, it *can* get confusing.) The latest releases of Gopher software are available via anonymous FTP in the /pub/gopher directory at *ftp://boombox. micro.umn.edu/pub/gopher*. Next you need to know the name of a Gopher server. A good place to start is *gopher.micro.umn.edu at gopher://gopher.micro.umn.edu*. With the popularity of the graphical user interface (GUI) used by both Mac and Windows-based computer operating systems, Gopher has gone the way of the

passenger pigeon, although curious readers might want to investigate Gopher Jewels, a site that lists many wonderful gopher links, at *http://einet.net/GJ*.

Archie

This is an acronym based on "ARCHIvE." Until the World Wide Web became a part of everyday life and popular culture, if you wanted to search the Internet you only had a few choices—Archie, Veronica, and WAIS. ARCHIE is an Internet utility that was used to search for file names. Over thirty computer systems on the Internet act as Archie servers and maintain catalogs of files available for downloading from FTP sites. On a random basis, Archie servers scan FTP sites and record information about the files that they find. Several companies, such as Hayes, offer software that provide a menu-driven interface that lets you browse through Archie servers on the Internet. Archie locations can be accessed using standard Archie client programs.

Veronica

Like Archie, Veronica has become something only hardcore Internet geeks are involved with. In case you're wondering, the acronym stands for Very Easy Rodent Oriented Netwide Index of Computerized Archives. (Someone is definitely hung-up on *Archie* comics, here.) Veronica locates Gopher sites by chosen topics and prompts users to choose keywords for searching, generating hundreds of references on a given subject. A user can choose a reference and instantly view the information. There are a limited number of Veronica sites and a plethora of users. Veronica is a tool to help you find the Gopher servers containing information you need, and you can browse a Veronica menu just like you would a Gopher menu.

WAIS

Wide Area Information Server is a system that can be used to search Internet databases. AIS is supported by companies such as Apple Computer (*www.apple .com*), Thinking Machines (*www.think.com*), and Dow Jones (*http:// dowjoneswsj.com/p/main.htm*). Using WAIS, you can do a keyword search to retrieve all of the matching documents. The search returns a list of documents, ranked according to the frequency of occurrence of the keywords that were used in your search. You can also retrieve text or multimedia files stored on the server. WAIS offers natural language input, indexed searching for fast retrieval, and a relevance feedback mechanism that allows the results to influence future searches. For most photographers, portal sites such as Excite and HotBot are all

that most of you will ever need to search for specific information you may be looking for.

Photographers and the Net

It's worth repeating: the Internet is big. This bigness can be the Net's undoing, when new users launch their browser, point it at a home page, and ask what's next. What's next is a quick overview of what's available for photographers on the Internet.

Little did Tim Berners-Lee and his small group of Swiss scientists realize they were creating when they drew up the original specifications for the World Wide Web. What they imagined—and what was used in the international debunking of "cold fusion"—was a place for scientists and engineers to communicate. What they didn't expect, I'm sure, was home pages—digital shrines, really—for personalities such as Gillian Anderson. (The Gillian Anderson Gallery can be found at *www.gillian-anderson.co.uk*. OK, so I looked. I told myself it was research for this book.) That said, there's still much for photographers to find on the Web. Here are a few categories that should give you an idea of what I mean.

Information and a Whole Lot More

When the Advanced Photo System was introduced to the world, photographers were able to download specifications, press releases, and even images on the Web sites of the consortium partners before it was in the newspapers, on CNN (*www.cnn.com*), or in the pages of your favorite photographic magazine. That's why the Web is one of the best places to get technical information. When the Nikon F5 was announced, you could read about it both on Nikon's home page, which you might expect, but also at Webzines such as *Digital Photography Review (http://photo.askey.net)* is an online photographic Webzine (more on Web magazines later) that is literally a digital translation of popular photographic magazines.

When looking for photographic information, the first thing you should do when you go online is to point your search engine to your favorite camera or film manufacturer's home page. Recently my interest in black-and-white photography has been rekindled, and I was curious about Agfa's black and white transparency material. The best place to get information about the product, including technical specifications and processing information, was at their home page (*www.agfaphoto.com*). The Web is your best source of current information about silver-based or digital imaging information. It's like having your own personal photographic C-Span channel, providing information twenty-four hours a day.

Agfa's home page for traditional film, paper, and chemistry is found at *http://www.agfaphoto.com*. They have a separate Web site for their scanners, digital cameras, and other electronic media.

Online Digital Imaging Services

One of the most exciting new online products found on the World Wide Web for photographers is online processing and printing. When I wrote the first edition of this book only Seattle FilmWorks—now PhotoWorks.com (*www.photoworks.com*) was providing this service. Now there are so many available that I can only include a few examples in this section.

Agfa's Consumer Imaging Group offers free AGFAnet Print Service software that lets you make traditional hard-copy photographic prints from digital images. The software uses a Wizard to guide you through the ordering process. After you choose a lab from the independent photofinishers that are part of the AGFAnet network, you select the images to be printed, indicating print size, number, and method of payment. You can even crop images using built-in tools. When you're ready to place any order, the software sends images and ordering information to a central server that automatically transmits the order to the selected lab for processing. Within two to three days, the photographs are returned by mail. A Windows version of AGFAnet Print Service software is available now at *www.agfanet.com*, and the company expects that a Mac OS version will be available by the time you read this.

Photographic Manufacturer's Web Sites

In the next chapter, you will encounter a listing of the Web site addresses for many photographic companies. Although the list is far from comprehensive, it does cover many popular film- and digital-based photographic manufacturers. If the company that you are looking for isn't on the list (such as Jobo at *www.jobo-usa.com*), you should visit a Web site called The Meeting Place for Photography at *www.fotograaf.com/links3.htm*. Although slightly biased to European manufacturers, this is a great place to start your search. For example, although Minolta, the U.S. importer of Cokin filters, does not have a Web site dedicated to the filters, their U.K.-based importer has one *www.cokin.co.uk* that provides both product information and great-looking photographs made with the filters.

EZ Prints (*www.ezprints.com*), an Internet e-photofinishing source, offers panoramic print capability in sizes of up to 12" × 60" as well as large-format prints in 11" × 14" size. The panoramic modes of some digital cameras represent an easy and convenient way to create prints in a wide-screen style. Using image-stitching software, such as Enroute's QuickStitch, digital imagers can combine several contiguous photographs into a single continuous image and send their work to EZ Prints for panoramic print processing. Photographers using two Mega Pixel (or larger) digital cameras can now enjoy the impact of having their images output as 11" × 14" prints. Both new formats are printed using the lab's Sienna Melica photographic lab equipment, ensuring high quality and fast production time. EZ Prints offers a wide range of e-photofinishing print services, including prints in 4" × 6", 5" × 7", 8" × 10", 11" × 14", and Panoramic (4" × 12" up to 12" × 60"), as well as photo greeting cards and a wide range of photo novelty items, such as mouse pads and coffee mugs, that are all backed by the company's twenty-four-hour guarantee. You can learn more about EZ Prints by visiting their Web site.

PhotoWorks.com is designed for online delivery of digital images, when you have film processed at their photo lab. They will even process and digitize your first roll for free. When you process a roll of film with PhotoWorks.com, your photos are electronically scanned and stored on your own personal, password-protected Web site. As of May 2000, PhotoWorks.com stores more consumer images online than anyone else in the world, with more than 100 million photos in their system. Users of the service benefit from immediate online access to their photos twenty-four hours a day, anywhere they might be. PhotoWorks.com users can e-mail pictures to friends and family around the world, and for people who still want prints they can hold and pass around, digital prints can be

The PhotoWorks (formerly Seattle FilmWorks) home page may not be the only place to download digital images from a photofinisher's Web site, but they were certainly the first. This is the screen that starts the download process.

ordered with a few simple clicks on the company's Web site. You can also create personalized greeting cards or have your images applied to T-shirts, calendars, mugs, and other gift items. For readers who are not interested in downloading lots of images, the company will still deliver their Picture on Disc product from your processed film as of this writing. This is available in both floppy disk and CD-ROM formats.

Ulead Systems, Inc., producers of PhotoImpact and other useful imaging and Web graphics software, has announced a new media-sharing Web site for digital imagers. Initially, *iMira.com* will focus on supporting the needs of digital photography users; however, applications and services for video and audio enthusiasts are expected to be available shortly. Users can upload image files and store up to 20MB in a Gallery for future projects. Digital photography users can create online photo albums that are accessible by friends and family or send electronic greeting cards for holidays and events. Membership on *iMira.com* is free, and new accounts can be created directly from within Ulead's Photo Explorer 6.0 software. Photo Explorer's Digital Camera Wizard simplifies downloading photos from a camera or card reader, and you can upload and share online files by

using the program's Drop Spot, a utility that uploads files in one step to a personal account on *iMira.com*. Image organization is quick and easy when you use the program's sorting options along with drag-and-drop file management. Enhancement options include lossless JPEG, rotation, cropping, brightness/color correction, and file format conversion. Photo Explorer's slide show feature has been improved, and users can create slide shows, add audio, then e-mail or output the shows as Web pages. Two versions of Ulead Photo Explorer 6.0 are available. The free version includes a banner advertisement area in the user interface, but a version without advertising may be purchased from online retailers for $29.95. For more information on Photo Explorer 6.0 and other Ulead products, visit the Ulead Web site at *www.ulead.com*.

I have lots of fond memories about Zing (*www.zing.com*). When I traveled to Europe last year, one member of our group captured lots of snapshots of our antics with an Agfa digital camera. Within a day of getting back from the trip, I got an e-mail from the guy, directing me to the Zing Web site where I was able to see all of the images he made from our trip as individual photographs or as a slide show. It was a perfect example of how digital imaging expands the limits of traditional photography while adding some fun to the process. But Zing offers more than just image-sharing, there is a wide range of services ranging from information, entertainment, education, and shopping for anyone who enjoys really "playing" with digital images. One of the most interesting of the 120 gift ideas that Zing offers is Photo Cookies. These are shortbread cookies that can be personalized by adding digital images to the frosting atop the cookie. Each box

Image Software for the Web

ActiveShare is a bargain-priced program that combines the abilities to capture images, perform basic image editing, and share digital photographs via the World Wide Web. The program helps you organize and store your images into digital "albums" and share them in personalized Internet communities using the ActiveShare.com Web site. ActiveShare is compatible with many popular image file formats, including Kodak's Picture CD but not FlashPix or Photo CD. The interface is a far cry from the conservative styling you usually see in Adobe's PageMaker, Photoshop, and even PhotoDeluxe. The interface is attractive, intuitive, and just plain fun to work with. Sharing photos or even albums online is a drag-and-drop operation from within ActiveShare to either e-mail or the ActiveShare Web site. Multiple language versions are available, and the program can be downloaded from the *www.adobeactiveshare.com* Web site. Users of Adobe's new PhotoDeluxe Home Edition 4.0 will also find a direct link to ActiveShare.com.

of cookies contains eighteen 2.5" × 3" individually wrapped cookies for $33.95. How good are they? As I write this I'm munching on one of the sample cookies and sipping a glass of milk. The cookie I'm eating has a photograph of three kids at a birthday party, and the quality is amazing—considering that it's in icing! In fact, it's downright tasty. Zing also offers greeting cards, T-shirts, Christmas ornaments, mouse pads, photo mugs, and coasters. Check out their Web site at *www.zing.com* for more fun things to do with your own digital images.

These sites are just a few of the many Web sites designed for image processing and storage. Some others include PhotoPoint (*www.photopoint.com*), PrimeShot.com (*www.primeshot.com*), and MyPhotoLab.com (*www.myphotolab .com*).

E-Mail

Writing e-mail sounds much like the electronic version of writing a letter to Granny; you think you already know how to do it. Or do you?

Let me start by dispeling a few misconceptions: E-mail is not a panacea, and there are times when you have to pick up the phone and actually talk to the person on the other end. That's because e-mail provides less context than other methods of communication, which means that e-mail is not the best method for resolving conflict. In fact it has been my experience that it can *worsen* conflict resolution rather than improve it. Some regular users weave in comments like "[grin]" and "[smile]" to indicate that their comments are intended to be humorous. Other use "emoticons," which are the e-mail equivalent of the "smiley face," that are constructed using punctuation marks. You can see some at *www.utopiasw.demon.co.uk/emoticon.htm*, but I find receiving emoticons in e-mail as annoying as getting notes from people who dot their "*i*"s with smiley faces.

One of the biggest problems that people have with writing e-mail is combining too many topics and too may words into a single message. The message should fit onto a single 15-inch monitor without having to be scrolled. Long messages and too many topics make it easy for the recipients of these messages to overlook something, which might produce a less-than-prudent response from the sender—causing any conflict to escalate. Keep it simple, and save the tricky questions and discussion for a telephone call—even if it is a long distance call.

Why this is even worth mentioning is that many people think that e-mail is an efficient way to communicate, but it lacks nuance. Keep that in mind when writing yours. Nevertheless, like the Internet, e-mail is here to stay. I recommend you read *Using E-mail Effectively* from O'Reilly and Associates—after you've read the next section.

SPAM: How To Avoid It

There is no perfect e-world. Just as your mailbox gets regularly stuffed with what some people refer to as "junk mail," and telemarketers continually interrupt your meals with offers to buy condos in Abu Dhabi, people who regularly use e-mail get *spam*. Named after a legendary Monty Python skit in which the only item on a restaurant's menu was Hormel's famed meat product, spam (note the lowercase "s") is an Internet buzzword for unsolicited e-mail. Spam can fill your electronic mailbox with everything from offers to buy computer products to reminders to visit a certain site on the World Wide Web. Some people get lots of spam and are bothered by the time it takes to go through and discard it, while others, like myself, get little spam and are not so hot and bothered.

I see the threat of spam as similar to that of a computer virus and take steps to reduce my exposure to it. The secret to minimizing the spam that you receive is to minimize spreading your e-mail address around while online. Here are a few tips on what you can do to avoid a mailbox full of spam.

Don't respond to spam: Some e-mailers get so upset by spam they immediately fire off a message condemning the spammer. Don't bother. It just gives them your address a second time. An exception to this rule is that if spammers are benign, they will give you a way to respond with a certain text (usually "Unsubscribe") in the subject line of your e-mail. I *always* respond to this kind of spam by using the appropriate text to cancel future spam from them. They may bury this text in their message, but if it's there, take the time to search for it and respond. I've never received additional spam from the same person or company when responding this way.

Don't sign up for anything online: Many home pages on the World Wide Web allow you to sign up to be notified if the page changes. Don't do it. Although this is convenient, posting your name on some—not all—Web sites exposes you name to software "spiders" that spammers use to round up e-mail addresses while online. Instead of posting your e-mail address, add the site's URL to your browser's Favorites or Bookmark list.

Avoid cookies: This may sound like dietary advice, but it's one of the most important ways to minimize and possibly even eliminate spam. When using a browser program to visit certain Web sites, an invisible message can be left identifying when you were there, how often you've been there, and your e-mail address. This message, called a "cookie," is stored in your browser's files and can be read by the site the next time you visit. Notice that I said "can be left." The first thing that must happen is the site must request cookie information from your browser. Most browsers give you the option to let you know via an on-screen dialog box when a cookie is being requested. You can also *deny* it—if your browser has an option to alert you. This control may be hidden, but look under the Options and Preferences settings and make sure to check the box that says

to prompt you if a cookie is requested. Better yet, you can set it to disable all cookie use.

Although I'm careful about what I respond to, I recently found myself on a list of a spammer who sold autographed celebrity photographs. I have a small collection of autographs (although I've never mentioned this online to anyone) and was pleased to be on this gentleman's mailing list announcing online sales and auctions. I even purchased an autographed print as a gift for my wife because of the spam. Something similar may happen to you if you get spam from an individual or companies specializing in products that you're interested in. Like unsolicited conventional mail, not all spam is bad.

Juno Really Is Free!

E-mail is the most popular Internet service. It's even more popular than the World Wide Web, but one of the biggest factors inhibiting some photographers from using the Internet is cost. It's not just the cost of the modems; modems keep getting faster and cheaper, and most of the time are built into any system—new or used—that you purchase. For many photographers the Internet means access—being able to communicate through e-mail with suppliers, colleagues, equipment manufacturers, and maybe just a note to yours truly. For all of you who have been waiting for some kind of price breakthrough in this area, I'd like to introduce you to a *free* Internet e-mail service from Juno Online Services.

Hard as it may be for all the skeptics out there, Juno Online Services offers a free Internet e-mail service. It is truly free. Nada, nothing, zip, zero! There are no monthly fees, no hourly fees, and no sign-up fees. The software is free and Internet access is free through a local telephone number. Juno is different from some of the other free e-mail services that are discussed next, because it does not require you to have an existing ISP, and as I discussed in chapter 2, Juno provides free Internet access as well. What's the catch? So far there are only two, and both of them are relatively minor.

First, the free software is designed only for Windows-based computers. Once upon a time, Juno expected to have a Macintosh version available, but that idea seems to have fallen out of favor. Mac users who don't want to work with a Windows computer can always use Connectix's (*www.connectix.com*) Virtual PC that will allow them to run this and other Windows software on their Power Macintosh computers. You might need some additional RAM and a larger hard disk to maximize the performance of the software, but if you can cost-justify the expenditure, it's an option.

Second, the software displays commercial messages. But anyone who has ever surfed the Internet with software that they bought and paid for, using an ISP that sends them a monthly bill, already knows there's nothing unusual about

Juno's e-mail interface is well-designed, user friendly, and easy to use. Notice the ad running in the software's header.

seeing your Internet rambling interspersed with ads for everything ranging from colas to sneakers to automobiles—and computer stuff, too.

The software is yours for a free phone call to 800-654-JUNO. It comes on a CD-ROM containing all the information you need to get started. Establishing an account and installing the latest version of Juno's software was a snap on my Windows machine. After you run the setup program and launch it, the program asks for some basic information and then automatically configures your system and modem. It took a guess at the kind of modem I have inside my PC, and one of the guesses was correct. I clicked OK and moved to the next step. After picking your e-mail address and password, you get to the "member questionnaire," which might be the only semi-controversial aspect of the process.

If you've ever filled out a warranty card for your computer or VCR, you will recognize this for what it is: market research. None of the questions seemed particularly intrusive to me, but they did want to know my annual household income and how many stock or bond trades I'd made over the past year. This might or might not bother the security-minded amongst you. As I mentioned earlier, Juno uses these profiles to decide what commercials they will display when you log on. After that, it's just a matter of launching and using the software.

If you've ever seen or used any company's online software or browser, you will be amazed at the easy-to-use design of Juno's software. There are two large tabs that let you switch back and forth between the service's two main functions: reading and writing e-mail. After that, everything has been designed to make the e-mail process an intuitive one, beginning with spelling. One of the most popular expressions on the Net is that "nobody can spell online." That's usually because your replies are written in much the same, less structured way as conversations. One of the victims of this lack of structure is spelling. Some companies have developed software plug-ins and add-ons (that you have to pay for) to add spell-checking capability to an Internet browser, such as Netscape Navigator. Here, a spell-checker is built into the free software that Juno provides so you can quickly spell-check your reply before letting it drive off onto the information superhighway.

Juno's software also contains a full function address book allowing you to build up a personal mailing list of friends, colleagues, suppliers, and client's e-mail addresses. To send a message to someone who's in your address book, all you have to do is click on the person's name, click the Send To button, then click OK. In addition to being able to send a message to anyone who hosts a site on the Internet, you can also send e-mail to anyone using a major online service such as CompuServe, Prodigy, and America Online. When mail arrives, it is stored in a folder and you can read it, respond to it, or file it in another folder.

One of the hottest trends in e-mail is the appending of an electronic "signature." Most users use this to add their name and some additional information about themselves, such as their street address. Some users use it to call attention to their achievements, such as a new listing in *Who's Who*, the awarding of a master's degree in photography, or just to add a pithy saying. A word of warning here: My friend Steve is currently adding little snippets onto his signature. For a while he was using "R2D2! You know better than to trust a strange computer!" This can be mildly amusing for a short time, but your regular e-mail recipients may get tired of it quickly if it is not changed regularly.

Other Free E-Mail Sources

Many Web sites also offer free e-mail services. The only catch with most of them is that you must already have Internet access in order to use them. That means your e-mail address at *bob255@yahoo.com* doesn't cost anything, but that you need to have some kind of existing Web access to make it work. Since you probably already have an e-mail address provided by your ISP, why would you want another one? I can think of several reasons.

First, you can access the free account from any computer anywhere in the world. When I am at a trade show, I can use any computer in the pressroom—

Free Web E-Mail Sources

The following is a brief list of just a few of the free e-mail providers that were available when I was finishing this book. The list is meant to be a jumping-off point for you to sign up for a free service that fits your e-mail needs.

- Free E-mail: *www.1freee-mail.com*
- AltaVista E-mail: *http://altavista.iname.com/member/login.page*
- Autoweek: *www.autoweek.com*
- Doghouse Mail: *www.doghouse-mail.lycos.com*
- FlashMail: *www.flashmail.com*
- HotMail: *www.hotmail.com*
- Mail.com: *www.mail.com/login/mailcom/logic.jhtml*
- Postmaster: *www.postmaster.co/uk*
- TurboSport Mail: *www.turbosport.com*
- Yahoo: *www.yahoo.com*
- WowMail: *www.wowmail.com*
- ZipLip.com: *www.ziplip.com/zplus/home.jsp*

Windows or Macintosh—to log onto *www.juno.com* and provide my e-mail address and password and be able to deal with any urgent messages. I also use this time to delete any spam or messages from companies and people whom I do not respond to. Like my personal hero Isaac Asimov I always respond to reader queries within twenty-four hours; but as a quasi-public figure, I get my share of messages that I don't plan to respond to. By deleting them when I am on the road, I don't have them waiting for me when I return.

Second, a second address can be used for personal rather than business use. You can use a HotMail (*www.hotmail.com*) address for your hobby so that if you want to communicate with fellow enthusiasts, you don't have to wade through your business e-mail to find that the headlight assembly you've been wanting for your Series I Jaguar XJ-6 is available from a dealer in Australia. Car lovers, by the way, should look at *www.autoweek.com*, which offers a personalized e-mail address that identifies you as an aficionado.

Communicating around the World: E-Mail's Downside

One of the best things about the Internet is e-mail. For the price of your monthly Internet access, or maybe for free, you can send electronic mail anywhere in the world. Communicating with a photography professor in Haifa, Israel, is just as simple as communicating with one in Rochester, New York. According to some

sources, the quantity of e-mail online users receive is growing astronomically and is expected to increase thirty times more than current volumes by the end of 2001.

For all of the convenience and benefits of e-mail, there is a down side. I have a theory called "Communications Hierarchy," which suggests that people such as photo buyers and clients tend to pay the most attention to the latest communications marvel. The first thing to drop out of the communications hierarchy was the U.S. mail. Here's a true story: I was talking to a potential client about doing some work, and he asked me to send some images and promotional material, which I did. When I called him back, he said he had never gotten the material. I ended up sending him the package two more times, but the result was always the same—he never received it. It turned out that his secretary sorted his mail, and anything she didn't think was of interest she tossed into the trash. Whether she did this on his orders is anybody's guess, but it was clear that anything in a 9" × 12" envelope was trash-bound at that company. And, no, I never bothered following up.

Next came the fax. There was a time that the best and quickest way to get potential clients' attention was to send them a fax. Sending a client an assignment confirmation or estimate by fax within moments of discussing the work on the phone always resulted in signed agreements being returned. Those were the good ole' days. With the advent of broadcast fax and junk fax mail, the output of the fax machine became the next victim in my theory.

E-mail, it seemed, would be the ultimate answer. It had everything. It was almost instantaneous, it was paperless, and it was cool. Sorry, Charlie. Within a very few years e-mail lost its luster, too. I started noticing this recently when fully one-third of the e-mail I sent to people, from whom I expected a response, went unanswered. To get another opinion on this, I spoke with someone who gets a lot more e-mail than I: Steve Deyo, the Editor Emeritus of *ComputerUSER* magazine. Here's what he told me about e-mail (via e-mail):

> There are always stories about people (of whom I confess I think unkind thoughts) who confess that they delete most of their e-mail unread. [*Author's note: In* Using E-mail Effectively, *the authors tell of a person who allows his queue of e-mail to reach 600 messages, then deletes the oldest 200.*] So it's not a problem of the technology or its convenience or its benefits; it's that some people are too damn lazy . . . or just overworked, partly through others' misuse of e-mail (cc'ing of newsgroup humor, chain letters, etc.). I think that until we have true inter-networked receipting of mail when it's actually been read (not just received) and digital authentication and security, we can't rely on e-mail as solidly as U.S. mail. And how much Pony Express mail gets read, anyway? (I prefer to use the term "Pony Express mail" rather than "snail mail" because ground mail has a noble tradition—"neither rain nor snow" and all that—plus I prefer to disgruntle our postal workers as little as

possible.) Appropriate use of the technology—and personal investment of time in a phone call for really important matters—seems to be the rule of a future, more ideal day. Until that day comes, e-mail really is a convenience for the sender—especially if you're a junk mailer—and an informal communications tool. E-mail is less formal than the fax and less secure, but cheaper too. It's a tradeoff, as always is the case with any mass-market technology.

The truth is that e-mail has all of the problems of postal mail with the added frustration of an enhanced level of expectations. People can ignore your e-mail as easily as they ignore your paper letters. As in the case of junk mail, they can toss your lovingly crafted e-letters into the digital trash can or recycling bin. Even worse, like politicians being asked tough questions, they can be selective in what they will answer. When combined with the high expectations that new e-mail users expect—quick delivery and response—the frustration levels can be high. The reason I have included what is mostly a negative look at e-mail is that new users expect e-mail to be a panacea for their written communications problems. As you can see, it's not, but there is . . .

The Good News about E-Mail

Just as a U.S.P.S. letter carrier carries more than letters, the Internet allows you to send files containing text, graphics, audio—even video clips. Any binary file such as graphics, sound, or video can be encoded as ASCII (American Standard Code for Information Interchange) text for transmission over the Internet. If you're wondering why you should even care about this concept, it is the perfect way to e-mail a photographic image—and a text message—to existing and potential clients anywhere in the world. Often these files are compressed or encoded to save space during transmission. The most popular methods for encoding and sending binary files over the Internet are BinHex, UUcode, MIME, and Zip.

BinHex

This format is an algorithm for representing nontext Macintosh files (such as software, graphics, spreadsheets, and formatted word-processing documents) as plain text so they can be transferred over the Internet. The file-name extension ".hqx" designates a BinHex file, which can be decoded with Aladdin Software's (*www.aladdinsys.com*) freeware utility StuffIt Expander. It is also available as part of the company's commercial product software called StuffIt Deluxe.

MIME

Rather than an annoying white-face–painted Marcel Marceau wannabe, MIME is an acronym for Multipurpose Internet Mail Extension and was developed by the

Internet Engineering Task Force for transmitting mixed-media files across TCP/IP networks like the Internet. To turn a MIME message into the original format, you need a conversion utility. There are utilities for Macintosh, Windows, and UNIX machines that will decode MIME files. For more information about MIME, visit *www.hunnysoft.com/mime.*

UUcode

This software allows you to convert a binary computer file into an ASCII format for sending across the Internet (or any other e-mail service), then to convert it back to binary. In UUcode or MIME format, a file may be visible and readable by your word processor as ASCII text, but it will look like gibberish on the screen. Some e-mail services, such as CompuServe, allow you to attach a binary (graphic, audio, video clip) file to a message without ever affecting the message. The person receiving your, now combined, message can read your e-mail and then convert the file into its original, intended form. You can find and download lots of utilities for translating MIME or UUcode files at *http://cs.millersv.edu/~jnrisser/binaries.html.*

ZIP

This is a Windows and DOS-based methodology for compressing and expanding files that are transmitted and downloaded over networks, including the Internet, or as e-mail attachments. The late Philip W. Katz created the ".ZIP" extension and placed it into the public domain, where it become the de facto compression standard on non-Mac OS systems. And even some Mac programs, such as the Macintosh version of StuffIt Deluxe, will decompress ZIP files. In 1986, Mr. Katz founded PKWare (*www.pkware.com*) to create products that will work with this format, and you should visit that Web site to get the latest versions for Windows or DOS as well as UNIX and OS/2.

More on Newsgroups

USENET, or USEr NETwork, began in 1979 as a bulletin board that was shared between two universities in North Carolina. It has grown into a public access network, maintained by volunteers on the Internet, that provides user news and e-mail services. USENET II (*www.usenet2.org*) was formed to create a structure for the USENET model of trust and cooperation that can be made to work with the Internet in the twenty-first century. A good place to start is the USENET Info Center Launch Pad at *http://metalab.unc.edu/usenet-i/.*

News traveling over the Internet is called NetNews, and a newsgroup is a collection of messages covering a particular subject, which can be anything from digital photography to politics and even silly topics like cult TV shows and

Newsreader Software

Alhtough you can use your browser for this, there are dedicated programs, such as TIN (Threaded Internet Newsreader) available at *www.tin.org* or Knews (*www. matematik.su.se/~kjj*), that allow you to read newsgroup messages. Another popular newsreader is WinVN (*www.ksc.nasa.gov/software/winvn/winvn.html*). Readers who want to know even more about newsreaders should also check out the Gnus Network Reader Services at *www.gnus.org*.

movies. There are seven newsgroup topic hierarchies that are called "trees": computers, miscellaneous topics, news or newsgroup information, recreation, science, society, and talk. Each tree branches into different subtopics.

Newsgroups abound on the Internet. As I write this there are more than ten thousand newsgroups on the Net. Using the Yahoo! search engine, I found fifty-three sites on erotic photography alone. In order to read the text of a newsgroup, you need a newsreader, which is software that organizes your USENET conversations and allows you to read and participate in newsgroup discussions.

More on Search Engines

Search engines are not engines at all in the conventional sense of the word but are really database managers that manage the content of the World Wide Web. In fact, since I wrote the first edition of this book, they have even stopped being called "search engines"—and, like kids who grow up and want to be called by their full Christian names, they prefer to be known as "portals." Since portals, such as Excite, have long been called search engines, I will continue the use of that term throughout the book, because that's what everybody calls them whether they like it or not!

As with any database, how well search engines do their job depends on the talents of the database designer and program, as well as how the parameters of the program were set forth in the first place. Most search engines are free and contain some advertising on their home pages, advertising that I personally find unobtrusive.

How They Work

A search engine, well, searches. It casts a net out onto the World Wide Web to help you find a particular home page. Each search engine is different and uses different search techniques to locate that special Web site you're looking for.

How they search can be important, especially when you're looking for a Web site of a service bureau or professional color lab that can help you when you're on the road. Here's an overview of the different kinds of searches that are typically done.

Boolean: This kind of search looks for specific data by giving you the ability to specify conditions and by allowing you to use one or more of the Boolean expressions "AND," "OR," and "NOT." Don't let the term "Boolean" scare you. It comes from Boolean logic, in which an answer is either true of false. It was developed by the English mathematician George Boole in the mid-nineteenth century. An example of a Boolean search request would be, "find a photo lab that processes black & white film AND Kodachrome." Database programs typically allow you to make Boolean searches for data, and so should a good Internet search engine.

Contextual: The most common type, this mode searches for home pages or Web sites based on the text you enter in a "search" keyword. The search engine uses the data that you enter to match with other data in the Web-site description database. It looks for Web sites whose descriptions contain the word you have specified. If you're looking for a lab to process Agfa's Scala black-and-white transparency film and you enter "Scala," you might find listings that include labs but also a photographer's Web site that has used Scala to create some of her images.

Fuzzy: The least common type of search uses "fuzzy" logic to look for data that is similar to what you are trying to find. (Fuzzy logic was originally conceived in 1964 by Lotfi Zadeh, a science professor at the University of California at Berkeley, while trying to program computers for handwriting recognition.) This is the best approach when an exact spelling may not be known or when you want to find co-related information. If you're looking for information on the images of Jerry Uelsmann and don't know how to spell his name (I always have to look it up), you type in "Ulesman" and a fuzzy search could lead you to the correct location.

A Comparison of Popular Search Engines

Like Web browsers, there are many, many search engines that you can use. The ones listed below are the most popular, but that doesn't mean that by the time I finish writing this book, there won't be ten more really good search engines. For now, consider this list to be a short version of the *Fortune* 500 of search engines. More importantly, don't be discouraged about trying to find the perfect search engine. Just as you have different lens, film, and filter combinations that are used for specific projects, you will quickly discover that there are search engines you prefer and those that you don't.

Yahoo! may be the granddaddy (in Internet years, of course) of all Internet search engines or portals. In addition to searching for sites and USENET groups, you can get a stock market report, check the weather at Mount Rushmore, or shop for a model of a 1955 Ford Thunderbird from the Franklin Mint.

Despite its somewhat silly name, Yahoo! (*www.yahoo.com*) is the Honda Accord of search engines; it is the search engine against which all of its competitors compare themselves. It uses a contextual search mode, so you should be specific when searching for a particular Web site; searching "photography" is not enough. Instead, try "art photography" and see what happens. If you click on Advanced Search you get access to Boolean searches as well as an exact phrase match and other choices. If you have a single word topic, such as Astrophotography, you can use the main Yahoo screen, but if you are searching for underwater infrared photographs, the Advanced Search features will be of more help. Like most search engines, Yahoo lets you choose a site according to its age, which you can set for one day old or for up to four years old. Yahoo! features inoffensive on-screen advertising that keeps the service free. The search engine is fast and responsive and displays its bounty in a clear, readable form. It's the first place I start, but not necessarily the only one I use.

Lycos (*www.lycos.com*), which is almost as popular as Yahoo!, sports what I feel has a more attractive interface. The search interface offers two choices: contextual and one that could loosely (fuzzily) be called fuzzy. You can access this second mode by clicking the Advanced Search link, below the area where you

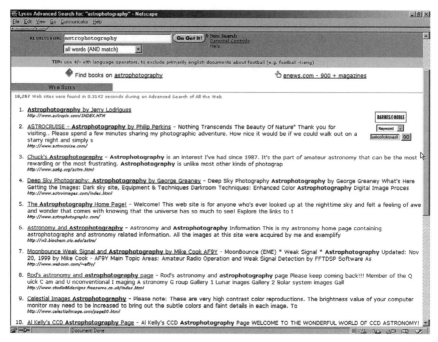

The Advanced Search function of Lycos' search engine is simple to use and delivers more detailed results than some others. Here are just a few of the more than ten thousand Web sites that are involved in astrophotography.

would normally type in your contextual text information. Clicking the link takes you to another screen that has been greatly simplified and streamlined since the first edition and thus is much easier to use than the former interface. You have a pop-up menu that gives you three choices: All Words (and match), Any Words (and match), and Exact Phrase (quoted query) that homes in on your specific request. Underneath you can home in on a specific type of document that ranges from what you would expect (Web sites) to multimedia, recipes, and even the weather. This kind of search engine really lets you hone in what you are looking for. At the top of the page, is a link to *USSearch.com* that lets you find someone you may be looking for. Unlike *www.switchboard.com*, this is not a free service and a fee is charged for each search. Testing Lycos by using the word "astrophotography" was an eye opener and says a lot about how the Web has changed since I wrote the first edition. Last time, a Lycos search brought up 737 locations; this time, I got 10,267 sites concerned with this topic.

Magellan (*www.mckinley.com*) is another popular search engine that allows some flexibility in searching. Magellan's technology lets you search the Web by *concept*. The search engine will look for documents containing the exact words you entered into the query box, but Magellan also looks for ideas that are closely

Despite its modest graphical interface, Magellan provides the kind of service that a twenty-first-century portal site should have, along with a powerful search engine capability.

linked to the words in your query to broaden your search. Magellan uses Intelligent Concept Extraction (ICE) to find relationships that exist between words and ideas, so the results of a search will contain words related to the concepts you're searching for. Magellan can search the more than 50 million Web sites in its database, looking for the most relevant matches: The results nearest the top will usually be the most relevant. You can also use Magellan's Find Similar link. If you find that one of the many returned results better describes what you are searching for, click on the words "Find Similar" next to the URL. Their search engine then uses that document as an example in a new search, to find more sites similar to the one you liked. When all else fails, you can try an Advanced Search by using the plus sign for words that your results must contain, or the minus sign to tell the search engine that your results should *not* contain a certain word.

Some Final Thoughts on Search Engines

The biggest question that most Internet newcomers ask about search engines is: Which one is the best? Answering a similar question about camera systems is

Crawling the Web

Like everything else on the Internet, the number of search engines varies over time as new ones are added and old ones are improved. To help you get started with your own searching, here's a short list of just a few search engines that are out there.

- Accufind: *www.accufind.com*
- AltaVista: *www.altavista.com*
- Ask Jeeves: *www.askjeeves.com*
- CNet's Shareware.com: *http://shareware.cnet.com*
- DejaNews: *www.dejanews.com*
- Excite: *www.excite.com*
- Go.com: *www.go.com*
- Infoseek Guide: *http://infoseek.go.com*
- Let's Search: *www.letssearch.com*
- Lycos: *www.lycos.com*
- Magellan: *http://magellan.excite.com*
- Pointcom.com: *www.pointcom.com*
- Snap.com: *www.snap.com*
- Starting Point: *www.stpt.com*
- Web Crawler: *www.Webcrawler.com*
- Yahoo!: *www.yahoo.com*

much easier. You ask a few questions about how the person plans to use the camera, ask what focal length lenses are important; find out if leaf-shutter lenses are necessary; determine the importance of format, interchangeable backs, and close-focusing accessories; and then you can make an educated recommendation.

Even though most European and Japanese manufacturers have accelerated the level of technical advances in the past few years—especially with digital cameras—nothing compares with the light-speed advance of technology that is associated with the Internet. The best search engine? That's a much more difficult question to answer. The people who operate search engines are rushing forward with changes that occur on a *daily* basis, and they are being pushed by the competition to be better and different. Nevertheless, I'm willing to stick my neck out and recommend Yahoo! It's one of the older search engines, and I like the way it displays its searches. It also seems to find more locations than the others; but I still use other search engines because more often than not, they turn up Web sites that Yahoo! (for some reason) doesn't seem to know about.

In this section I've tried to provide an introduction to search engines and

how they work. Although I have provided a few examples, the best way to find out which one you prefer is to use the URLs in the sidebar to give each search engine a visit. Be careful not to write off a particular engine if you are not initially happy with its interface—nobody's perfect. Visit the site occasionally to see what's new. You may be surprised at the changes that have been made since your last try. I was. During the several months that this new edition was being prepared, all of the search engines included in this chapter were improved—some dramatically. Like improvements in film emulsions—which are just another tool for photographers—improvements in search engines are improvements in tools to help you find what you're looking for on the Internet or World Wide Web.

Web Sites You Shouldn't Miss

Toto, I don't believe we're in Kansas, anymore.

Dorothy Gale in L. Frank Baum's *Wizard of Oz*

In this chapter, I want to introduce you to some home pages that will be of particular interest to photographers. At the time I wrote the first edition, the Infoseek search engine showed that there were 21,466 Web sites containing the keyword "photography." This morning the same search engine showed me that there were 627,570 "hits" on the same word. So that you won't have to look at every one of the more than half-million and growing Web sites, I've prepared a guide to some of the more interesting photography-oriented home pages on the World Wide Web.

What you'll see should be considered a highly subjective (consider it much like you would a movie review) look at Web sites that should be of special interest to photographers. The sites were selected for the same reason that a movie may appeal to one reviewer but not another. One reviewer may love it, while the other may give it a big thumbs down. I've given all of these sites a "thumbs up," not for their great design or graphics, but on the basis of their usability to the professional or advanced amateur photographer. That benefit may be in the form of information about a product, tips on creating digital or

silver-based images, or a source of information on photogenic shooting locations.

Since there are so many different aspects of photography, I've tried to cover as many of them as I could, but there are some topics that may be lacking. If you're interested in forensics or photomicrography, you may be disappointed in my selections. If these specialties are where your interests lie, use any of the search engines that I mentioned in the last chapter to find Web sites that feature your specialty!

You will also not find Web sites from any of the major film and camera companies. As photographers, we often become possessive about our cameras and films to the exclusion of others, and my inclusion of information about a Kodak or Fuji home page seems both personal and redundant. Rather than throw you to the search engines to find the Agfa home page, for example, I've collected the URLs for many photographic camera and film companies in a sidebar. Having these addresses will save you time in looking them up. If you're interested in information that will help you take better photographs, a camera company's Web site may not be the most objective.

While you can get the specifications on the F5 from Nikon's home page, you may find field tests and hands-on testing in one of the Webzine Web sites. Likewise, there are no camera stores or mail-order dealers listed in this chapter. We all have our favorite companies that we prefer to deal with, and rather than show any preferences, none are listed.

Lastly, I have tried to find some Web sites that can easily be compared to that "great little restaurant that's hard to find." So, mixed in with some sophisticated home pages with great graphics, some more homely sites make up in content what they lack in panache.

A word of warning is due here: Because of the nature of the Internet, there are many home pages that were created by individuals and not by manufacturers or retailers, that contain a combination of uninformed opinion and bias about a particular brand of equipment or film. Within the Web, this can easily be passed off as fact not opinion. For example, when using search engines to develop the manufacturer's sidebar, I was sidetracked by a home page that was supposed to contain a comparison of two leading camera manufacturer's products. What I found were some nicely prepared charts comparing many out-of-production models, coupled with fan-like (and biased) enthusiasm for one of the manufacturers.

Yes, the Internet and World Wide Web contain information, but there is a difference between opinion and fact, and often the line between the two is blurred by the way that information is presented. I have tried to avoid including any of these kinds of sites in this chapter, and my advice is included only as a general warning that, when surfing from Web site to Web site, it's easy to get lost. Information, as I stated before, is not wisdom. *Caveat Wilsoni*—let the surfer beware.

Photography and Imaging Manufacturer Web Sites

The following is a list of many camera and film manufacturers that currently have Web sites. If your favorite equipment manufacturer's home page is missing, check the Links to Manufacturers Web site at *www.fotograaf.com/links3.htm* for the most detailed listing of manufacturers sites that I have found.

- Agfa digital imaging (digital imaging and electronic prepress systems): *www.agfa-home.com*
- Agfa photography: *www.agfaphoto.com*
- Bogen Photo Corp.: *www.bogenphoto.com*
- Bronica/Tamron: *www.tamron.com*
- Paul C. Buff, White Lightning: *www.white-lightning.com*
- Canon USA: *www.usa.canon.com*
- Canon Computer Systems: *www.ccsi.canon.com*
- Chimera: *www.chimeralightning.com*
- Eastman Kodak Company: *www.kodak.com*
- Fuji Photo Film USA: *www.fujifilm.com*
- Konica Photo Imaging: *www.konica.com*
- Leica: *www.leica.com*
- Lightware: *www.lightwareinc.com*
- Minolta USA: *www.minoltausa.com*
- Nikon Inc.: *www.nikonusa.com*
- Olympus America Inc.: *www.olympusamerica.com*
- Pentax Corporation: *www.pentax.com/home.html*
- Polaroid: *www.polaroid.com*
- Ricoh: *www.ricoh-usa.com*
- Scitex Corporation Ltd.: *www.scitex.com*
- Sinar-Bron Imaging: *www.sinarbron.com*
- Sony: *www.sony.com*

Top Photography Sites

After I started this quest, I realized that a "ten best" might not be enough. So I grouped what I felt are the best and included an honorable mention section at the end. The top-rated sites are listed in no particular order and are grouped by type.

While doing your own Web surfing, I recommend that you make a note of the URLs of the sites listed here and visit them—even if you're not initially interested in the topic. Why? Now is the time that you should see what other photography Web sites look like and how they interact with the viewer so that they

Rohn Engh's PhotoSource International (*www.photosource.com*) is a must-visit Web site for photographers interested in selling stock images as well as keeping up-to-date on the impact that digital imaging and the Web has on the stock photography business.

can help you when it comes time to improve or create your own site. Don't compare your Web site to home pages produced by Microsoft or Netscape using teams of dozens of programmers working night and day. Most likely your own resources will be more modest. The best place to see what can be done with Web site design is to scope out what other photographers in your chosen field and photo-related companies are up to. You find some of them here and even more in the next chapter.

Information

As is often mentioned on *The Prisoner*, "I want information." Patrick McGoohan's cult TV series was made well before the Internet had developed into what it has become, and, if it were available back in the sixties, his character would have used the WWW to look for information. The Internet contains a wealth of information about many subjects—including photography. Some of these sites are created by equipment and camera manufacturers and some are private enterprises, but all provide a way for today's photographer to keep up to date with both digital and silver-based technology.

Informational sites can take many forms, from Webzines, which will be covered later in this chapter, to "links" pages. A links page is a Web site that simply contains links to other Web sites, often grouped by category. One example is the Links to Manufacturers Web site at *www.fotograaf.com/links3.htm*. Although some of these sites represent a commercial undertaking, other times it is an individual who produces them and does all the heavy lifting. I don't know what compulsion leads individuals to do this, but their hard work in seeking out, listing, and posting links by specific subject is largely an unappreciated task. To reward these unsung heroes, I would like to include the following Web sites in my "best" list.

OnLine-PhotoWeb (*www.Web-search.com/photo.html*)

What started out as a links page has evolved into a search engine that will also let you look for photographers, models, and photography home pages. OnLine PhotoWeb contains links to other pages and is grouped by thirty different photographic specialties, including nature, commercial, travel, sport, and celebrity photography. You will also find links to video resources, photofinishers, and photo equipment repair. What's more, the site includes links to obtain freeware, shareware, and demo software related to digital imaging and photography. OnLine PhotoWeb takes a world view and features sites that originate in Europe as well as the United States. This is one site that you should start with when searching for photo-oriented sites, and it might prove to be a valuable addition to your Favorites or Bookmark list.

WJ's Photo Homepage (*www.a1.nl/phomepag/markerink/mainpage.htm*)

The tale of *The Ugly Duckling* is a Danish fable but perhaps has some resonance with the Dutch. WJ's Photo Homepage originates in The Netherlands, and although it contains the most extensive collection of information about infrared photography I've discovered so far, it won't win any beauty contests. The site was previously known as WJ's Infrared Home Page, but the Webmaster, Willem-Jan Markerink, now includes information on panoramic photography along with one of the biggest collections of photo arcania you'll find anywhere on the Web.

You've *got* to love a Web site that opens with this quote that William Herschel made in 1800: "It being now evident that there was a refraction of rays coming from the sun, which though not fit for vision, were yet highly invested with a power of occasioning heat, I proceeded to examine its extend [*sic*] as follows . . . ," and which also includes "25 Photographic Truths," one of which is "color slide viewing cures insomnia." This same dichotomy of content and irony can be found everywhere at WJ's Homepage.

Infrared photographers will find technical information on the spectral data of Wratten #3 and #87A IR filters along with a table comparing several brands, including Schott, B+W, Heliopan, Cokin, and Hoya.

Wratten Filter Trivia

In 1878, Mr. Wratten founded Wratten and Wainwright, one of the earliest photographic supply businesses, which produced and sold collodion glass plates and gelatin dry plates. With the assistance of E. C. K Mees, Wratten produced the first panchromatic plates available in England and became a manufacturer of photographic filters. Eastman Kodak purchased the company in 1912 and as a condition of hiring Mr. Mees, agreed to keep the Wratten name on filters. There's much more to this fascinating story, and I urge filter fans to read what Mr. Markerink has to tell on his Web site.

The opening section contains information about the kinds of cameras and film Mr. Markerink uses for his personal photography. In this section you will find a thumbnail gallery called "A Selection of My Images" that shows many of the Webmaster's infrared photographs. I recommend you visit this part of the site first because it sets the stage for the rest of your visit by letting you see that the Webmaster is an accomplished photographer. Many of his images, especially the infrared panoramas, are quite striking. After clicking on the thumbnails you'll see a larger version of the photographs along with technical data about how it was made. In these captions, he explains the camera, lens, filter, and film used and in some cases how he intends to improve similar images in the future. Such humility in the photographic world is rare.

Center of Gravity is Mr. Markerink's "Infrared Chapter" of the Web site. It features links but is mostly what seems like endless pages of original information about everything from processing infrared color slide film to how to develop Konica 750IR and Kodak HIE in Agfa chemistry. In this section, you'll also discover practical information on topics such as why the Hasselblad Xpan doesn't work well with infrared film, along with more esoteric, technical data such as the spectral irradiance of the sun at sea level. If you are passionate about or just interested in infrared photography, you will visit each page of this section and revel in what you uncover.

Miscellaneous Photo Chapters is even larger than the previous section and contains over fifty different topics, mostly related to cameras and accessories. The general focus is on the cameras that Mr. Markerink personally uses, including Canon, Noblex, and Minolta, but you'll also find stories on the Combat Graphic 70mm, Horizon 202, and information on fisheye lenses. It's here that you'll find the "25 Photographic Truths," along with an overview of medium format slide projectors, and a dissertation on "Why APO is not always APO . . ."

External Links to Other IR and UV sites has an Infrared FAQ section that includes contributions by eighteen other photographers. Like the rest of the site,

this FAQ is deceptively simple and includes practical advice from all of the contributors about their experience working with black and white and color infrared imaging. The FAQ also includes hyperlinks to charts and graphs to make even the most technically minded photographer happy, but is written in such a way as to appeal to even an IR novice. This is must reading for any visitor to the site. *Sites Containing IR Pictures* is exactly what it says and lists over sixty photographers' Web sites that feature at least a few infrared images. There's also a short list of sites specializing in UV pictures.

Travel Photography

Looking for the answers to those age-old questions that have plagued photographers since the invention of roll film? Where can you go to make interesting images? What's the best time to make the trip? What's there to photograph after you get there? When looking for new locations to produce outdoor-oriented stock or assignment images, this is the Web site where you should start.

Photo Travel (*http://phototravel.com*)

This is the home page that helps you discover the best places to take pictures in North America with travel guides written especially for photographers. The Web site is the online home of the publisher of *Photo Traveler Newsletter* and *Photo Traveler Guides* that cover national parks, scenic areas, wildlife locations, slot canyons, and little-known but interesting locations. *Photo Traveler* has been publishing information about photo opportunities since 1985, and there's a lot of source material available here, including Online Travel Guides for Bryce Canyon, Monument Valley, Yellowstone, and many other photogenic locations. The online information are excerpts from their more detailed (and inexpensive) *Photo Traveler's Guides* which you can order online.

Digital Imaging

The Web is the perfect place to find information on digital imaging. The equipment manufacturer's sidebar includes the URLs of popular camera and electronic device companies, and previous chapters have included information on online photofinishers and service providers, but here are a few Web sites that digital imagers will find indispensable.

Ultimate Photoshop (*www.ultimate-photoshop.com*)

This site provides access to different kinds of tools as well as information about using Adobe Photoshop. Ultimate Photoshop is a gateway to some of the best Adobe Photoshop-related content and links you'll find on the Internet. The Web

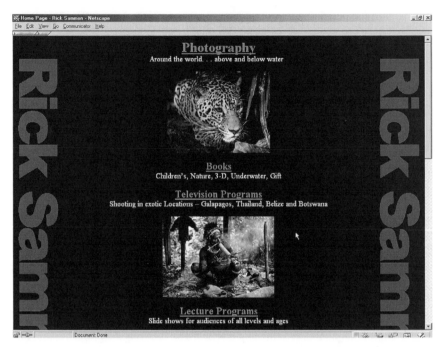

Rick Sammon is one of the best travel photographers in the world. To see how you can learn from this master of the on-location image, visit his Web site at *www.ricksammon.com*. Images © Rick Sammon.

site is divided into four major sections and several minor ones. The Filters and Plug-ins section provides download access to a wide collection of commercial demo, shareware, and freeware plug-ins. All plug-ins are identified as either Mac OS or Windows-based. While searching through the available downloads, I found as many Windows plug-ins as there were for Macintosh users. The graphics in this section, like most of the others, are quite professional and include a "What's New" listing of new items added since the last update and a search function designed to help you locate a specific plug-in. The Webmaster is modest enough to provide links to other sites that have plug-ins available for download.

Ultimate Photoshop is not just about downloading tools; its Tips and Techniques section contains files packed full of information that will improve your own Photoshop efforts. Most of the listings under each heading are links that take you to the Web site of a photographer who created that particular tip or technique, and you have to marvel at how much research the Webmaster has done to find these links in the first place. Whenever a tip or technique is opened, it's displayed in a new window, so you only need close it to get back to Ultimate Photoshop. While reading about a specific technique, you may, as I did, uncover

many sites you may not have otherwise found. Consider this part of Ultimate Photoshop to be the most serendipitous.

Of all the three major sections, the Site's Action Archives is the least extensive, but there are still plenty of interesting Photoshop Actions designed for images and text and available for download here. There are no platform designations for Actions because they are inherently cross-platform. An Action created on a Macintosh will run on any Windows-based computer. The only restriction is that you must be using Adobe Photoshop 4.0 or later. If you've never used an Action before, download one from Ultimate Photoshop. Action files are so small that, at 56K, downloads are instantaneous.

While on the first page, take the time to "subscribe" to the site by providing your e-mail address in the space provided. Whenever the site is updated with new links, tools, or techniques, you will receive an automated e-mail message from the Webmaster inviting you to see what's new. Worried about spam? There's also an "Unsubscribe" button. At 56K, Ultimate Photoshop loads quickly and there are no annoying delays moving from page to page and item to item. The site features an occasional advertising banner, but they are small, unobtrusive, and computer-related.

Art and Publishing

Since photographers do not live by technology alone, I've found it's always a good idea to recharge your batteries by spending time turning the pages of a good photography book. Not a book about the nuts and bolts of photography, but one that shows the work of a particular photographer or genre. If you need such creative recharging as much as I do, I urge you take a look at the Twin Palms Publishers and Twelvetrees Press home page.

Twin Palms (*www.twinpalms.com*)

Twin Palms Publishers and Twelvetrees Press have, so far, produced more than eighty fine art and photography books. These are not namby-pamby books with pictures of cute kids and dogs. No, these are cutting edge; often, sexual imagery is combined with the finest book craftsmanship available. As of this writing, they are the only publishing house that still produces top-quality photography books in sheet-fed gravure (for more information on gravure printing, see the history section of their site). In recent years, they've published the documentary work by Danny Lyon, Bruce Davidson, and Norman Mauskopf. They were the first to publish monographs by Joel-Peter Witkin, George Platt Lynes, Herb Ritts, Robert Mapplethorpe, and F. Holland Day. High-quality papers, printing, and award-winning design assure the long-lasting value of each volume.

Technical

The Web can be a great information resource for traditional darkroom enthusi-asts and photographers. As befitting the worldwide nature of the Web, Digital Truth: Photo Source was created in the United Kingdom. The Web site's open-ing screen is attractive, deceptively simple, and features a table of contents of what's available for reading or download. Even a casual glance at the major sec-tions listed tells you there's a lot of information available for photographers interested in film processing and darkroom technique.

Digital Truth: Photo Source (*www.digitaltruth.com*)
Significant features of the site include *The Massive Dev Chart*, which is purported to be the "world's largest list of development combinations," and who am I to argue with a Web site from the home of *The Guinness Book of World Records?* The development times shown on the chart are primarily oriented toward 35mm camera users and include a combination of data from manufacturers, as well as independent information obtained from the Webmaster's own experience and from other contributors who are listed on the Web site. To find a specific devel-oping time, simply choose your favorite film from a pop-up menu that includes a long list of black-and-white films beginning with Agfa Ortho and ending with several Tura films. After selecting your film, you'll be linked to another page showing charts that list Developer, Film Speed, and Development times for those specific film types. If you prefer, you can download all of the data for every film covered by the chart.

There's tons of photographic darkroom advice to be found in the *Technique and Data Sheet* area, beginning with information on reciprocity failure and filter factors, but also tips on making a Cyanotype along with how to make and use Chromium Intensifier. Darkroom fans will find the formula for Farmer's Reducer—both Subtractive and Proportional—along with instruction for its use. All of the formulas shown in this section contain weights and measures in grams or milliliters, so the Webmaster kindly includes a brief conversion chart for those of us who are not metric-aware.

Digital Truth: Photo Source isn't fancy. There's no color or animations (thankfully) to rob system resources and slow loading on your screen. Instead, you'll find gobs of practical information and links to useful Web sites wrapped around a great-looking design. Occasionally you'll see an advertising banner, but they are few in number and tasteful in size. This simplicity translates into a site that pops on screen when you move from one page to the other or are search-ing for processing information for a specific type of black-and-white film.

Glamour Models on the Web is one of the best Web sites that you can visit on the Internet to find models.

Glamour Photography

Another useful type of Web site is one that includes a database of available free-lance models that is searchable by location and/or model specialty. For example, if you want to find models who are interested in glamour photography and live in a particular state or region, you can use the Web site as a search engine to do just that. Once you have selected the model that seems to have potential, con-tact information is usually listed, as well as a link to the model's own Web site—if there is one. One of the most useful online model databases will be found at Glamour Models on the Web (*www.glamourmodels.com*). Dave Hall, a top glam-our photographer in upstate New York, operates it. What makes his site worth visiting is that he features photographs and online portfolios of more than 200 models who are specifically seeking glamour assignments. He also includes links to dozens of model and photo industry bulletin boards. I have found models this way, and since the Webmaster allows photographers to post their own listings, too, several models have found me! Glamour Models on the Web is a great place to start your search for glamour models online.

Experimental

One of the best characteristics of the Web is that it thrives on creativity. Nowhere is this more true than in sites created by photographers that push the boundaries of traditional imaging.

Ronald Warunek: Fusionist (*www.warunek.com*)

Ronald Warunek calls himself a "fusionist" because his work involves many different disciplines, including drawing, painting, collage, and holography. When you get to his home page, click the section marked "Art, Science, and Technology" to see his holograms. Mr. Warunek divides his holography into two types: Holograms and Holograms Plus. Within the hologram's three-dimensional space, he has stored multiple layers of drawing or collage. Hologram Plus images are constructed in four layers: hologram, transparent painting, lens montage, and mirror. A lens montage is a collection of Fresnel lens cutouts that are "reconstructed upon a mirror." In this system, the visual elements of the artwork are projected into midair as light, within a three-dimensional space. When clicking through the slide show that Mr. Warunek has in this section, you'll see a collection of haunting colorful images that defy easy description.

Other parts of the Web site feature images from his other work, including chemical paintings, transparent painting, and interactive art that appears to be a combination of sculpture and all of the other elements that Mr. Warunek uses for his images. He states that "this body of work incorporates the primary colors of light with the primary colors of pigments, electronic, lenses." With the exception of some NFS (Not for Sale) pieces, all of the images on Mr. Warunek's site are for sale, so you might consider this a gallery Web site, but the Webmaster has stripped away all nonessential elements to focus on the fantastic images themselves.

Nature Photography

There are many nature and wildlife photographer's sites on the World Wide Web and picking one as the best wasn't easy. The one I chose was not selected just because it has great photographs—it has lots of them—but it's also full of information on equipment and techniques that make it a useful resource for nature and wildlife photographers.

Grizzly Bear Nature Photography (*www.grizzlyjhphoto.com*)

Grizzly Bear Nature Photography features the images of John Herbst. John and his wife Cheryl own Grizzly Bear Nature Photography, a stock agency that at the time of this writing had 90,000 original nature and wildlife images on file. The Herbsts live in the Black Hills of South Dakota and photograph bison, prong-

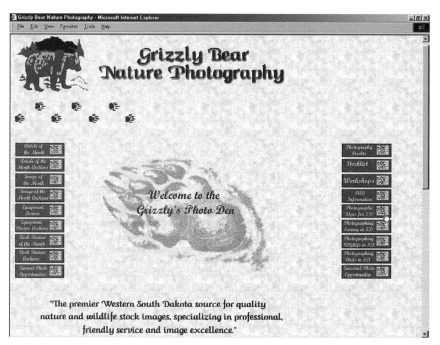

The Home Page of John and Cheryl Herbst's Web site is a gateway to a cornucopia of information that wildlife and nature photographers will find invaluable. Don't miss the animated bear tracks that meander across the top of your screen. © John W. Herbst.

horn, bighorn sheep, prairie dogs, deer, and mountain goats on a daily basis. John told me that "next to Yellowstone Park, we probably have the richest variety of photographable wildlife in the country." They've established their Web site to serve as a resource for nature photographers in general, but even more so for those who venture out to South Dakota for nature photography.

John and Cheryl understand that the best way to create a useful Web site is to update it frequently. They update the site every month, including departments such as Article of the Month, Image of the Month, Book Review of the Month, Equipment Review of the Month, and information on current wildlife and nature photo opportunities in South Dakota. All of the previous months' information is placed in archives for visitors to review whenever they wish. John told me that one visitor commented that their "Web site is a virtual course on wildlife and nature photography," and I think that's a fair statement.

The home page of the site provides a directory for all of the site's eighteen different sections. You'll also see an animated sequence of bear paw prints moving across the screen. The page includes links to many practical resources in Western South Dakota such as a guide to South Dakota State Parks that includes a listing of accommodations that are available in the area.

The Article of the Month section features a story about wildlife photography and, when I last visited, was the fourth part of a series on photographing bighorn sheep. If you missed the first three parts, the previous parts of this story are archived. The text for this story was accompanied by some great and one downright spectacular image of these critters.

Grizzly Bear Nature Photography, like most well-designed sites, has a Frequently Asked Questions section. One difference is that, instead of providing information about the site or computer-related details that you might typically find, Mr. Herbst shares his preferences for equipment and film. You'll also find some trivia. One tasty tidbit answers the question, "Why did you name your company Grizzly Bear Nature Photography?" Mr. Herbst's reply: "Because I wanted to," proving once again that Westerners are, by their nature, people of few words. In this case, the Webmaster lets his images speak for him.

The Webmaster has also taken the trouble to create an archive of these Image of the Month photographs. The size of the images in this section, as well as the rest of the site, are modest but viewable. If you click on an image to copy it, a JavaScript application automatically runs, displaying copyright information and contact—phone and e-mail—for purchasing the rights to use the image.

Anyone interested in nature photography shouldn't miss the three sections on photographing scenery, wildlife, and birds. Landscape photographers will find tips for visiting "undiscovered" areas to create breathtaking landscape images. Specific areas, including Mount Rushmore, have links to Park Service and other sites that provide details on hours of operation, cost, and other information that a traveler might need. While it's easy to take a cliché photograph of Mount Rushmore, I urge anyone who's never been there to visit the park. Movie buffs will enjoy seeing the location where Alfred Hitchcock's *North by Northwest* was set, and all Americans will feel a sense of pride viewing the massive presidential sculptures. Devil's Tower, from *Close Encounters of the Third Kind*, although located in Wyoming, is not too far away.

Bird photographers will also find tips in this small section, but the Wildlife section is comprehensive and includes the where and when to photograph deer, elk, mountain goats, bighorn sheep, bison, and pronghorn antelope. You will also find information on photographing smaller animals such as least chipmunks, thirteen-lined ground squirrels, and black-tailed prairie dogs.

Grizzly Bear Nature Photography is the kind of site that has many nooks and crannies, and you'll be able to spend hours learning from Mr. Herbst's work as well as about what the state of South Dakota has to offer for nature photographers.

Honorable Mention

Pssssssst! Hey, Bunky, wanna get a really good image manipulation program for free? In case you're wondering, I'm not talking about the ubiquitous Mac OS freeware program, NIH Image 1.61, that can be downloaded from *www.share-ware.com* and all of the other usual shareware suspects. NIH sports an interface that only a techie could love, and while its capabilities won't keep the engineers at Adobe Systems up all night worrying, the price is right. Of course, it wasn't really free; our tax dollars supporting the National Institute of Health paid for NIH Image. No, the free image manipulation program I'm talking about can be found on this month's Web Site of the Month, and it carries the politically incorrect title of The GIMP.

The GIMP Home Page (*www.gimp.org/the_gimp.html*)

GIMP (GNU Image Manipulation Program) turns out to be an acronym within an acronym. GNU stand for "GNU's Not UNIX"—I'm not making that up. The GNU General Public License under which The GIMP was released was developed by the Free Software Foundation, and more information about it can be found in the sidebar "It's Gnus to Me" or at the GNU home page (*www.gnu.org/copy-left/gpl.html*).

Written by Peter Mattis and Spencer Kimball, The GIMP is designed for photo retouching, image composition, and image creation. Instead of the Mac OS or Windows environments most of us are familiar with, The GIMP runs under the UNIX or Linux (Linus UNIX, named after its originator Linus Torvalds) operating systems. In case you didn't already know, even Adobe's Photoshop is available in a UNIX version. The GIMP home page contains information about downloading, installing, using, and enhancing the program as well as serving as a distribution point for the latest releases, patches, plug-ins, and scripts. In addition, the site provides information about The GIMP community and related subjects.

You can download the latest version of The GIMP, as well as a developer's version, at FTP download sites shown all over the world from Africa to the United Kingdom. But there's more to this month's Web Site of the Month than just a place to download a really cool graphics program.

The first thing you'll notice is a graphic thermometer that displays all of the sections of the site and allows you to move back and forth between pages instead of using your browser's controls. The first part of The GIMP home page contains an introduction to the program, system requirements, sample screenshots, and basic information about the site's organization. Moving down the "thermome-ter" you'll find complete documentation, including a GIMP User Manual in Adobe's PDF (Portable Document Format.) If you don't already have Acrobat Reader 3.01, which lets you to read PDF files, you can download a copy from *www.adobe.com/supportservice/custsupport/download.html*.

The GIMP supports plug-ins, and the site includes all of the information a developer needs to create what must certainly be a non-Photoshop-compatible plug-in. A Resources page contains the kinds of ancillary files a good image manipulation program needs, including collections of patterns, brushes, gradients, and fonts that can be loaded into The GIMP's tool palettes. In lieu of Actions à la Photoshop, the GIMP uses "scripts," and there are plenty of different ones available for downloading to extend The GIMP's capabilities. Something you won't find in Photoshop, and most other image editing programs, are tool and control palettes that can be truly customized. This part of the site has links to an FTP site where you can download a large collection of interface goodies. The Resource section also offers a collection of fonts, including a selection of free versions of Standard 35 Type 1 PostScript typefaces.

The Web site has a GIMP Art section featuring a gallery of artwork created with the program, a Script of the Month section, a semimonthly contest for the GIMP-produced artwork, and a collection of "Made by GIMP" logos, including Larry Ewing's famous Linux penguin along with a link to Larry's Penguin Page for details on how it was created. The penguin—and this penguin in particular—are widely associated with the Linux movement and have become, in fact, its mascot.

It's Gnus to Me

The GNU General Public License applies to most of the Free Software Foundation's software and any other program whose authors commit to using it. The Foundation's General Public License is designed to make sure that software developers can distribute copies of free software (or charge for this service if they wish), that they receive source code, and that users are allowed to change the software or use pieces of it in new, free programs. To protect the rights of the original creators, the Foundation's restrictions forbid anyone from denying these rights. If you distribute copies of the software or modify it, these restrictions incur certain responsibilities. If you distribute copies of a program, whether gratis or for a fee, you must give the recipients all of the rights you have and declare these terms so the recipients know their rights too. The Free Software Foundation protects rights in two ways: They copyright the software and offer a license giving people the legal permission to copy, distribute, or modify that software. For each author's protection, they make certain that everyone understands that there is no warranty for this free software. If the software is modified by someone else and passed on, they want its future recipients to know that what they have is not the original, so problems introduced by others will not reflect on the original author's reputation.

Finally, there's the Important Links section offering many different hyper-links to GIMP-related sites, including: a mammoth Plug-in Registry, which is the place to check for the latest GIMP Plug-ins; Everybody Loves the GIMP; and a Frequently Asked Question site (*www.rru.com/~meo/gimp*). Also included are links to galleries, Web sites that discuss image file formats, and even links to home pages about *other* image manipulation programs. What's nice about this page is that the Webmaster has written a brief summary for every link so you don't have to waste time surfing over to something that might not be exactly what you thought it would be.

There are always some caveats with any open source program like The GIMP. For example, if you take the time to read the GIMP Compilation and Installation section of the Web site, you may be surprised to learn that you need to have a C compiler and related tools to compile and install the source package. The pro-gram also makes use of the GIMP Toolkit or GTK that can also be downloaded from the site. If all this downloading and compiling doesn't appeal to you, visit one of the "Important Links" at the WilberWorks home page (*www.wilber-works.com*). This company offers a commercial version of the GIMP bundled with an assortment of useful fonts, patterns, and brushes, along with online docu-mentation for just $15 plus $3 shipping. Wilber, by the way, is the name of the fox-like critter that is The GIMP's mascot.

National Association of Photoshop Professionals (*www.photoshopuser.com*)

Whenever working with Adobe Photoshop, I'm often reminded of what my friend Carl Milner said the first time he saw the program. "This isn't software," he exclaimed, "it's a life's work." There are so many nooks and crannies in the program that I'm constantly finding new ones. Whether you work or play with Adobe Photoshop, I suggest that one of the best ways to maximize your knowl-edge and enjoyment of the program is by becoming a member of the National Association of Photoshop Professionals (NAPP).

Their bimonthly publication *Photoshop User* itself is worth the $99 cost of membership. NAPP has a members-only Web site called Photoshop Online, which provides discussion groups, live chats, tips and techniques, and downloads of plug-ins and Actions. I recently downloaded a Photoshop Action called Shadow Lifter that's designed to soften and lighten shadows in digital images. It bailed me out when I was working with some troublesome photo CD scans of over-developed film and not only fixed some of my lighting problems but did an amaz-ing job of minimizing grain as well.

If you have questions or problems, a NAPP Photoshop Help Desk is available to help members get straight answers to vexing Photoshop problems. Membership entitles you to discounts from several prominent mail-order hard-ware and software dealers. The organization sponsors an annual Photoshop

World convention that's a great place to attend seminars and visit trade show booths full of products that are of special interest to digital imagers.

Webzines

Webzines or e-zines—call them what you will—are never going to replace *Playboy*, *Fortune*, or even the *Brighton Standard-Blade* any time soon. You can't take an e-zine to the bathroom with you, and if you fall asleep under your laptop while reading the latest monkeyshines in *Primates Monthly* on the World Wide Web, you're liable to wake up with some dents in your physiognomy.

Nevertheless, Webzines offer many advantages over a conventional paper-bound publication. First, there is immediacy. Late-breaking changes in a new standard—like the introduction of the Advanced Photo System—can be rapidly updated depending on the latest information and rumors, without waiting the two or three months a print deadline normally imposes. Multimedia is another advantage. Digital video clips can show a camcorder's performance, and being able to download a digital camera's output will let you evaluate the camera's performance on your own computer's screen. Webzines are interactive. Readers can immediately respond to an author or editor directly, with no stamps to lick. E-zines are cool. That should be enough for most high-tech-oriented photographers to check them out. Lastly, Webzines are here to stay.

ZoneZero (www.zonezero.com)

ZoneZero is a combination of the traditional photographic magazine with the best of interactive technology that the World Wide Web allows. The e-zine takes its name from Ansel Adams's famous "Zone System" analog darkroom process. *ZoneZero*'s aim is to explore photography's "transition from analog to digital image making," according the Pedro Meyer, the e-zine's editor. Based in Los Angeles, *ZoneZero* offers a truly diverse set of contributors, with photographers and essayists hailing from over thirty-two countries, including Mexico, Argentina, Spain, Great Britain, Israel, and the United States.

ZoneZero's basic appeal is shared by other Webzines: There is no waiting for monthly issues. The editor and staff post new information—in English or Spanish, according to your choice—as it comes their way. One of my favorite aspects of this e-zine is that it offers multiple points of view. *ZoneZero* provides a photography forum and chat room, a gallery, current reviews of new books and technology, and even a page that guides viewers through the calibration of their monitors. There's a direct feedback channel via an e-mail system that allows readers to leave messages for the writers and editors. With nearly 4 million hits per month, *ZoneZero* is one of the most popular photography sites on the Web.

PhotoBetty (www.photobetty.com)

Female readers might want to bookmark *www.photobetty.com*, "the e-zine for the woman photographer." The name of this site always seems to bring a smile to people's faces when I mention it, and when you visit this site you'll see a graphic of Betty herself, Leica rangefinder camera in hand. That's not to say that male photographers and surfers won't find something of interest. The site features the work of many contemporary and historic female photographers, including Diane Arbus and Julia Margaret Cameron in its Before You section.

Today's women photographers are featured through work including (the last time I visited) dramatic color images from the Balkan conflict made by Ami Vitale and the haunting color photographs of dolls' heads made by Kristine Bailey. Being able to appreciate these photographers' work is helped by the display of images in a format large enough for us to appreciate when they appear on a 17-inch monitor, and by providing information about the photographer. There's even the work of one man, Robert Croslin, currently featured on the site. Mr. Croslin documented the preparation for and the birth of his daughter Emily. His black-and-white documentary images range from a nude image of his wife Leslie to a heartstring-tugging portrait of their baby at one week old.

The "Singles" section features individual images from photographers such as Maura Lanahan, Martha Rial, and Veronique Poulin, whose black-and-white image of a dancer was both stunning and inventive. None of the work appearing here can be pigeonholed into what some might consider images made by female photographers. The work speaks for itself.

There is more than photographs here. The In Charge section includes interviews with Tarhra Makinson-Sander, who talks about what it was like to be director of the 1999 Women in Photojournalism conference. A link (*http://metalab. unc.edu/nppa/women/1999/info.html*) is provided in case you want more information about the event. In the recent edition of the e-zine, there's an interview with Frannie Rauch, former art director at *Glamour* magazine. Other interviews include one with Robin Daughtridge, chief photographer at the *Chicago Tribune*.

PhotoBetty is the model of what an e-zine should be and is focused on a single topic—the work of female photographers. But it is not exclusionary. The photographs are plentiful and are well displayed, and all of the navigational tools are easy to use. Interviews add to the visual insights provided by the photographers, and historical context is provided as well.

Nature Photographers (www.naturephotographers.net)

John Herbst, whose Grizzly Bear Nature Photography is featured earlier in this chapter, suggested I give this site a look. This Webzine is dedicated to nature and wildlife photography and features the work of Charles Glatzer, Jim Erhardt, and

a team of dedicated nature photographers. The site went online on March 18, 2000, and had 45,000 hits during its first week. No wonder. It features a clean, attractive design that's easy to look at and loads fast, even on my slow, free Internet access connection. You can submit your own images to the site, and their Reader's Gallery displays some impressive images. An equipment section features hardware tips as well as a forum where visitors can express their views on the photographs that are on view or exchange nature photography tips. Nature and wildlife photographers shouldn't miss this one.

Data Storage: No Media Required

The World Wide Web is changing the way that everybody—including photographers—work. It has also created new concepts, such as "Internet time," which, much like "dog years," amplifies the passing of time. A week of Internet time is more like two months. The overnight services that were pioneered by FedEx have been replaced by requests from client asking "can you e-mail that image to me, now!" One of the problems with some e-mail systems is that gateways can choke when files larger than 2MB are attached to a message. Having your file crash a client's computer is no way to build a long-lasting relationship. One way to overcome this problem is by using online data storage.

The concept of online storage is simple: Instead of saving a file on your hard disk, you save it on *somebody else's* and can access that file online whenever you need it. If you have a large photographic file that a client needs right now, you can e-mail him a URL on the World Wide Web, where he can download the file. With echoes of the "Love Bug" virus still ringing in people's ears (and their computers) as I write this, sending a URL instead of a file shows your clients that you are also sensitive to their security needs. Some online storage services are free, and some charge modest fees. Generally, the more storage you get, the more likely you are to pay a fee. Some services, such as Magic Floppy, provide 25MB of storage free and charge for additional space. This kind of service is ideal for photographers using the new generation of floppy-drive-less computers from Apple and Sony. While on the road you can upload information to an online service, and either someone in your office can download it right away or you can retrieve it when you return.

The Magic Floppy

The Magic Floppy Web site (*www.magicfloppy.com*) provides remote virtual storage facilities via the Internet for computer users. Once you've opened an account with Magic Floppy, you may access and use the features of the system to upload files into the storage area and download or retrieve your files from their system.

The Magic Floppy Web site provides remote virtual storage facilities via the Internet for personal computer users.

In order to provide additional security that is under your direct control, you can encrypt files before storing them on Magic Floppy's system. If your account is inactive for more than twelve months, they may move files to offline storage or even delete files, so if you plan to use the system, *use the system*. Magic Floppy's policy is that it will not charge for up to 25MB of storage, although their agreement states "10MB," and they reserve the right to charge for upgrade services, particularly enhanced file handling features or extra storage space. Since I anticipate getting a floppy-drive-less iBook notebook computer, I set up a Magic Floppy account. The registration process asks for basic data such as name, address, phone number, and e-mail address. Those screen printers that have privacy concerns should know that such information is already online in many places, including *www.switchboard.com*.

Backing Up Is Easier To Do

More than 90 percent of computer users have lost data from systems failure, and nineteen out of twenty users lose data each year. Yet only one-third of them

@Backup (*www.backup.com*) is an online data storage service for Windows users that remembers to back up and protect your files every day, so you don't have to think about it.

bother to back up at all! Among the many excuses that people have for not backing up their work is that they don't have the software and don't have the hardware. You don't have any more excuses! @Backup (*www.backup.com*) is an online service for Windows users that remembers to back up and protect your files every day, so you don't even have to think about it. The service features automatic and custom backup schedules so that you can protect your data when you want it protected, and the schedule can be customized to fit your studio's operation.

One of the advantages of using an online backup system is that you have access to your files from anywhere through any Web-enabled PC. If you're away from your shop computer and need a file that's backed up with @Backup, you can access it from any browser software. If you need to get to a file that may have been deleted a few weeks ago, @Backup offers multiple file-version archiving so you can access and restore your files online from up to a ninety-day archive of previous backups. If you're worried about security, @Backup's data compression, encryption, and storage technologies are designed to protect your valuable customer data files. Using @Backup's File Selection Wizard you can find your most

important files—all you need to do is click on your applications and @Backup becomes part of your Windows desktop. A File Selection Wizard will automatically protect and backup data files from applications such as Quicken, TurboTax, and Microsoft Word, Excel, or PowerPoint.

Online Storage for Photographers

MediaDepot (*www.mediadepot.com*) is a service that recognizes that the online storage requirements for graphics professionals, such as photographers, is different from the requirements of other types of businesses. MediaDepot provides its clients with the ability to create private communities, with the sole purpose of sharing content across multiple locations and platforms. It's the first content management service that incorporates version control, an audit trail, and even offers an insurance policy backed by Lloyd's of London, that allows creative professionals to store, share, and manage intellectual property in a secure environment. Anyone with a Web browser and an Internet connection can use MediaDepot. Photographers can store image files in a centralized repository that

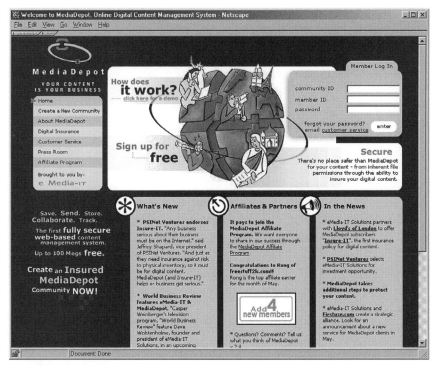

MediaDepot (*www.mediadepot.com*) provides its users with the ability to create private communities, with the sole purpose of sharing graphic image files across multiple locations and platforms.

can be accessed by them or their customers. MediaDepot supplies up to 100MB of storage at no cost. To protect your photographs from unauthorized access and theft, MediaDepot offers a secure sign-in/sign-out procedure that ensures that only authorized persons can access your content. As the owner of a file, you get to decide who has access to that file and what type of access they have.

What all of these services offer is off-site, secure storage of data that can be accessed when you're not in the office or studio. Most important, you can use it as an off-site archive. If a disaster were to strike your computer, all of your important files could be safely downloaded later—even onto another machine. Visit all of these Web sites and take a look at what they have to offer your studio.

Promoting Yourself on the Web

Pizza delivered in 30 minutes or take two bucks off.

Domino's Pizza

6

7

8

9

10

11

12

13

If you're wondering what pizza has to do with photography, read
on . . .

One of the most important aspects of creating your own Web
site is its marketing potential, as it allows you to display your work
to the computer-using world—and that's just about everybody. The
Web can be used for image and product marketing, but how you
design your Web site can have a bearing on how it achieves either
of these goals.

Conventional wisdom has it that the WWW's greatest asset is
its ability to market your image, and for some photographers that
may be enough. It's easy enough to include your Web site on your
business card and casually mention to potential clients that they
should "drop by my Web site and take a look at [their hot but-
ton] images that are displayed there." The reality is that they may
never look at your macro images of the Panamanian Water
Moth, but the mere mention that you are *au courant* enough to
have a home page on the World Wide Web may improve your
chances of getting an assignment. On the other hand, don't
expect an Art Director *not* to ask to see a conventional port-

Clients Looking for Stock Images?

Hindsight's (*www.hindsightltd.com*) SearchLynx image search engine will help. Visitors to your Web site can search for images by keywords. and when images matching their criteria are located, SearchLynx displays the images along with captions and serial numbers. The page design is under the control of the Webmaster site owner. The latest version of SearchLynx enhances the design capabilities, but it also allows everything to be translated to any preferred format or even to another language. If they need the site to be in Portuguese, every button, link, and dialog can be translated. There are even ways to configure a multilanguage site. A demo of the program can be viewed on the company's Web site.

Hindsight's Web site (*www.hindsightltd.com*) has a section that lets you see how it's SearchLynx search engine works under a real world test. You can enter a keyword to do a search and see what's displayed.

folio before an assignment is given. So if you're going to use the Web as a sales tool you have to be sure your design includes several important functions.

It must be an uncomplicated process. As Pizza Hut found out—the hard way—people don't want to order pizza by using a computer. The same is true for most commercial photography assignments. Although existing clients may use e-mail to communicate, don't expect too many assignments to come in electronically. Just like a person who's hungry for a pizza, they want the instant response of talking with a photographer and going over the details of the assignment—including getting an estimate—before the assignment is given.

On the other hand, a properly designed Web site is the perfect way for a client to find the exact stock photos they are looking for. And the best part is that the client does the searching, not you. As FedEx discovered with their Web site, people are more than happy to use the Internet—at their own expense—to check on when a package is delivered and who signed for it. The same is true for someone looking for a photograph of dinosaur bones. Let them do the searching on your Web site. They could, for example, download an FPO (For Position Only) copy and leave you a message to send the original transparency so they can download a useable version of the image—after supplying a credit card, P.O., or similar payment information.

Finally, you must be able to measure the results. The simplest measurement is the use of the "hit meter" you often see on Web sites. This can be impressive to the client who discovers that she is the 16,435th person to visit your site, but it will be far less impressive if she is the 3rd. A far less glamorous method is simply to ask people if they called you as a result of visiting your Web site.

An Online Brochure?

That's what a home page is, all right: an electronic version of the same kind of print-oriented material you've been showing and mailing to clients and prospective clients. As the late Don Petersen never got tired of reminding photographers, "You never get a second chance to make a good first impression," so it is with your home page. That's because it is the first page that potential photo buyers will see on your Web site. You can also think of your Web site as an electronic storefront or store window. The home page is your welcome mat; it says welcome to my site—my studio.

A well-designed home page typically contains a table of contents or a summary of the kind of information that anybody visiting your site will find. This listing can be as simple or as complex as your operation is. If you sell assignment photography, you want to show the breadth of the work you do, including any specialties, such as underwater, architectural, or aerial. If you do on-location executive portraits, include a section on that too. In other words, a Web site is

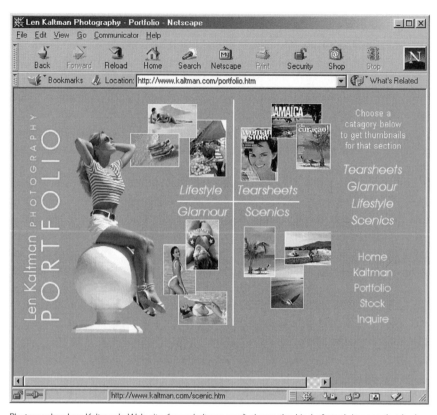

Photographer Len Kaltman's Web site (*www.kaltman.com*) shows the kind of stock images that he has available. © Len Kaltman

a reflection of all of the kinds of assignments that you do—or want to do. There is no rule stating that your Web site cannot be used to promote an activity of your studio that you want to increase. If you want to move your operation from assignment-based to stock photography, focus the Web site on the kind of stock images you have and be prepared to show samples.

If you're concerned about digital theft, how to deter someone from stealing your images will be covered later in the book. I would also recommend that stock shooters include a little blurb (or even an image or two) that says, "Oh, by the way, I do assignments, too." You still have to make a living and pay the bills, so never miss a chance to plug your bread-and-butter work.

Promoting and Selling Your Images

A home page on the World Wide Web has many advantages over a conventional laminated print portfolio or four-color promotional piece.

First, a Web site is much less expensive to change and update than conventional, nonelectronic media. Four-color printing is expensive, and if you order 5,000 brochures, it may take some time to distribute all of them. By the time you're down to brochure number 4,989, you've probable created even better images than the ones that are pictured on the brochure. Changing the images on a Web site is a matter of scanning the new images (or having someone do it for you) and posting them on your home page. And have you checked the prices for having a custom print made and laminated?

Second, you only need one Web site. There's no need to print 5,000 brochures or to have duplicate portfolios made so you can ship the images to several different places at the same time. A single Web site will be accessible to thousands of photo buyers around the country—even around the world.

Before you construct a Web site, you need first to establish the parameters for the site—what you hope to accomplish and how you intend to accomplish it. Without clear goals, a Web site will be just as wasted as a brochure that's full of pretty pictures but doesn't ask for the sale. Here are a few ideas on ways to establish the content and orientation of a Web site.

Stock Photography

When photographers tell me that it's too complicated for them to produce a Web site I tell them four words: "Picture of the Month."

One of the simplest ideas for stock photographers is the "picture of the month" concept. This type of home page can consist of a simple photograph along with some basic information about the image along with some contact information—including e-mail address—for the photographer.

This kind of home page has two advantages. Since it contains a single image, the Web site is easy to set up and maintain. Because it is easy to set up and maintain, the images can be changed on a regular basis, allowing you always to have something fresh for potential buyers to see. If you have several fields of concentration, I would suggest you use a "picture of the week" concept and feature each specialty once a week.

A variation of this theme is to add a few additional pages to your Web site, allowing you to archive previous pictures of the week (or month) so that you can tell buyers, "Oh, you want a ski shot? That was my picture of the week on October 2nd." That way they can go to your archive section and easily find the image you told them about. Make sure you advertise the fact that your Web site has a featured picture that changes regularly and include that information on your business card, letterhead, source book ad, and any verbal communication you have with potential photo buyers.

Photographic Assignments

Assignment photographers will need to have a little more depth of information in their Web site than average stock shooters, who tend to be more specialized.

You remember how it goes: the Art Director says, "I *know* you can photograph right-handed baseball players, but can you photograph *left-handed* ones?" An unfortunate reality of this business is that you are constantly having to prove (or reprove) yourself to potential photo buyers that you can produce—and have already made—images just like the one they need right now. Therefore, assignment shooters' Web sites should reflect the kinds of images that may already be appearing in their ads in source books or their laminated portfolio; it's even possible to combine both in a well-designed Web site. That means more images—a striking example in each of the photographer's specialties.

The danger here is that trying to include so many images means a greater number of smaller images, which diminishes the effect. You might be better with a few images on the first page that occasionally change, along with a listing of your specialties, such as food or architecture. Surfers would then click a button to go to another section of your Web site to find examples of images along with tear sheets and lists of awards won for particular images. Caution is needed to keep from overdoing it—as my mentor, Eddie Bafford, used to say, "You need someone in the darkroom with you with a two-by-four to hit you upside your head" when you get too carried away with an effect. The same kind of restraint is called for in a studio that is involved in many disciplines, such as portrait photographers who do weddings, families, and high school seniors.

Fine Arts

What the fine art photographer's Web site needs is in many ways similar to the needs of the stock shooter's site. The images they sell are those that have already been created. Unlike the assignment shooter who is always pitching her next shoot, the fine art image-maker is selling photographs that have already been created. A Web site can be an extension of an existing print brochure or can even be a replacement for it, since color JPEG images are less expensive to produce than four-color separations. A good way to establish a home page for the fine art photographer is the "picture of the week/month" concept. One of the differences in this home page is that galleries and art purchasers are often interested in a photographer's background and pedigree, so there should be an extensive section on degrees and awards so that a potential buyer knows they are getting "the good stuff." This kind of home page should feature elegant simplicity, such as you can find at Steve Jordan's *www.mohonkimages.com*.

One of the advantages that fine art photographers have (although the idea can be used by *any* photographer) is that the site can be turned into a real store,

Security Issues for Online Retailers

If you are going to sell photographic items, such as cards and posters, and take credit card numbers from your customers, you are going to need a "secure server." This is a Web server that supports any of the major security standards, such as SSL (Secure Sockets Layer). These servers will encrypt and decrypt messages to protect them from tampering by hackers and other misanthropes. Being able to make a purchase from a secure Web server ensures that a potential purchaser's payment or credit card information will be translated into a code that is difficult for unauthorized individuals to access. There are companies, such as I Transact (*www.itransact.com*), that can provide this kind of service and even provide credit card authorizations.

just like brick and mortar galleries. You can sell framed or unframed prints, or smaller impulse items such as note cards, greeting cards, and posters.

Photographic Products

In addition to your photographic services, you may also produce a product or service that photographers or others might use. A Web site provides a continuation of your customer service operations, especially if you produce software for studio management or something similar. Updates can be posted on the Web site, so that users can download upgrades to their software without having to call your studio or office. The other side of the coin: A home page can save you the cost of creating a disk and mailing it to your customers when changes or bug fixes are made. It's also a great place to place a Frequently Asked Questions section that minimizes the amount of hand-holding you need to provide and that, unlike typical customer support, is available twenty-four-hours a day, seven days a week. If your product is a more traditional commodity, such as camera bags, you can still use the Internet.

Take Lightware (*www.Lightwareinc.com*), for example. Created by photographer Paul Peregrine, Lightware equipment cases have been called by some the finest soft cases available in the world, and my personal experience bears this out. Lightware's Web site provides an online version of a product catalog listing all of the airline shippable cases that the company makes, including multi-format camera cases, backpacks, portfolios, and cases for all kind of lighting equipment and the necessary accessories. Lightware also has a section called "Seconds Online," which offers items that sometimes have microscopic cosmetic imperfections that do not affect how the case or pouch functions. These are offered at substantial discounts, making Lightware a great place to find bargains.

Lightware Inc.'s Web site (*www.Lightwareinc.com*) has all of the detailed product information that a surfer needs when shopping for one of these superb equipment cases.

There's More to Come

Yes, there's a little more to the promotion of your Web site. This chapter provided information on getting ready to produce your Web site. In the next chapter you will see how easy it is to actually build a home page. Chapter 9, after a chapter on photographers online, will get back to promotional information for your new Web site.

Build a Home Page

The time has come, the Walrus said, to talk of many things.

<div align="right">Lewis Carroll</div>

7

8

9

10

11

12

13

14

Just as there is more than one way to create an image on the World Wide Web, there is more than one way to create a Web site. The actual mechanics of creating a site from scratch are beyond the space available in this chapter, but I'll try to introduce you to some of the tools and techniques that you will need to build a site or to have someone else do it for you.

Home Page Basics

The World Wide Web is really a collection—a big one—of Web sites that are stored on computers, called Web servers, that contain many different home pages and that respond to requests for information from browser software. Web sites are really collections of Web pages—individual files that make up a Web site. The pages within a Web site are linked together so that surfers can move easily between them, often in a nonlinear fashion.

A Web site consists of several parts: A home page is the launching point for any Web site. You can consider it the table of contents, because it lists the various items or images that

can be found at the site. The glue that holds all this together is HyperText Markup Language (HTML), a computer language that enables Web surfers to move between Web sites by selecting (clicking) on links. The ability to link one Web site to another is one of the reasons it is called a Web. HTML is a simple, yet powerful programming language that allows you to structure your Web site to include such items as:

- Links to other Web sites, perhaps a book publisher that offers some of your books for sale, such as Allworth Press at *www.allworth.com*. Even if you haven't published any books, you might want to provide a link to *www.amazon.com* or *www.barnesandnoble.com*. Later in this chapter I will give you a good reason for doing this. Hint: You can make a few bucks.
- Links to other Web pages (within or outside your Web site) or even to a specific element within a page. For example, a click-on link can provide a large version of a thumbnail-sized image that is displayed on one of your Web pages.
- Structural elements, such as (pricing) tables or (client) lists.
- Graphic elements, like photographs.
- Common Gateway Interface (CGI) scripts are programs that run on a Web server to process all this activity and extend the capabilities of the server. Browser software enables computer users to view your home page.

Do It Yourself?

These days, most photographers send their film and printing out to professional labs for printing and processing. Some photographers keep the photographic version of a hospital's "stat lab" for rush prints, but readers of my book *Re-engineering the Photo Studio* may be doing these digitally, using inkjet or dye-sublimation printers. Not all professional photographers maintain their own fully-staffed labs that can deliver transparencies or prints to clients. The point of all this is that you don't have to produce your own Web site; there are many graphics professionals that are ready and willing to do it for you—for a price. So here are a few reasons that you might want to farm out the construction of your first or next Web site:

1. **Time.** The reason that you send your film to the lab instead of processing it is that it takes time and money to process film properly, and your lab is better equipped to do a good, consistent job than you might be. They will even stay open late at night, for an extra fee, to process your rush jobs, while you sleep contentedly at home. Many photographers still don't realize that they make more money when they make more images and that they should use whatever outside suppliers necessary to increase their productivity and profitability.

2. ***The Procrastination Syndrome.*** Many photographers are perfectionists, and for that reason they prefer to process their own film and prints as well as build their own Web sites. I have a friend who is a talented photographer who spent almost three years working on his site. Part of it was a lack of time—he was busy making money making photographs—but part of it was that he was making the site as perfect as it could be. How much money in lost assignments and lost sales did he lose over those years while building this site? My guess is that it cost him more than he would spend, but in the early days of the Web, many photographers felt they had to build their own sites—it was a point of honor. Today, a Web site is not the ego trip it might have been, and as a business necessity, you need to have it constructed.

3. ***Value.*** Many times the people building your site will also host it (more on that later) and toss in some goodies, like a bunch of free e-mail addresses that you can use. If you do both stock and fine art photography, you can have an e-mail address such as *stock@yoursite.com* or *info @yoursite.com*. That later address is a typical one that you will find on many Web sites as a way of finding out more information from the company whose Web site they are visiting.

4. ***Updates.*** This is not a one-time deal. A Web site is more like a daily newspaper than a brochure. If you don't update it periodically, visits will drop and render your Web site useless in generating sales. The typical conversion rate (from surfers to buyers) for Web sites is about 3 to 4 percent. Although this is twice as good as direct mail, if you only get ten visitors a month, that translates into no sales.

Nevertheless, I recognize that many of you readers want to do it yourselves, and I don't want to discourage you. By using some of the software that I will introduce you to later in this chapter, it's not difficult to create your own Web site—but remember that updating it at least once a month is necessary to keep the site profitable.

Get Ready

There's an old cliché that states, "Prior planning prevents poor performance." That's just as true for Web-site design as it is for the rest of your photographic activities. Keep in mind that these steps—including the construction of the Web site itself—can be undertaken before you even get online or contract with an Internet Service Provider to host the site, so you have few excuses for putting off getting started.

Register Your Domain Name

There are several inexpensive and even free ways to have a Web site. Many ISPs will provide you with free space to store the pages. My guess is that they offer this knowing that only a small percentage of users will actually take advantage of this service. The problem with these free or inexpensive sites is that you can end up with a URL that reads like: *www.hyperzine.com/writers/joef.html*. That is the address of my very first Web site, and it may still be up when you read this. (If so, go and take a peek.) It doesn't exactly roll off your tongue, does it? How much better it would be to tell potential clients that the URL is *www. joefarace.com*. If they remember your name, they'll remember your Web site address. Don't forget to put the URL on your business card. A photographer gave me a card the other day. It was impressive and included a photograph of him in his elegant studio, but his zip code was missing. He also lacked an e-mail address (even though there's plenty of free e-mail out there) and a Web site address.

The Internet Corporation for Assigned Names and Numbers (*www.icann .org*) is a nonprofit, technical coordination body for the Internet—specifically for domain names. It's a private sector corporation that represents a coalition of the Internet's business, technical, academic, and user communities to coordinate the assignment of domain names and IP address numbers, among other details. If you want to register your Internet domain name, the first step is to go to ICANN's Web site and find a list of accredited registrars. You can contact any of these companies that, for a fee of approximately $75 for two years, will give you your own unique domain name. The name must be renewed after those first two years or else it falls into availability to anyone else. Before you do anything, register your own domain name. Pick a unique name such as your own or your studio's, but if you use a studio name, there's a good chance it may already be gone. Some Web-site designers and hosting services will even register your domain name for you; that's what they did for me.

Storyboard It First!

Don't let the word "storyboard" scare you. All you really need is a visual plan of what will be on each page of your Web site. After you get your domain name registered, and maybe even before, it's time to make a list about what will be on your Web site. When I talk with Web-site designers, the number one thing that they tell me is that their clients do not know what they want to do with the site.

Start by taking out a blank sheet of paper and use a pencil (easy to make changes) to make a list of the kinds of things, besides the obvious photographs, that you want to include in your site. The Home Page Basics section earlier in the chapter includes some broad ideas of what you might include, but let's get specific.

Domain Bank is one of the ICANN Accredited Registrar sites that you can use to search for and see if your preferred domain name is available. You can reach it and others from the ICANN Web site (*www.icann.org*).

Bio

Most photographers don't seem to have a short biographical sketch or a recent photograph of themselves. You're going to need both for your new Web site. Don't be overly modest about your achievements, and make sure that your potential clients know about you and what you've done. New and aspiring professionals still have their educational backgrounds to talk about and can always provide information on the kind of work they like to do and who their mentors and influences were—even if their clients may not know who Edward L. Bafford was.

A portrait is important because clients want to know what kind of person you are, and the right kind of portrait can be a prime marketing asset. You can always have a photograph made of you at work, or just ask a photographer-friend to make one. My most recent portrait was made by Brad Mikel while I was photographing a model in his outdoor studio. Brad wanted to test a new digital camera. The model was taking too long, so he photographed me!

Contact Information

Every page on your Web site should have your name, address, phone, and fax number so people can contact you. Make it easy on them and provide an e-mail link that will pop up the e-mail software that's part of their browser.

A Gallery

Or maybe more than one. The Galley section of the site works no matter if you are a commercial, stock, or fine arts photographer. (The next section will cover tips on preparing image files for the Internet.) You might have separate galleries for each of your specialties or different aspects of your work. You can have large images or small thumbnails that surfers can click to see the image in a larger size. It's right about here that the hackles on some photographer's neck start standing up as they imagine the possibility of theft. This subject is covered in detail in the final chapter.

The Storefront

Consider doing some e-commerce here. Many photographers, including both commercial and fine arts practitioners, offer something for sale. This can be as simple as posters or note cards or as elaborate as framed and matted prints. What's the point of having a gallery if you can't make a sale or two? If you conduct photographic workshops, this is the place to provide details that show some sample images and provide a way for potential workshop attendees to sign up.

If all this seems like too much work, consider becoming an Associate of *Amazon.com* or *Barnesandnoble.com*. Even if you haven't written a book, you can offer books on subjects that visitors of your site might enjoy. In association with *Amazon.com*, Dave Hall's Glamour Models on the Web (*www.glamourmodels .com*) has a section that features books on glamour photography that will be of interest to anyone visiting his site. If you've contributed image or text to books, make sure they are represented here. When you have a "books" section via an Associate arrangement, all you have to do is provide the space on your site; the bookseller takes the order through a click-through arrangement, collects the money, ships the book, and then sends you a monthly commission check. Check each online bookstore's Web site for information on joining its associate program.

Whatever you do, use the space well. Len Kaltman uses one of his Web sites (*www.glamourportfolios.com*) to find new glamour models, and he recently told me that the Internet has become his major source of new models. He provides a Model Search area that lets potential models fill out an online form that contains the kind of information that most photographers use for casting.

The point of the Web site is to have it do many things—without looking like it. That's the advantage of HyperText linking. A stock photography buyer may be

interested in looking for a skiing shot for a magazine ad, and while he may skip your model search, he might decide to click on your storefront icon, finding a item he can give as a gift. Ka-ching! That's the sound of e-commerce, and a well-designed site that integrates sales can be not only self-supporting but can also be a profit center for your studio. In the next chapter, you will see how some photographers have constructed their own Web sites, which may help you see some alternative ways of doing things not covered in this chapter.

The Photographs

Once you have a gallery planned, the next step is deciding what images you want to display. The photographs that you decide to use will have an effect on both the site's design and text content.

Here's a bit of advice: Make the first page of your home page contain a single, signature image, perhaps with bits and pieces of other images used as design elements. If you've been around for a while, you know what images clients respond to positively, so the decision is not too complex. If you're a newcomer, don't ask your family and friends which images to include; they know you too well and don't want to hurt your feelings. Try asking the manager of your local color lab which photographs he or she thinks would catch a potential buyer's eye. Lastly, use your own gut feelings about which images you want to display. Remember that the images shown can reflect the kind of work you want to do, not just what you have been doing. This may require that you shoot some of this work on spec or for free to accumulate the images.

After the images have been selected, you need to have them digitized. If you have a film or flatbed scanner, you can do it yourself; otherwise, have them digitized by Kodak's Photo CD or Pro Photo CD process. The cost of having the images placed on a CD-ROM are modest, and you will be able to use the digital images to prepare marketing materials and other means of visual communications; so the cost of producing the disc will be spread over more than one application.

The next step is to prepare the images for use on the Web. There are two approaches. First, using Adobe Photoshop (or whatever your favorite image editing program is), open the Photo CD images and size them to match your Web site, keeping in mind how many images can be viewed on a 15" or 17" monitor at one time. Second, since Photo CD images come in groups of five (six if you're using Pro Photo CD), you can select one—I suggest you start with the Base size—to use for your Web site. A Base image, with a file size of 1 MB, has a resolution of 300 dots per inch (dpi), contains 512×768 pixels, and measures 2.56" × 1.707" in size. If that's too small for you, go up to the next size—4Base. This image size is 5.12" × 3.413" and has a file size of 4.5 MB. This is probably too

large, but you can resize—and lower the resolution—to make it fit your Web site.

Once your images have been selected, you need to optimize them for the Web. To do this, you'll need some kind of image enhancement program. (You can always use images in the sizes that Photo CD provides, but as you will see, tweaking them will help users access the site more easily.)

1. Use the Image Size command to make the image the size you want. This only has to be a ballpark size, since most wysiwyg (literally, What You See Is What You Get, meaning that on-screen visuals will not change when printed) Web tools allow some limited control over image size.

2. Next, change the image's resolution to 72 dpi. Since these images will be viewed on screen, saving them in any other resolution means the file will be larger, which translates into taking longer to display on screen—without improvement over a 300 dpi image. Smaller files load faster, which prevents any potential surfer from getting bored and clicking her browser's Stop button.

3. Next, save the image file in some form of compressed format. (Remember, I talked about Web formats at the beginning of the book.) This can be GIF, JPEG, or PNG. One photographer told me that he switched from JPEG to GIF for images on his Web site because they loaded faster, but a 150K file—in any format—is going to take the same amount of time to load. Your choices of format may be determined by the software you are using. If you don't have an image enhancement program, look into a file translation program such as DeBabelizer (Mac OS) or DeBabelizer Pro for Windows. Both will allow you to adjust resolution and save in one or more of the above formats, and DeBabelizer will let you adjust image size as well.

JPEG or GIF?

Among Web designers there is some controversy over which graphic file type— JPEG or GIF—is the best to use on the Internet. Like everything else in digital imaging, there are trade-offs when making a decision about which file format will work best. A GIF file, for example, works best when there are a few colors in the image. If your photograph contains less that sixty-four colors, a GIF will be smaller than an equivalent JPEG file. If your site has a hand-drawn illustration, like a caricature of you, chances are it uses less than 256 colors, making it a great candidate for GIF-dom. If you're using navigational buttons on your Web site, they also probably contain only a few colors, so the GIF format would be a good choice for them. The same holds true if you're using splashes of color. Most of these decorative files contain only a few pixels and use very few colors. Because JPEG is a "lossy" compression method, text can become blurry when displayed.

Photographers who are using Adobe Photoshop 5.5 or later might prefer to use one of its specialized Web commands to produce Internet-ready files. Here, the Save to Web command is used to prepare a JPEG file for the author's Web site. © Joe Farace

That's why GIF is the best choice if your graphics contain text or sharp edges.

In general, it's best to use JPEG when saving photographic image files. JPEG files permit the use of more colors but, depending on the viewer's graphics card and monitor, they could be wasted on the viewer and can even take longer to display because the files tend to be larger than GIF. On the other hand, GIFs have less on-screen quality but usually display faster. JPEGs make good backgrounds. Because of the low contrast and similarity of colors required for a good background, the larger number of possible colors available makes JPEG a good bet.

Unlike other compression systems, GIF was designed specifically for online viewing. If your image was stored in noninterlaced form, when half of the image download time was complete, you would see fifty percent of the image. At the same time during the download of an interlaced GIF, the entire contents of the image would be visible—even though only one-half of the image data would be displayed. An alternative to using interlaced GIF is progressive JPEG. This file format rearranges stored data into a series of scans of increasing quality. When a progressive JPEG file is transmitted across a slow communications link, a decoder generates a low-quality image very quickly from the first scan, then gradually

improves the displayed quality as more scans are received. After all scans are complete, the final image is identical to that of a conventional JPEG file of the same quality setting. Progressive JPEG files can be slightly smaller than equivalent sequential JPEG files, and most Web browsers support progressive JPEGs.

The Text

After you've gotten your images ready, it's time to think about what the text will be. Web designers tell me that this is the most difficult information to obtain from their clients. My suggestion is to use yet another cliché to guide you: Keep it simple. Tell them who your are, what you do, and why they should hire you or purchase your images. Anything else is superfluous. Nevertheless, here are several additional items that you should include in the text that may seem obvious but are sometimes left off photographer's Web sites.

Your Address, Including City and Zip Code

It should be on every page of your Web site. You never know how a potential customer may find a Web page. He or she may have used a search engine to find photographs of lighthouses, one of which is displayed on your site. Make it easy on them by having the information readily available. A phone number and fax number that potential clients can use to contact you should be on each page for the same reason.

Your E-mail Address

Most photographers include this one but leave off their other contact information, expecting that if anyone is surfing their site they will contact them by e-mail. It is more likely that the surfer will contact you later by e-mail, but will prefer a phone number when they need to get hold of you right away.

Awards

I would limit any mention of awards to big ones or the inclusion of your images in the collections of major museums. Getting the "Good Citizen's Award" from the local Kiwanis may be important in your local market, but with your Web site you are marketing to the world. A photo buyer in Tel Aviv may not know where Brighton, Colorado, is but he's probably heard of the New York Museum of Art.

Clients

Commercial photographers can include clients' lists if they like, although paranoid shooters may prefer not to list them for everybody in the world, including their competition, to see.

Other Design Considerations

There is one overriding concern when designing graphics for the World Wide Web: Loading time. All other design parameters are secondary to the amount of time it takes a graphic to display on screen. Because surfers have the attention span of a Honduran Water Moth, if something doesn't display *fast*, you have lost them. Other design concerns include: Limiting your graphics to 256 colors. This makes them easier to translate into the popular GIF format that, in most cases, will load faster than JPEG formatted files.

Web Construction

Although your new home page can be constructed by writing HTML code using a text-editor software such as BBEdit (*www.barebones.com*), few photographers may be willing to spend time to learn the programming language—although it is simpler than other computer languages, such as C—to become proficient programmers. The easiest way to construct a home page is through the use of WYSIWYG Web-site construction software, such as FileMaker's Home Page (*www.filemaker.com*). There are other products that you can use, including TrellixWeb (*www.trellix.com*).

Home Page

Before you start using Home Page, you'll need to set preferences, such as the folder that will store your images. Instead of having to select which browser you will use to preview your Web site, the Home Page tool bar has a drop-down menu that lets you preview your Web site using either Netscape Navigator or Internet Explorer—if you have both installed. For the purposes of this chapter, I set Internet Explorer Navigator 3.0 as the default browser. Home Page features sev-

So Long, Adobe PageMill

One of the first programs to popularize WYSIWYG Web-page creation was Adobe's PageMill. As I was finishing this chapter, Adobe announced that they will discontinue development of PageMill. The company plans an upgrade program that will allow PageMill owners to switch to Adobe's high-end Web development tool GoLive. In addition, GoLive 5.0 and later will be simplified, allowing new users to work with the program and providing a quick transition for PageMill users.

Free Web Sites—a Great Place to Start

The techniques covered in this section are based on creating a custom Web site that will be hosted (more on hosting later) by an ISP or hosting company. But many online services, even Juno, offer free Web sites, and they might be a place to start. Photographers just getting started on the Web might look at sites such as Clever Content (*www.clevercontent.com*). Alchemedia (*www.alchemdia.com*) is a company that offers Web-based copyright protection via its PixSafe product for large corporations or stock photo libraries. The company works to bring this theft-proof technology to individual photographers, but they have implemented a free Web site—*www.clevercontent.com*—that allows you to post a limited number of protected images. Photographers can sign up for a free online portfolio that includes a personal URL, a biography, and a showcase for their images. Photo buyers can use a search engine on *cleavercontent.com* to locate photographers, images, or subjects by name.

eral toolbars that you can use to perform the tasks of creating and working on your Web site. These are Basic, Style, Tool, and Image Map Editor.

Step One

I started by using the New command from the Edit menu to open a blank page. Then I went to the Document Options (also from the Edit menu) to give the page a title. The words that appear in a Web page's title are important because they are used by Internet search engines to locate various sites. Make sure the title includes words that your potential clients are likely to use when doing a keyword search. The first thing I did was to set the background color. This is done using the Document Options from the Edit menu. For the purposes of this book, I set the background to white.

Step Two

Next I added text to the page to provide a title for the Web site. You can add text to your Web page by typing directly onto the page and by copying and pasting from another Web page or application. Once in place, the text can be manipulated using the toolbar. First, I used the center button to center the title and subhead. Next, I made it bold by clicking the "B" button; then, using the "A+" button, I kept clicking until the title was as big as I liked. For the subtitle I used similar techniques but added italics. Adding color to each text line—or even a single character—is a matter of selecting (highlighting) the text and clicking on the pull-down Text Color item in the toolbar. You can select from Red, Blue, Green, Yellow, and Black, or mix your own through the Other color picker.

Claris Home Page's Document Options dialog box has a pull-down menu that allows it many functions. One is Colors and Background, which can be used to set the background color. A color-wheel dialog box lets you pick whatever color you like.

Using Home Page's built-in text-editing capabilities, the Web site title and subtitle were directly typed into the document, then manipulated using the Text tool button in the toolbar.

Step Three

My plans for this site include using several small images—each representing various aspects of my on-location work—to be used as buttons. Visitors would only need to click on an image to see more of that type of photograph.

Consider your Web pages to be miniportfolios. As more and more search engines add image search capabilities, I think it's a good idea to create these portfolios so that if a photo buyer is looking for specific images—such as "dinosaurs"—your Web page will pop up on the buyer's screen.

All of the images used on this page were digitized using Kodak's Photo CD process. Then they were opened inside Adobe Photoshop and, using the Image

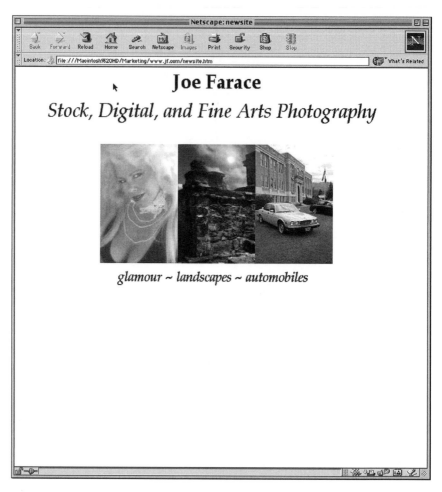

Three different JPEG images were stored in the default Images folder and placed on the home page using the Insert Image command. All three image were centered on the page using the Center button on the toolbar and are viewed using Netscape Navigator.

Size dialog box, were given the same height (I wanted them to line up) and saved as 72 dpi JPEG images at the maximum quality. The complete JPEG files were placed in the Images folder.

To add an image to the page, place the insertion point where you want the image to be and choose Image from the Inset menu. From the dialog box that appears, select your image file, and it will be placed on the page. If the image is a JPEG or GIF file, Home Page creates a pointer to the current location of the file. If the image is a BMP or PICT file, the program converts the file into GIF format and places the converted file in your default image folder.

Step Four

Next I typed the major areas of specialty under the small photographs. This text, plus the images themselves, will be used as links to other sections of the Web site.

If you want to save some work, Home Page and many other WYSIWYG HTML editors, come with pre-formatted pages to which you can just add your own text and images.

At this point I recommend you take a break in the process. Clicking on the Browser button in the toolbar launches your preferred browser. Since any WYSIWYG Web authoring program's job is to convert the actions on the screen into HTML code, there is always the possibility that the interpretation can vary slightly. Since every browser may interpret the HTML code differently, you may want to check your finished Web site with other popular browsers, or you can do what many Web sites do—they specify which browser makes the pages look best.

Step Five

The next step was creating a page for my glamour photographs. Using the same techniques previously introduced, I placed a large photograph of my favorite model, Dawn Clifford, on the page with some text. Next step? Linking this Web page with the small glamour image on the home page. To create a link to the glamour page, I selected the image. When you do, a light blue rectangle surrounds the photograph. Next, I chose Link to File from the Insert menu. This causes an Open dialog box to appear. Find the Web page, select it, and click the Open button. This creates a link and places a colored border around your photograph, indicating that it is linked to another page. While I was at it, I selected the text "Glamour" and created a link to the page, too—giving surfers two ways to get to my collection of photographs. Back at the Glamour page, I copied my group of links under the glamour heading. I deleted the text for "dinosaurs" and changed it to "Home." Then using the same techniques, I linked this Web page back to the home page.

Step Six

Next I wanted to create an online order form, so that buyers could purchase limited edition posters of some of the images. In this case, I want to be able to sell limited edition posters. First, I needed to get their attention. I created a page of small glamour images, using the techniques covered up to this point, and created a link back to text on the glamour page. Each of the images was linked to a separate page (for each one) showing the image as near to full browser-size as possible. That page was linked back to the poster page to place an order.

Here's where we get to take our customers' money. To add form-like data to the Web page, I placed the insertion point, selected Forms from the Insert menu, and then chose Text as the forms type. Then, I used the Object Editor to enter the name of this text box (the first one being the purchaser's name) and the maximum number of characters to accept. This naming is important because the program will use it when building a CGI script to locate all of the input data. Next, I added all the kind of data you need from a purchaser—including credit card information. I wanted to make it possible for purchasers to check what kind

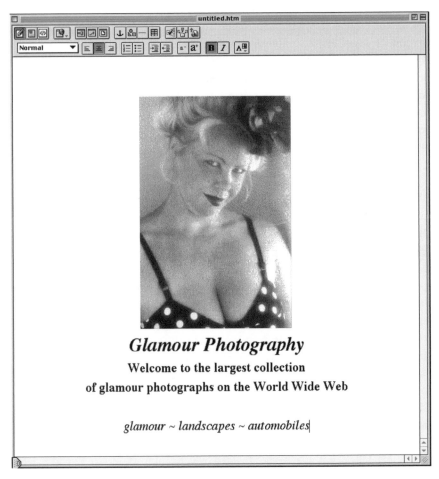

Using Home Page, the now-linked Glamour Web page with links back to my home page.

of credit card they want to use. In my hypothetical example—I'll accept Visa and Master Card—I used the Insert/Form/Radio Button command to place the buttons. At this point they will need to "submit" this data so the order can be accepted, processed, and mailed to the purchaser. I drag-and-dropped a button from the clip art library of Home Page supplies with the product, and surrounded it with text that says, "If you want it, click here." To make this button active, I chose Form Button from the Object Editor.

Step Seven

Forms need to "call" a CGI script in order to process any data that is entered on your Web site. You can (and need to) specify a CGI script for each Web page that contains "form" data. To specify a script for this page you need to choose

Document Options from the Edit menu. To display the document options information, choose General from the pop-up menu. Type in the name and path for the CGI script file on the server in the Form Action text box. At this point, you need to have had a conversation with your Internet Service Provider over what you need to enter when using forms on your Web site.

Next, choose Get or Post from the Form Action pop-up menu to specify how you want the form data sent to the server. After you click OK, you're ready to receive e-mail from potential purchasers of the glamour poster set.

Hosting Your Web Site

After you have created your Web site, you need to find someone to host it. There should be many companies in your town or a nearby area that provide hosting services. Prices for this service will vary based on the amount of hard disk space that you require for image storage and how many extra services you need. For a fee, a good hosting company will do lots of extras for you—from registering your domain name, to providing assistance for the creation of CGI scripts for collecting credit card information, to helping you design your site. Most have vast à la carte menus, so be sure to read the fine print before placing your order. But there are also differences in what they charge for the same services. When I checked with three companies in the Denver area about their hosting services for an identical Web site, I received quotes ranging from $9.95/month up to $50/month. Interestingly, the guy who had the lowest price seemed both more technically competent and easier to work with.

Once you cut a deal with a hosting service, you will need to upload all of the files associated with it to a server provided by your Internet Service Provider. How this is accomplished will vary from ISP to ISP but here are a few basics.

To get your pages onto the World Wide Web, you need to transfer them from your hard disk onto a Web server. This server can be any kind of computer: Macintosh, UNIX, or Windows NT. The first thing to do before transferring your

Ask First!

Please check with your ISP for their specific procedures before uploading. You may find that it's easier to copy all of the files onto a CD-ROM disc and simply hand or mail the disc to the hosting service. No matter what you do, talk to the person who actually works with the files and ask her how she prefers to receive all of your files. The more time spent before sending data—in no matter what form—the less trouble you will have getting your site online.

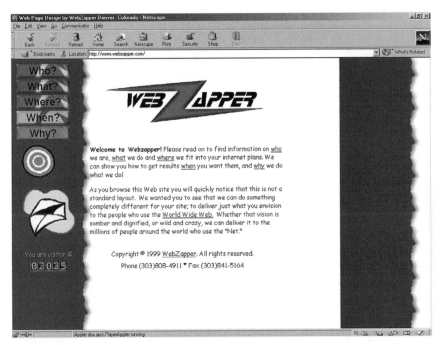

Web Zapper (*www.webzapper.com*) is a company that both designs Web sites and offers hosting services at several levels depending on your needs, with the lowest level starting at under $10.

Web site to a server is to make sure that all of your files and subfolders are found in a single folder. If you set up everything this way—by creating an Images folder, for example—before creating your Web site, this should be no problem, but it's still a good idea to check that all the bits and pieces are there.

Be careful that you don't move files from other folders. If you move them, you may be breaking links and creating problems for yourself later on. Some users may have direct file access to their server. If you do, an icon for the server will appear on your desktop. In that case, all you have to do is drag your Web-site folder to the server icon. Chances are most of you don't have this kind of access and will need to upload, via FTP, to the server. To do that, you will need a program designed for such an upload. Your hosting service should be able to provide one or send you to the appropriate source. One of the most popular Mac OS programs is called Fetch. The current version should be available from *http://shareware.cnet.com*, where you can use their search function to find a place to download a copy.

What Fetch enables you to do is to make an FTP transfer of your Web-site file to the server of your ISP. Two tips when using Fetch: If you have a space between words in a file name, Fetch will convert blank spaces into underscores,

which will then break all your links because of a change of file names. UNIX is case-sensitive and therefore knows the difference between *dino.html* and *Dino.html*. Be consistent in naming your files.

The safest thing to do, before you upload your Web site, is to put in a call to the hosting service and have them send you instructions on how to get your site online.

Make Sure Your Web Site's Working

A Web site has so many components that some Webmasters find it can be difficult to know if each one is performing properly. If you're looking for a way to keep an eye on your site to make sure it's doing what you think it's supposed to do, visit *www.atwatch.com*. Their Web Shepherd engine performs five critical watches that simulate a surfer's visit to your site, including checking average response time and peak response times. This information lets you know if your ISP is providing consistent service. Content Watch identifies missing content before visitors are affected. @watch will immediately notify you if it identifies content problems. Up/Down Watch sends alerts by e-mail, fax, or pager if your site is not up and running. Link Check Watch finds broken links, saving you the time and trouble of running link-check software, and Hacker Watch protects against unauthorized changes to the home page or to crucial URLs. Naturally, all this work isn't going to be free, but @watch has a fee structure that starts at under twenty bucks a month, after a setup fee.

Photographers Online

The first day I was on the Internet, I received an order for one of my photographs.

Bill Craig, fine arts photographer

Photographers were among the first small business people to recognize the power the Internet possesses to provide them with the same kind of marketing presence that *Fortune* 500 companies have. Since there are as many different ways of using the Internet to market photographic products and services as there are photographers, this chapter will take a look at some of those who have taken the plunge and established a home page on the World Wide Web.

In the first edition of this book, the photographers' Web sites that appeared in this chapter were selected based on a survey of the World Wide Web responding to the word "photographer" when using the Yahoo! search engine. In compiling the original list, I tried to find different kinds of photographers with varying specialties, ranging from wedding to wildlife, from color to black-and-white image making, and from commercial to fine art photography. But it was not an easy task; many of the photographers I contacted did not want to share information about their Web sites or about how they were created.

Times change. In the years since the first edition

appeared, I have been writing about photographers on the Web for *Shutterbug* magazine—first in a column called "Web Site of the Month," and later with my current column called "Web Profiles." During the creation of those columns, I have come in contact with many different photographers who are using the Internet to market their work, and, unlike the first edition, every one that I have asked to participate here agreed.

I deliberately wanted to use a different group of photographers from those who appeared in the first edition. That way, any readers who have a copy of the first edition will find that this chapter—as I tried to do with the rest of this edition—is not just a rehash of what's new since then.

All of the photographers whom you will read about in this chapter were more than willing to share their experiences with readers of this book, and I want to thank all those who responded and whose stories appear in these pages. After the photographers told me they would like to participate, I asked them to respond to a set of standard questions, the answers to which I thought would help anyone contemplating establishing their own home page on the World Wide Web. Those questions were:

1. Provide a brief history of your operation. (This was included so that readers might get a feeling for the photographer, his background, and experience.)
2. When did you first get involved with the Internet?
3. Did you create your own home page, or did you have a Web designer do it for you?
4. If you did it yourself, please tell us about the hardware and the software you used.
5. Please talk about the process. For example: How long from the time you decided to create the home page did you have it up and running? What problems did you encounter, and how did you overcome them?
6. If you had a designer create your Web site, please describe the experience. If you had to do it over again, would you do it yourself or hire a consultant?
7. Who is your ISP and what were your experiences with it?
8. How long has your Web site been in operation?
9. Is the maintenance of the site time-consuming?
10. What have been the results? Please list any intangible results as well as the tangible ones of more sales or assignments.
11. Are you pleased with the results, and will you expand your Internet presence in the future?
12. Would you recommend that other photographers get onto the Internet?

The photographers were also allowed to add any comments that were not covered in any of the above questions. As you will discover, some photographers chose to answer all the questions, while others focused only on some of them. What follows is an almost verbatim copy of responses to my questions. Here's a look at their Web sites in alphabetical order.

Gary Auerbach Platinum Photography
(*www.platinumphotographer.com*)

Gary Auerbach produces platinum portrait and landscape images as well as Polaroid Image Transforms, and his site displays more than one hundred of his images. More importantly, these images can be viewed in a size that let's you appreciate the photographer's vision. Visitors to his site who are not familiar with the platinum printing process should start with a page called "What is Platinum Printing," which contains a brief, nontechnical view of this alternative process.

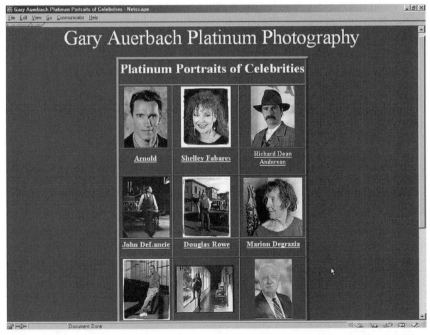

Platinum portraits of celebrities should be your first stop when visiting Gary Auerbach's Web site. Most of the large thumbnails show the image as it will appear when you double-click it, but the photograph of Arnold Schwarzenegger is actually much looser than the head shot indicated in the thumbnail. Platinum prints of these images, like many others on the site, may be purchased from the photographer. © Gary Auerbach.

The Virtual Gallery consists of three areas: Portraiture, Landscapes/City-scapes, and Polaroid Image Transfers. Each of these sections has several sub-sections. For example, the Portraiture section contains Celebrity, Native American, Wedding, and General portrait galleries. The Celebrity gallery includes portraits of subjects as diverse as Walter Cronkite and Arnold Schwarzenegger, but my favorite was an environmental image of *Star Trek*'s John DeLancie. The Native American section contains platinum images of individuals wearing both traditional and contemporary dress. The portrait entitled "Young Apache" is my favorite, but there's much to enjoy—and learn from—in all of these photographs. The Wedding section contains both bridal and engagement portraits and is inter-esting, if only for the striking full-length image called "Night Bride." The General section includes portraits of adults and children, but Mr. Auerbach is clearly a master of photographing kids. His sensitive photographs of Lauren, plus the one of Michael, are not to be missed.

The Webmaster's Landscape/Cityscapes area contains five sections devoted to specific geographic areas, such as Washington, D.C., Niagara Falls, the Ameri-can Southwest, the San Xavier Mission restoration, and "International" locales. This later section contains impressive images of Switzerland, Spain, France, and a wonderful full-moon view of the Acropolis. Mr. Auerbach's photographs of these United States are also worth viewing, especially the Vietnam Wall image in the Washington, D.C. section.

Want to see some color photographs? Visit his Polaroid Transfer section. Every piece is one of a kind since the original image is used in the process. Fans of the late Bill Mortensen will find that Mr. Auerbach has a touch of his magic as well—except in color.

Surfers interested in getting involved in platinum printing, should read the Artist's Statement, which includes information about what inspired Mr. Auerbach to begin working with the process. Much of his decision has to do with the permanence of the medium, but also involved is the artistic expression that's possible when working with platinum imaging. You should be sure to read "Platinum Printing Made Simple" in the Articles section of the Web site. Although the section only contained this single story the last time I visited it, it provides an excellent introduction to platinum printing, while demystifying the process at the same time.

Other sections include a "New" area containing news about the photogra-phers' current activities and gallery exhibitions. A link labeled "Reviews" con-tains additional portraits, including an environmental image of painter Carlo Giantomassi at work at the San Xavier Mission. This area of the site also con-tains clippings of stories exclaiming how great Mr. Auerbach's images are, although by the time you get to this section, you'll already know that. You'll also find a résumé presented in academic style, a links section to sites concerned with

fine arts imaging, and a list of online galleries. Of special note is Platinum and Polaroid (*www.frii.com/~uliasz/photoart/polaroid/t_gallery/gary.htm*), which contains a story by Mr. Auerbach containing many of the details about how he creates his Polaroid Transfer portraits.

The site is available in three other languages, and you might want to try looking at them even if you don't speak the language. These pages feature a slightly different design and highlight different images and sections than the English language version.

In His Own Words

I have been flirting between serious amateur and professional photography all my life. I decided early in my life, that my photography was going to be for love not money. Not to say that money wasn't and still isn't a consideration. But the pursuit of the photographic arts has been a passion all my life. I have always striven to photograph and print my images and had reached the level of fiber-based, selenium-toned images, but I knew that there was something more. It turned out to be one of the alternative processes, one known for its permanence, softness, and tactile qualities: the platinum photograph.

I have been involved with my platinum photography business since 1992, when it became apparent that I wanted to have a presence in that field. In 1995 I met some consultants who showed me a canned layout of a Web site that they were producing. They had around ten other artists and galleries that wanted to participate. Everything was loaded onto one page, then there was a directory that let you click to that section of the page. It was not really using multiple URLs. I was using GIF files to enlarge the nine or so images that I was allowed. You can imagine how long that first page took to load.

It was clear after one year of no updates of this site, and my unhappiness growing each day, that I needed a new site. That occurred when I met an Arizona State University grad student who was trying to learn platinum printmaking and wanted to trade prints for a Web site! From that day on, I thought about all that I liked about my first site, and what I wanted the new site to do.

That's where we started when we designed the home page, with lots of info and lots of links to go in other directions—including a virtual gallery with over 150 images loaded. The main pages of the site, such as "What is Platinum Photography" or "Articles," are all translated into four languages. All the photo pages are layered so that there aren't more than ten thumbnails or one large photograph. This way, the waiting time for those of us with less than T1 speed is minimal.

It took eight months to get the new site up once we started working on it. It didn't make it easier that we were 125 miles apart. But we got the site up and

running, and for six months or so, I was able to get reasonable once-a-month updates on the site. But after that it became more difficult to tie him down to make my changes.

Around the end of 1997, my fourteen-year-old son took over as Webmaster of my site, and we began making lots of changes. Sometimes these were just little things, but they were all items that I had noticed and wanted to change. We streamlined the site, and we added the four language translations.

My son and I are working on a new version. We are six to eight months away from being ready. This will bring a new version of frames, banners, and improved mobility through the site. We are using Microsoft Front Page. My original ISP, *azstarnet.com*, has been too expensive. I pay $39 a month for 5MB of space. At my other site I am only paying $15 dollars a month.

I started out with around a few hundred hits a month. Then as I added one link after another to my site, my numbers went up. After a few more articles (all of which have my URL address in them) appeared, my numbers started to go up. Now my numbers average around five thousand hits per month, with around three thousand unique computers looking at my site per month.

Tony Sweet Photography (*http://tonysweetphotography.com*)

You can learn a lot about a photographer by looking at his portrait. The two Tony Sweet displays in the "Bio" section of his Web site make him look like a warm, friendly guy, but it's his stunning images, some of which make color itself the subject, that will make you want to bookmark this site. Click on the section he calls "Exploding Color," to see what I mean, but you will soon discover that his black-and-white infrared images are equally powerful. Mr. Sweet is a nature and landscape photographer, but his images of urban Baltimore show that he knows his way around the cityscape genre pretty well. Although mostly a portfolio site, he also includes an interesting section of his recent work. In a low-key retail section of his site, Mr. Sweet offers greeting cards and posters that feature his work for modest prices. I'm a native Baltimorean who's lived in Colorado for the past twenty years, and some of Mr. Sweet's images exerted a strong emotional pull that made me downright homesick. Even if you're not a Maryland native, you'll enjoy this site, as it includes photographs made all over the country.

In His Own Words

1. Provide a brief history of your operation.

I began as an assistant, then an instructor, for the Great American Photography Weekends workshop company, where I taught with John Shaw, Pat O'Hara, Bryon Peterson, and Galen Rowell. In 1995 I began Art of Nature

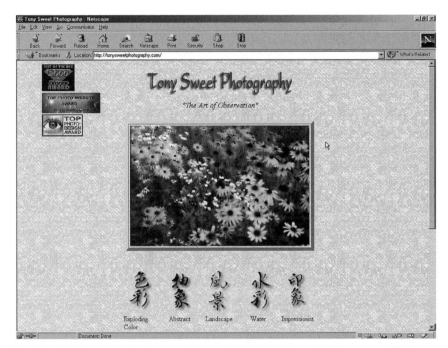

Tony Sweet's Web site contains images made not only in his (and the author's) hometown of Baltimore, but sensitive landscape and nature photographs made all over the country. © Tony Sweet.

Photography Workshops, conducting workshops throughout the continental United States. In addition to my workshops, my clients include Nikon, Fuji, *Shutterbug* magazine, At-A-Glance, Hallmark, National Wildlife Federation, and the Ink Group; and I am a stock photographer for the Orion Stock agency in Japan. I am personally represented in Asia and Europe by Phillip T. Edgerly.

2. When did you first get involved with the Internet?
Five years ago.

3. Did you create your own home page, or did you have a consultant do it for you?
I realized that the Internet was the future several years ago and had a developer design my first Web site, while I acquired the knowledge to build one myself. After a couple of years, it became apparent that I had to design and maintain my site personally.

4. If you did it yourself, please tell us about the equipment and the software you used?

I used Apple Power Macintosh G4, Adobe GoLive, and Photoshop software, as well as a SprintScan 35Plus for scanning images for Internet display.

5. Please talk about the process.
Initially, my developer had the Web site up in a couple of weeks after I approached him. When I redesigned the site with GoLive, I had the new site ready to go in about seventy-two hours. That's seventy-two hours of working exclusively on the site design, scanning, and uploading. It's a constant work in progress. Any problems that I encountered were based on lack of knowledge of the software—and of being in too much of a hurry to read the book.

6. If you had a consultant create your Web site, please describe the experience.
After speaking with him and giving him a basic framework, I scanned and e-mailed images based on his specifications. He designed the site, and I gave him feedback on modifications until I was satisfied. No one cares about a Web site as much as the photographer.

7. Who is your ISP and what were your experiences with them?
I use two different Internet Service Providers: EarthLink for Internet access and e-mail, and MacServe for "parking" [hosting] my Web site. The reason I have two is that the monthly fee with MacServe is $125/year, and to "park" it on EarthLink's server is $240/year additional.

8. How long has your Web site been in operation?
Since 1995.

9. Is the maintenance of the site time-consuming?
It depends on the additions, but adding a "Recent work" page, for example, takes less than an hour.

10. What have been the results?
I use my Web site as a marketing tool. I send it to possible clients as a portfolio, refer people to it for workshop information, sell posters and cards through it, and use it to just get and keep my name out there.

11. Are you pleased with the results, and will you expand your Internet presence in the future?
I expand it in every way possible. I link to as many camera clubs, schools, publishers, clients, and other photographers as much as possible.

12. Would you recommend that other photographers get onto the Internet?
Recommend it? I would say it's mandatory.

Tom Zinn (*www.adrenalinimages.com*) _____

Tom Zinn's Web site is so chock-full of photographs of racing yachts in action
that you can almost feel the surf spray. His site contains dozens of you-are-there
images of sailors battling the elements during racing events such as the America's
Cup, Louis Vuitton Cup, Millennium Cup, and Logan Classic Regatta races. Mr.
Zinn also offers virtual tours of the America's Cup Viaduct Village in Auckland,
New Zealand, as well as in San Francisco in Apple's QuickTime VR format. All
of the racing photographs are presented in galleries of small thumbnails, some
in color others in black and white. Double-clicking the thumbnails reveals large—
and I mean screen-filling—photographs that not only show Mr. Zinn's consider-
able technical skills but his artistic ones as well. When I first visited the site,
Adrenaline Images was slow to load at times. A recent redesign improves loading
times and features a new eye-pleasing design. Even if you're not interested in
yacht racing, you owe it to yourself to see Tom Zinn's powerful photography.

Tom Zinn's Web site features dramatic images of sailors battling the elements in yacht races such as
the America's Cup, Louis Vuitton Cup, and Logan Classic Regatta races. © Tom Zinn.

In His Own Words

1. Provide a brief history of your operation.

I had been down in New Zealand between 1998 and 2000 shooting for America True, Dawn Riley's America's Cup syndicate out of San Francisco. I was going out on the water during practice and shooting either on the race yacht or from a tender. I was trying to build up a good library of images for all of the media requests that were directed to the America True PR department. I was also e-mailing images to the America True Webmaster back in San Francisco, but network connections weren't nearly as fast as they were in the States, nor were they as reliable. Oftentimes I would send off an e-mail with a dozen images as I was leaving the office for the day and return the next day to find that they hadn't made it off of the office LAN.

I had another Web site that was already up and running, though it had nothing to do with photography other than the fact that it had a few images on it. I decided to create a directory on this existing server on which to dump images and let the Webmaster download what he wanted. Word got around the sailing community after someone mentioned my images and the URL on an e-mail list called "Scuttlebutt," and within a week the site was getting so many hits that the server was crashing every night when our access accounting software would try to parse the log file.

Within a week I was averaging close to four thousand hits a day. I decided that it made sense to register another domain, and *adrenalinimages.com* was born.

2. When did you first get involved with the Internet?

My first exposure to the Internet was when I was in college around 1986. I took a "cybernetics systems" course to avoid a calculus class—I'm not a math person. At the time, we really didn't get that involved with the Internet. All it really consisted of was e-mail and USENET news groups. After I graduated with a B.A. in Film and Video, I took a temporary position at a small software company and started to spend more time online, as it was a useful tool for my job. A few years later, I was working at Cisco Systems when the Mosaic browser made its debut. The Web consisted of about seventy Web sites at the time, and there were no search engines, so you had to know the URL address to get to the site. At the time, I remember thinking that the Web wasn't going to go anywhere. Insert foot in mouth now.

3. Did you create your own home page, or did you have a consultant do it for you?

I created the original *adrenalinimages.com*, which was a pretty basic site. I thought I'd let the images speak for themselves. After a few months, I decided to take it to the next step and enlisted the help of an old friend of mine, Doug

Axt of *axtdesign.com* to help create some flash graphics. A Web site has to be con-
stantly evolving and changing, otherwise people lose interest and you see fewer
repeat visitors.

*4. If you did it yourself, please tell us about the equipment and the software you
used?*
I use Adobe PageMill, BBEdit, Photoshop, and FotoStation on a Macintosh
G3 500 PowerBook. I scan the film in with a Canon Canoscan FS2710 trans-
parency scanner.

*5. Please talk about the process. For example: How long from the time you decided
to create the home page did you have it up and running? What problems did you
encounter, and how did you overcome them?*
I had the basic site up and running in an afternoon. This just included the
index page and about twelve image pages from my existing site. These days it's
so easy to get a site up and running that you don't really run into many prob-
lems. Disk space would be a huge problem for me if I didn't have a dedicated
server sitting on a high speed T3 line, which fortunately is a freebie provided by
an acquaintance of mine. I've kept the images at 300 dpi, which takes a fair
amount of space and bandwidth.

*6. If you had a consultant create your Web site, please describe the experience. If
you had to do it over again, would you do it yourself or hire a consultant?*
I would do it again by myself. Once you learn the basics, it's a fun hobby.
You're basically a publisher working on your own creation and making it avail-
able for the world to see, in real time.

7. Who is your ISP and what were your experiences with them?
In New Zealand I was using *xtra.co.nz*. Overall they were pretty good, though
the connection speed and the high cost leave something to be desired. We were
ending up with $1,500 monthly connection fees for an ISDN data circuit. When
I returned to Sausalito, California, I immediately signed up with their ADSL serv-
ice. For $40 a month, I get about 150K download speeds and about 128K
uploads—way faster than the high-priced N.Z. ISDN circuit.

8. How long has your Web site been in operation?
Since spring 1999.

9. Is the maintenance of the site time-consuming?
Hardly at all. Backups of the data are automated, so there isn't any time
spent on that side. Creating new pages these days only requires a couple of hours

on the laptop, scanning the images and dumping everything into a template that has been created previously.

10. What have been the results? Please list any intangible results as well as the tangible ones of more sales or assignments.

The results have been varied but have accounted for close to $10,000 in additional income in the last year since the site has been up. I've had sales of images in Europe, to private parties, magazines, and newspapers. I'm proud to say that in one month, I had full-page images in the *New York Times,* the *Wall Street Journal,* and the *New Zealand Herald* that were chosen out of the images on my site.

After returning to the States, I received a call from a company who happened to be one of the sponsors of America True during the America's Cup. They wanted some QTVR imaging of two of their offices. I thought that they had called me because of my connection with America True, but it turned out that they had found my site through a search on Yahoo!. When I got to the offices to shoot the QTVRs (QuickTime Virtual Reality), they had a few of my posters on the walls and didn't even know that I had shot them.

11. Are you pleased with the results and will you expand your Internet presence in the future?

I'm very happy with the results that I've seen so far. At the present time, I'm working with another photographer who shoots similar images. We'll be contributing to each other's sites; he's in Southampton, U.K., for two years and I'll be between San Francisco and Auckland, N.Z. This way we can cover more events and make our images more accessible.

12. Would you recommend that other photographers get onto the Internet?

Absolutely. If you enjoy shooting images and sharing your work, there's no better way to do it. Every day is a showing and your audience is endless.

B. Moose Peterson (*www.moose395.net*)

Moose Peterson is a noted naturalist, photographer, and author of books such as *The Nikon System Handbook* and *Wildlife Photography: Getting Started in the Field.* His Web site resembles more of a course in wildlife image-making than of a photographer's commercial Web site. Sure, he sells a few things, including his special "Moose" polarizing filter and information on his photographic seminars, but almost the entire site contains information about the tools and techniques of photographing nature.

When you get past the opening screen, you get to the "Trail Head," which

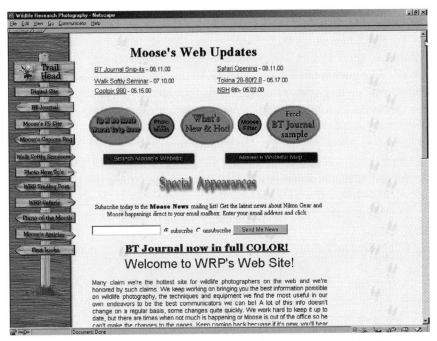

Moose Peterson's Web site, Wildlife Research Photography, is like the photographer himself: larger than life and full of surprises. If you are interested in wildlife and nature photography, don't miss this site.

can take you in many directions, including Photo of the Month, Photo How-To's (including the don't-miss "Teddy Bear Test"), Moose's articles (in PDF format), and First Looks, which is a series of reviews of new camera hardware. Moose is also involved in digital imaging and has a Digital Site that addresses all things digital, including cameras and scanners, and has a gallery that should answer anybody's question about the quality of digital images. Nikon owners will want to check out his site dedicated to the company's F5 model. If, like me, you are curious about what people keep in their camera bag, check out the Moose's Camera Bag section, in which he explains "what is in my bag and why." Like Moose himself, this Web site is "larger than life."

In His Own Words

1. Provide a brief history of your operation.

At Wildlife Research Photography, we specialize in photographing California's rare, sensitive, and endangered wildlife and wild places. Our bio sheet provides you with some of our accomplishments to this end, but the goal of our work goes beyond simple editorial and book sales. The goal of our work

is to preserve our wild heritage. In reaching this goal, we work towards educat-
ing the public as well as other photographers. It's our hope that in teaching the
needed biological and technological skills to other photographers, they too can
capture the same type of images as we do. In this way, there are more and more
individuals working towards educating the public through photography about
our wild heritage. As a community, we can make a difference!

2. When did you first get involved with the Internet?
Before there was an Internet, before e-mail was called e-mail. *(Author's note:
Readers should be aware that this is some of the famous "Moose wit.")*

*3. Did you create your own home page, or did you have a consultant do it for
you?*
[It's] all mine, [although] I did have some of the graphics made for me.

*4. If you did it yourself, please tell us about the equipment and the software you
used?*
In the beginning, [I] tagged it all in a text document. Now, I maintain it
using [Macromedia] Dreamweaver and WebEdit Pro.

5. Please talk about the process.
[It] didn't take long in the beginning—pretty simple page—but I first started
tagging on a Word document, which didn't translate correctly to the Web.

6. If you had a consultant create your Web site, please describe the experience.
I am looking for a consultant right now to give the Web site a face lift. Can't
find anyone—money isn't the problem; the size of my site scares them off.

7. Who is your ISP and what were your experiences with them?
Quantum, [who are] friends who started the business and who take good
care of me.

8. How long has your Web site been in operation?
Since 1994.

9. Is the maintenance of the site time-consuming?
Only as much as I want to make it. I could easily spend my entire time there
but opt not to.

10. What have been the results?
Out of the 360 pages, only 3 pages sell anything in the way of a product,

seminar, or subscription. The site is all about providing free information which, with over 1.2 million hits last month, it seems to be doing.

11. Are you pleased with the results and will you expand your Internet presence in the future?

Yes, and yes.

12. Would you recommend that other photographers get onto the Internet?

Yes and no. Many think it's a way to riches, which it isn't, at least not at this time for wildlife photographers.

The Photo Essays of Herman Krieger (*www.efn.org/~hkrieger*) _____

Although he spent thirty years as a computer programmer, Mr. Krieger's black and white images exhibit the humor that is too often lacking in contemporary photography. This wit, combined with his obvious photojournalism skills, produces images that will make you smile while you marvel at his technical and people skills. The images on this site are large and beautifully digitized, although they can sometimes be slow to load. The topics of his essays vary from the panoramic imagery of "The Big Country," to the compassionate photojournalism of "A Day in the Life of a Mobile Veterinarian." Not to be missed in this latter series is his touching yet humorous image "CAT Scan." "Along West 111 Avenue" is a journey along the main thoroughfare of Eugene, Oregon, with periodic stops along the way to see a world that many people pass by but never notice. At a time when photojournalism seems limited to getting the one big picture that runs on page one of a major publication, the essay appears to have gone out of favor. Mr. Krieger's Web site should be in your bookmarks so you can see that it's alive and well and living in Eugene, Oregon.

In His Own Words

1. Provide a brief history of your operation.

As a youth, I worked as a photo lab technician and did a stint as an instructor at the U.S. Army Air Corps photo school in 1945. After the war and graduation from the University of California, I worked as a computer programmer. Upon my retirement in 1990, I returned to photography via the University of Oregon School of Fine Arts and received a B.F.A. One of the photo essays I worked on looked like it had the potential for being made into a book. After an unsuccessful attempt to find a publisher, I decided to put the photo essay onto a Web site. The photo essay was an offbeat look at churches in America. It was called "Churches ad hoc." Subsequently the book was published. The Web site

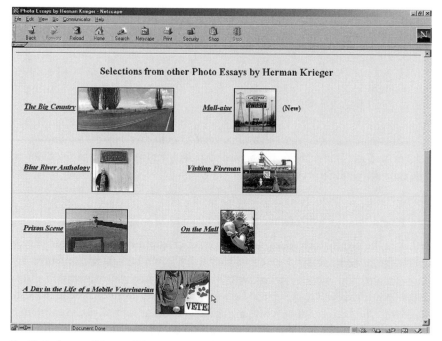

The Photo Essays of Herman Krieger cover a wide variety of topics that comprise the human experience. Be sure to bookmark this site. © Herman Kreiger

then served to show selections from that photo essay, along with many newer photo essays.

2. When did you first get involved with the Internet?

I started my Web site in 1996 after first setting up a Web site for the PhotoZone Gallery (*www.efn.org/~fotozone*). This is a nonprofit cooperative for fine art photography in Eugene, Oregon. Prior to that I had no involvement with the Internet. I had, however, a fair amount of experience with programming devices involved in telecommunications and with the making of user-friendly programs.

3. Did you create your own home page, or did you have a consultant do it for you?

I created my own Web site.

4. If you did it yourself, please tell us about the equipment and the software you used?

I use a Gateway P5-133 computer with a Microtek E3 Scanner, together with

Adobe Photoshop. For the Web page, I do the editing with the Windows WordPad and the DOS Edit.

5. Please talk about the process.

I started by looking at other Web sites that involved photography. I copied the basic HTML structure of an existing photo Web site and built upon that. The Web site was up and running within a week. The initial problem was learning the procedure for setting up a Web site with the ISP. The most work was involved with making the Web site download as quickly as possible. Many viewers were using 14.4-band modems with early versions of Netscape. I had to make the JPEG files as small as possible, and still maintain a reasonable size and quality for the photos. The HTML language is a basic one that takes a minimum time to run with any browser. Afterwards, I tried to make the Web site as user-friendly as possible.

6. If you had a consultant create your Web site, please describe the experience.

I would not use a consultant. The site is not commercial—it has a fairly simple theme. I rely upon the content rather than the razzmatazz that a professional graphic designer would bring to it.

7. Who is your ISP and what were your experiences with them?

The ISP is Eugene Free Network (*www.efn.org*). I started with them for the PhotoZone Gallery Web site because they provided a very-low-cost service for local nonprofit organizations. The service was somewhat amateurish and erratic. If I had my own URL, I would have probably changed to another ISP. There are quite a few Web sites that have links to mine, and that inhibited me from making a change.

8. How long has your Web site been in operation?

Since 1996.

9. Is the maintenance of the site time-consuming?

The maintenance does not take much time. I set up the site with a simple structure that allows easy adding of new photos or photo essays.

10. What have been the results?

There must be hundreds of sites with links to mine. The church photo page has several hundred Christian organizations with links to it. There are also a large number of atheists' pages with links to it. The series on the veterinarian, the prisons, and others, each have their own following. I get a lot of e-mail from people who enjoy the photos. That has been very satisfying. The site is essentially

noncommercial. I take no orders for photos. I have given permission to a number of sites to download any photos they wish to use. I only ask that they cite the source. A few people have told me that they ordered the photo book, "Churches ad hoc.," but I have no way to track what may be sold online by Amazon.com, or others.

11. Are you pleased with the results, and will you expand your Internet presence in the future?
The results have been gratifying. I have changed some of the photo essays from time to time, but I keep no count on hits. I only go by the e-mail comments that I receive.

12. Would you recommend that other photographers get onto the Internet?
I think all fine art photographers should go on the Internet, especially those who don't have the opportunity to exhibit in a gallery. I wouldn't count on it being worthwhile from a financial point of view.

Len Kaltman (*www.glamourportfolios.com*)

This home page features the work of one of America's foremost glamour photographers, whose stunning images are integrated into an attractive and functional Web design. The concept is a simple one and is built around the idea that adults like to look at pretty women, preferably with as few clothes on as possible. This is decidedly not a porno site, and features a soft, flattering style of photography as exemplified by *Playboy* magazine. Nevertheless, there is nudity here, and if you are offended by the unclothed female form, no matter how tastefully depicted, I suggest you skip this site. On the other hand, there are many photographers who are interested in how Len got into the Internet I'll let him explain in his own words.

In His Own Words

1. Provide a brief history of your operation.
For years I was a traditional stock photographer shooting travel and tourism photos. Over the years, my mix of images started including more glamour and centerfold images. A company that ran several of the forums on CompuServe got in touch with me, and I started providing them with images for their forums. Glamour Portfolios began as an extension of my glamour libraries on CompuServe. I was then approached by a Web-site designer who primarily did corporate accounts. He was interested in getting into the glamour photography market but did not want to do a hard-core site. He showed me a mockup of a

site, we fine-tuned it, and we opened our Web site in 1995. It was one of the first "soft" adult Web sites.

2. When did you first get involved with the Internet?

I've been online ever since 1980, when I first joined CompuServe. Shortly thereafter, I created PhotoNet, the first professional photography network. We concentrated on linking stock photo agencies and stock photographers with photo buyers who either placed photo requests directly or through our 800 number. As the Internet developed over the last five to seven years, I was able to get my Web site relatively early, and build on the popularity of my images among thousands of CompuServe subscribers, who in very large numbers became subscribers of my new Web site. Since then, I've been online but have been concentrating my efforts on building and expanding my Web site.

3. Did you create your own home page, or did you have a consultant do it for you?

From day one I decided to concentrate on my photography and let someone else work on programming the Web site. Once your site becomes a certain size, it's not practical to do it yourself.

5. Please talk about the process.

As I previously mentioned, I was approached by an experienced Web designer, and we would discuss basic concepts about the site. He would then do a mockup, and we would review it, make some changes, and then once we both approved it, put it online. We became partners in Glamour Portfolios. My main responsibility was content; his was design and operation. It works well because we have a mutual respect for what the other is bringing to the table. And although it probably goes against common sense, we've worked together for six years without a contract. In fact, we worked together for the first three years without ever having met in person. Hopefully it will continue to be a smooth relationship, but nothing that has happened so far leads me to think it wouldn't be.

7. Who is your ISP and what were your experiences with them?

I am not even sure. (Not my job!)

8. How long has your Web site been in operation?

The Web site has been online since 1995.

9. Is the maintenance of the site time-consuming?

Maintenance is not very time-consuming, because we have tried to keep things simple and concentrate on the basics, which is supplying our customers

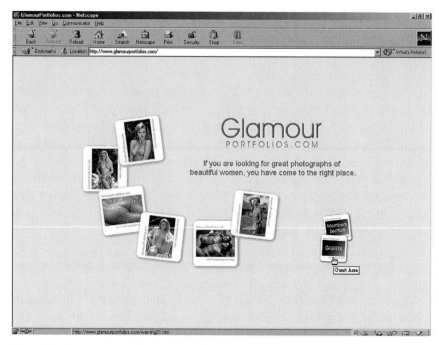

GlamourPortfolios.com is a boutique glamour photography site that puts up only several hundred exclusive new photos each month. © Len Kaltman

with high-quality photos. We decided early *not* to compete with the adult mega-sites that offer every imaginable service and hundreds of thousands of photos. We're similar to a "boutique" site, in that we put up only several hundred new photos each month, but because they are exclusives, our customers are quite satisfied. Where we really do well is with personalized customer service. My Webmaster or I personally respond to every request within several hours of receipt. This has been greatly appreciated by our customers who get to know us personally.

10. What have been the results?

Well, we obviously were looking for a reasonable income, and I am very pleased with the results. We get between three hundred to five hundred new customers every month, and we expect to expand our site and customer base over the next two years. I have also had a large number of stock sales as a result of the exposure my photos receive through the site.

11. Are you pleased with the results, and will you expand your Internet presence in the future?

I am pleased with the results and look forward to increasing our exposure online through an extensive links network and other promotions. I certainly recommend using the Internet for marketing photography, regardless of specialty.

Open for Business

Life is a crowded superhighway with bewildering cloverleaf exits on which a man is liable to find himself speeding back in the direction he came.

Peter deVries

The next thing you should do after creating your new Web site is to get the message out to the world—and any potential clients—that you *have* a home page. This initial announcement has to be followed up by regular maintenance of your Web site and an active program of continually telling the world that you're open for business. But first, let's start with the basics.

Getting the Word Out

If you think that all you need to do is create an attractive Web site and the phone will start ringing off the hook with assignments or stock photo sales, you're in for a big surprise. These two actions are not necessarily related. Yes, having a Web site can help increase your sales, but you can't expect potential buyers to find your site amongst the two thousand that are supposedly created each hour of the day. You've got to tell people *where* you are doing business on the information superhighway. The Web site is, in effect, a new office location, so you should start by using the same kind of marketing techniques you would use if you opened an office out of state.

Send Out an Announcement

This announcement can be as simple or elaborate as your budget allows, but you should send out some kind of mailing that specifically informs existing and potential clients about your new Internet presence. One of the unwritten rules of marketing is that the mere act of promotion often generates sales activity—not necessarily where you might expect. If you market *anything* properly, they will come.

The first group to receive notification should be your existing client database. If you don't already have such a database, now would be the right time to start one. This is the easiest group to sell to. They already know you, like you, and have proven it by giving you money. Since 80 percent of your business comes from 20 percent of your customers, the Web site should introduce your existing clients to services that you already offer but that they may not already be using. If all you're currently doing for a company is studio portraits of their employees and officers, make sure the Web site features your on-location or architectural work—then be sure to tell them about it in the announcement.

The next group you should send the announcement to are any potential clients to whom you may have pitched your work in recent months—even years—but who haven't yet taken the plunge and hired you for an assignment. An Internet home page may provide them with a new reason to take another look at you and your work. Finally, there are all of those potential clients whom you don't know. These names can come from purchased mailing lists, Chamber of Commerce membership rolls, or "lead" groups, such as Le Tip (*www.letip.com*).

New Letterhead and Business Cards

Although this necessity is seemingly obvious, I have too often been given business cards in which people write their Web site URL on the back with pencil. These are usually the same people who moved two years ago and are still penciling in their not-so-new phone numbers. Spending money on new business cards is a small investment for a small piece of advertising that tells people about your new Web site.

Want to design good-looking business cards or promotional materials? Stop by Paper Direct's Web site at: *www.paperdirect.com*. You've already got a computer, and if that's connected to a laser or ink-jet printer, you can create professional quality marketing material on your desktop using Paper Direct's paper products and software templates.

Nonstandard Forms

Wear your URL. Racing driver Jeff Gordon's safety suite has *www.jeffgordon.com* embroidered on the back. One successful entrepreneur I know almost always wears a golf shirt emblazoned with his company's logo. These are nice-looking shirts, some are even silk, but all of them get attention because you never know where your next sale might come from. Several of his clients liked the shirts so much they've asked him for one, turning *themselves* into walking advertisements for the company.

Standard Business Forms

Add your Web site URL to *anything* that bears your name and address. This includes assignment confirmation and estimate forms, rate sheets, price lists, packing lists, and transmittal forms—you get the picture.

Advertising

Take an ad out in local business publications, announcing that your Web site is in operation and inviting people to come see for themselves the kinds of images you can create. This technique may allow you to get potential buyers to look at your work, buyers who may never have seen your images using conventional print portfolio methods. Don't forget to include it in your yellow page ad!

The Photo Request Web Site

By registering as a photographer on the Photo Request Web site (*www. photorequest.com*), not only are your photographic images posted on the site, but registered photographers also have access to the request board, where they may pick and respond to requests made for certain types of photographs. A profile of the photographer is also posted on this Web site. Registered photographers are also able to enter photography contests, become judges for these contests, become the featured photographer of the month, and have their articles posted in Photo Request. The photographer's profile and photographs are then available to viewers around the world, twenty-four hours a day, seven days a week. Registered viewers can submit requests to Photo Request for a particular photograph or photographs. There is no charge for making this request. Registered viewers are also able to enter contests and submit articles dealing with photography.

Maintaining Your Home Page

Your home page must be dynamic. Next to not publicizing your Web site, the worst thing you can do is *not* make changes in your site. No matter how great the first images potential buyers see when they reach your home page, if they visit more than once—and are on the edge of becoming paying customers—they need to see something different the next time. That's one reason why it's a good idea to include a tagline on your Web site that states "Last updated. . . ." If that date is a recent one, second visitors are more likely to give you a second look.

Since many photographers are frugal and hate to waste the energy and time spent creating a Web "signature" image, why not create an archive of past images? That way new visitors can also see some of these images. Providing access to past images is simple. You only need to create a link to a new page that has small thumbnails of photographs from previous months, and give viewers the ability to double-click on the small image to take them to another page containing a larger version of that image.

How often do you need to make changes? One of the benefits of using a hit counter is that it helps you determine how often you need to make changes to your Web site, but a hit counter is double-edged. It gives you a way to track the number of people who visit your site, but if the numbers are low, those visitors may not be so impressed. Nevertheless, if you're getting a lot of hits you want to update your site on a regular basis.

Adding a Hit Counter

If, after analyzing the pros and cons of hit counters, you decide that you want one for your Web site, it's a lot easier than what I showed in the first edition. For example, I provided an HTML script that you could copy, but now I'll just point you to a Web site: *www.beseen.com.*

While at the BeSeen site, click on the "Hit Counter" button. This will take you through the steps necessary for adding a hit counter to your site. The counter will let you get hourly, daily, and monthly statistics on your site. You don't have to write an HTML script, BeSeen will do it for you. The first step is selecting the style of counter that you want; they provide eight different types. Next, you fill in some information about the site, including your e-mail address, the site subject, and the number you want to be the starting number for the hit counter. Yes, you can cheat a bit by having a number such as 5,000 to start with so that even if five people visit your site the first day, the sixth visitor will be visitor 5,006. Finally, you must agree to the terms of their service agreement, which you can view online. It looks like basic boilerplate to me, but I'm no lawyer—and I

Want a "hit counter" for your Web site? Go to *www.beseen.com* and download a free one.

don't even play one on TV. So, you can always have your attorney look over the service agreement just to be safe. When all of the blanks are filled in, you click on the Submit button and BeSeen will e-mail you the HTML script that you need to set up your counter.

To insert the Hit counter HTML code into your Web page, copy the block of code from the e-mail you received after registering. Paste this code into your Web site creation software. You should be aware that some HTML editors, such as Netscape Composer or Microsoft FrontPage, will alter the code after you paste it. If this happens, try using a plain text editor, such as Notepad or SimpleText, to paste the code.

Making Sure People Can Find You

One of the best ways of letting people know about your Web site is being listed on as many search engines as possible. This service is free, and I recommend that you contact each of the search engines listed earlier in the book to tell them about your new site. While the procedures for each search engine are a little different, here's some information about a few of the most popular ones.

The Ever-Changing Web

When approaching a portal site like Yahoo! to ask them to add your site, keep in mind, that like everything else in this book, these search engine pages operate on "Internet time." What the procedure is today may be different tomorrow, so if you don't see a button or hyperlink that I mention in the following section, poke around the Web site looking for something similar. Believe me, they want to know about everybody's Web site—including yours.

Yahoo!

How does someone get their information listed in Yahoo!? Yahoo! is a database of links to other sites; they do not provide any original content—they only reference sites that already exist. To get listed, you must first set up a page on the World Wide Web. Once that's done, you're ready to move to the next step.

The first step is to see if your Web site's URL is already listed. If it is and you don't agree with the comments, title, or placement, you need to submit a Change Form. You can access this by clicking on "How to Suggest a Site" on Yahoo!'s

Adding your Web site to the Yahoo! search engine is as easy as clicking "How to Suggest a Site" when surfing *www.yahoo.com* and filling out an on-screen form.

main page. When you get to it, you will notice that is says "How to Suggest *Your Site*" (italics mine).

Keep in mind that you cannot add your site to the top level of any of Yahoo!'s list of reserved categories. If your Web site is a hit, Yahoo! will do that for you. All businesses must be placed in a "Business and Economy" category, and all listings under the Companies and Products and Services categories will be listed in alphabetical order by the company or product name. Yahoo! requests that new Web sites confine all business additions to *one* category. Be sure to pick the category that contains the most valid choices. All others will be ignored. Personal home pages must go in the Entertainment/People category. (Sometimes your ISP will determine whether you are a "business" site or a "personal" one. Make sure to ask them that up front.) If your site is regionally specific, please add it to the respective Regional information category. Comments should be kept to fifteen to twenty words. And best of all, there is no charge for listing your site.

Excite

The Excite search engine has an easy way to add your Web site to it. Start by visiting the site at *www.excite.com.* Clicking on the "Add URL" brings you to Excite's

Getting registered with the Excite search engine consists of filling in the information in this simple on-screen form.

"Directing Targeted Traffic to Your Web Site" page that includes lots of information about how to get listed not only on the Excite search engines but also on their partner sites, which includes MSN, Alta Vista, Time Warner, NVV, Net Zero, and over 370 ISPs. The cost of what they call Excite Plus is a one-time charge of $199, but you can get into their main Excite database for free by simply entering the URL in a simple on-screen form. Thrifty photographers will want to click the Submit Now button for the "Excite Search Index Only."

In the first edition, I included information on how to get listed with the Magellan search engine, but now when you go to *www.mckinley.com*, you see a Web page that looks identical to the Excite Plus page. While you may be tempted to go with the free listing, keep in mind that for less than $200 you have access to 58 million people. The cost per person is so low that this seems a bargain to me, but you and your accountant know your financial situation better than I do.

Lycos

The Lycos portal and search engine has a link on its home page (*www.lycos.com*) called "Add Your Site to Lycos," which resembles the kind of Add Link process

Lycos has a simple, straightforward way to add your site. You should use Lycos as well as every portal and search engine that's listed earlier in the book, and any other that you uncover on your own, as a big first step in helping people find your new Web site.

that appeared in the last edition. Follow the instructions on the page, especially the suggestion to come back to the page and submit updates when any of your Web pages change. If you add images that might have broad appeal, go back to Lycos and other search engines and update your site's information.

Lycos asks only for your site's URL and your e-mail address. Once your site has been "spidered" (a spider is a computer program that surfs the Web), it will be entered into the Lycos catalog "within two to three weeks." That's the official estimate, but it will probably be sooner. The good news is that registering your site is absolutely free. You may submit more than one URL from your site as long as the URLs represent distinct Web pages; for instance, you can have one listing for stock photographs of vintage race cars, with another one for glamour photographs. Multiple pages that contain the same content should not be added, and when Lycos is giving you access to 7 million surfers for free, don't be piggy.

Cyber Theft

> *Copyright issues are beginning to develop concerning the Internet. Currently, only three cases have been decided by the courts, but disputes are expected to increase significantly with the growth of the Internet. Industry experts contend that copyright infringement can be subject to criminal penalties, but a high number of cases are managed in civil court.*
>
> Chris Nerney, Network World

The Internet represents a marketing and sales opportunity for photographers greater than any previous technological breakthrough, but it's not without a few problems. First and foremost in many photographers' minds is the possibility of digital theft of their copyrighted images.

Ali Baba and the Digital Thieves

What sends shivers down many photographers' spines is the ease in which Internet images can be illegally obtained. Most browsers, including Internet Explorer and Netscape Navigator, allow you to click on any object—like any one of your best-selling photographs—and print it, save it as a file, or copy it to the Clipboard. Once on the Clipboard, your image can be pasted into a blank document in any kind of image editing program. Because of the ease in which this copying is done, some photographers feel that they will have no real control over their copyrighted images once they are posted on the Internet. To many, it is worse than the adverse effects that the color copier or digital copy sta-

To grab an image off the Internet, all you have to do is click (or right-click under Windows) and you will see this dialog of the author's own Web site that allows the image to be copied or duplicated. Fortunately, there are ways around this problem.

tions brought to their business; some see it as the color copier from hell. Before you run screaming to your lawyer, let's back up a bit.

All of the hysteria surrounding Internet copyright issues is based on the naïve assumption that stealing images isn't already going on in the nondigital arena. We all know that it is. Even ignoring the impact of the color copier and digital copy stations, we must acknowledge that people have been stealing our images for many years. Does this true story sound familiar?

A client called me to talk about a concern that she had with the quality of some prints that I had delivered to her. It seemed that the prints of a portrait I made of the company's CEO were not acceptable and a publication they sent it to told them it was not of "reproduction quality." This sounded hard to believe, so I made an appointment to meet with the client to look at the "problem" prints. Before I went, I pulled the client's file along with a file print of the same image that she had questioned. When I went to her office, I asked to see the bad print, and she showed me the poorest quality copy print I'd ever seen. It was flat, unspotted, and covered with scratches. At that point, I whipped out the file print and told her this was the quality of the prints that I had delivered to her and without naming names suggested that someone in her organization had made illegal copies of my original prints. I left with a big print order and a client better educated in what copyright means on a practical level.

Here are a few other examples of nondigital theft: FBG, a New York stock agency, received an out-of-court settlement for $20,000 from a newspaper that was illegally copying one of its photographer's slides that had been sent for review. When a New Jersey Federal District Court awarded photographer Edward Sarkis Balian $156,000 in a copyright infringement case, he wrote, "I think a message should be sent to these defendants and frankly to those people who are similarly inclined. I think the way to get the attention of a thief is to hit him in the pocketbook." Ed Balian's fine art print had been copied with a camera mounted on a copy stand with nary a pixel to be found anywhere.

Basic Copyright Protection _____

One of the most obvious ways to protect the rights of your digital images is with a visible copyright symbol. One of the easiest ways to include this symbol is to use your image editing programs. The one that I use is a Macintosh shareware Photoshop plug-in ($10 fee) called Watermark, which was created by John Dykstra; it adds a faintly visible copyright symbol, "©", to the image being edited. When used on an image that will be distributed in digital form, it allows clients to evaluate that image and use it for FPO (For Position Only) and comp purposes while preventing unauthorized usage. To use this plug-in, you must have a TrueType version of the Times font installed. To use Watermark, select it from Filter's "Other" hierarchical menu. A dialog box will appear, allowing you to specify how much the copyright symbol will affect the image. A value of 1 is almost invisible; a value of 99 results in a complete reversal of the image underneath the watermark. The Repeat field controls how many times the copyright symbol is placed horizontally across the image. The default setting of 1 produces a single symbol scaled to cover the current selection. Clicking the OK button in the filter's dialog box will create the watermark. If the filter processing takes more than a couple of seconds, a status window will appear to show you Watermark's progress.

Watermark is available from the Adobe Photoshop library on CompuServe and from other online and shareware resources. This software is shareware, and if you use it for commercial purposes, or if you keep a copy of it after the initial two-week evaluation period, please pay for it. Besides keeping your conscience clear, your payment will ensure that Mr. Dykstra and other shareware developers will continue to provide you with useful and inexpensive software. The shareware fee for Watermark is $10 U.S.

Image Size and Resolution

One of the most powerful protection tools you have at your disposal is the ability to create small, low-resolution images. Here's a three-step process for reducing file size and resolution while only minimally affecting on-screen appearance. I use Adobe Photoshop, but other programs have similar ways to adjust image size and resolution; check your user's guide.

After opening your photograph, use the Image Size command in the Image menu. When you do, a dialog box appears showing the image's height, width, and resolution. Next, change the number in the resolution field to 72 dpi. Doing this dramatically reduces the file size. When changing the resolution to 72 dpi for a 16.2MB TIFF image, for example, its size was reduced to 968K. To carry this process one step further, save the file in a compressed format like GIF (or JPEG). When my test image was saved as a medium resolution JPEG file, its size was fur-

ther reduced down to 162K. One last step you can take is to use that same Image Size dialog box to reduce the physical size of the photograph. Since, unlike with a print, it will be viewed quite close, why not make the digital image wallet-sized? The resulting file will look fine on-screen, but if downloaded and printed, will have less-than-usable quality. Will this reduction in quality be bad enough to scare a digital thief? The sad answer is it will deter some, but not all.

You can extend this resolution-based protection by using a utility like Digital Frontier LLC's HVS Color plug-in. This useful software tool is designed for Adobe Photoshop and compatible programs, and allows you to convert 24-bit images to 8 bits with no visible loss in quality. The results allow you to have realistic photographic images saved as GIF files, providing all the advantages of 24-bit images, but at less than a third of the file size. Because HVS Color achieves its effects without dithering, your GIF files will compress 5 to 40 percent better, meaning less download time for your Web pages. HVS Color provides a superior method of reducing images with 17 million colors to 256 or less colors with no visible image degradation. A built-in threshold mechanism allows selective flattening of dark and light colors, which also has a positive effect on compression. For the protection minded, this compression means that displaying your image with 50 colors instead of 17 million makes it more difficult for viewers to use for anything other than on-screen viewing. At the same time, on-screen viewing will be improved. HVS Color allows the user to achieve 24-bit image quality using an 8-bit system, without dithering or any visible banding. The product is available as a plug-in for Mac and Windows versions of Adobe Photoshop and compatible image editing programs, as well as for the custom code modules found in Equilibrium Technologies' DeBabelizer file conversion utility for both 68K Macintosh and Power Mac.

Post a Notice

Just as you can post "No Trespassing" signs on your property to keep interlopers out, the first thing you need to do when setting up a Web site is to post a notice saying "No Stealing Allowed." Rohn Engh, author of "Sell and re-Sell Your Photos," suggested posting a legal notice on your Web site relating to the photographs that appear there. Here is his suggested warning label:

> Image Restrictions: Each image on this Web site is legally protected by U.S. and International Copyright Laws and may NOT be copied and used for reproduction in ANY way unless arranged for in writing. All pictures on this Web site are Copyrighted © [YOUR NAME] and are for Web browser-viewing only. Usage of any image (including comp usage) must be negotiated. No image on this Web site may be used for any purpose without express written consent of the Copyright

holder, [YOUR NAME]. Unauthorized duplication of these images is prohibited by U.S. and International Copyright Law. In the event of an infringement, the infringer will be charged triple the industry-standard fee for usage, and/or prosecuted for Copyright Infringement in U.S. Federal Court, where they will be subject to a fine of $100,000 statutory damages as well as court costs and attorney's fees. (Quoted by permission from PhotoSource International, producers of the stock photographer's directory, *The PhotoSourceBook.*)

Digital Protection

In addition to visual deterrents you yourself can put on your photographs, a number of Web-based programs have been developed for the purpose of tracking your photographs once they are online. Embedding invisible data in each of your images, the following programs make it possible for you to police the use of your photographs, even after they have been printed, cropped, or photocopied.

Web Police

Some Web sites have started using EquitySoft's ImageSafe program, which converts photographs into Java "applets" that block people from copying or saving the image files. Since an applet is a small program executed within a browser, copying an image is much more difficult than grabbing a GIF or JPEG file. The only downside to using ImageSafe is that the applets it creates are not currently compatible with Mac OS browsers. As the popularity of the iMac and this kind of software soars, I expect that incompatibility to change. If you're interested in learning more about ImageSafe and other Web-oriented products, visit EquitySoft's site at *www.kagi.com/equitysoft*.

Alchemedia is a company that offers online copyright protection for images via its PixSafe product that is designed for corporations or stock photo libraries. Although the company works to bring this technology to individual photographers, they've established a free Web site at *www.cleavercontent.com*, which allows

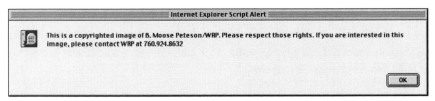

ImageSafe protects photographs on a site by making images hard to grab. This is what you see on Moose Peterson's Web site (*www.moose395.net*) if you click on an image with a browser in an attempt to copy it.

pixographers to post a limited number of protected images. The only problem has been that the Clever Content image viewer needed for people to view these protected images was only available for Windows-based computers. Just before I was finishing this edition, Alchemedia announced that the Macintosh version of Clever Content Viewer was available.

Clever Content technology prevents the copying, printing, or screen-capturing of digital images. Macintosh users, many of whom work in photography, graphic design, or related fields, will now be able to use the free Clever Content Viewer to see protected image catalogs. Other Clever Content Products include:

- **Clever Content Server:** An application for companies that have dedicated servers allowing content owners to protect and control the use of their digital images. The Clever Content platform is comprised of image-protection software for Windows NT and Sun Microsystems' Solaris, installed on the host server along with a JAVA-based, platform-independent, remote-management tool that is used to select which images are to be protected.

- **Clever Content Viewer:** This is a free browser plug-in supporting both Windows and Macintosh browsers, implemented as an ActiveX Control for Microsoft Internet Explorer and a SmartUpdate for Netscape Navigator.

- **Clevercontent.com:** A free Web service that allows individuals to create an online portfolio containing ten images and that protects those images from being copied, printed, or screen-captured.

For more information about any of these products and services, visit Alchemedia's Web site at *www.alchemedia.com* or *www.clevercontent.com*.

BayTSP.com scans Web sites on your behalf looking for copyright infringements and alerting you to violations that deserve your immediate attention. Once an infringer is identified, BayTSP.com automatically notifies you and can issue a Digital Millennium Copyright Infringement notice to the violator and his or her ISP. It identifies your images without tagging or watermarking them; they stay as they are. Much like human DNA, digital files contain a certain inherent unique makeup. Even if your images have been cropped, slopped, and dropped, these characteristics remain, and the company's BaySpider polices the Internet twenty-four hours a day, seven days a week, looking for sites that are illegally using your copyrighted photographs. You can get more information on this unique service at *www.baytsp.com*.

Digital Watermarking

In addition to the slightly visible copyright watermark discussed earlier, Adobe Photoshop also offers a software plug-in called Imagemarc Lite from DigiMarc Corporation. DigiMarc's technology allows image creators to imbed an invisible digital watermark on an image. The watermark carries an "image signature" that contains copyright and owner contact information in the form of a creator serial number. This number can include full contact information available via the Internet. The watermark is part of the image and remains so even when printed— and can be read later by scanning the image into a computer. Imagemarc Lite is designed to integrate with image tools and Web browsers so that, as an image is opened by programs such as Adobe Photoshop or Netscape Navigator, the user is informed that a watermark is present. Clicking on an icon allows the user to view the image signature to discover the photographer's contact information. This watermark persists through copying, editing, downloading, and even through photocopying and color print reproduction. More information can be found at *www.digimarc.com.*

Signafy's digital watermarking uses technology that is based on a method that the company calls "Invisible Ink," which places a permanent, nondestructible digital watermark inside your images. Their software, called OwnerMark, is a proof of ownership application that was designed for Windows computers. The

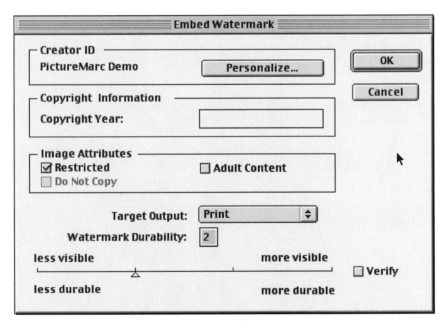

Adding an invisible copyright watermark to your photographs is as simple as using the DigiMarc plug-in found in Photoshop's Plug-in menu. When you select it, this is what you see.

program imbeds an invisible digital watermark that is constructed from characteristics of the original photograph. Even image-editing operations such as scaling, cropping, or manipulating brightness, contrast, or color won't affect the marked photographs created with OwnerMark. Even if the image is compressed, the watermark will remain. The program supports fifty image file formats including TIFF, JPEG, JFIF, PCX, TGA, Photo CD, BMP, PICT, and SGI. If you discover one of your photographs being used in print or on the World Wide Web, your watermark will prove ownership and copyright of the original image. Placing a tag on every image on your Web site, along with a statement that images are protected by Signafy's OwnerMark software, should help cut down on digital theft. You can even add a "Do Not Copy" watermark on images that you sell or license. More information and a free trial version of the program can be found at *www.signafy.com.*

It's a Jungle Out There

The bottom line is that your images are as safe on the Internet as they are anywhere else. Once the images leave your hands—no matter what form they may be in—they are fair game for thieves, goniffs, and other rip-off artists. What you can do regarding digital images is to work smart and take all the reasonable precautions that you can, while never losing sight of the fact that *nothing* will prevent a determined thief from stealing your copyrighted images.

To most people, the Internet is a useful tool. We use it to send e-mail, research new cameras, and download scanner driver updaters. The World Wide Web is a giant repository of knowledge, and you can find more information online than in any library since they burned down the "big one" in Alexandria, Egypt.

Those who don't actually use the Internet and who get their information from what *people* say about it take a different view. They see the Internet as a hunting ground for pedophiles and as the biggest dirty bookstore on earth. The sad truth is that this is the dark side of the Web that polite computer users seldom like to talk about—even though it's there for all to see. Another ugly side of the Web is that many people quote sources on the Internet as if it were the *New York Times* or the *Wall Street Journal* with a staff of fact checkers. What you see and read on the Net is just as likely to be misinformed as it is to be accurate.

Although I surf the Internet looking for information about the latest Photoshop plug-ins, I prefer to play with analog toys such as model trains or automobiles. I'll confess to having used many different digital imaging tools and techniques to

create photographs of cars, but I prefer lying on the ground and having oil drip on me over having a mouse clutched in my right hand while surfing the Net for fun. I'm afraid we are breeding a new generation of young people whose epitaphs will read, "He lived, he surfed, he died."

In truth, the Internet has come to reflect *all* of humankind, and that includes the good, the bad, and the ugly. Congress passed and the President signed the Communications Decency Act, whose goal was to restrict access of images deemed "indecent" to adults. The Supreme Court, who has struggled with the definition of pornography since the American publication of Henry Miller's *Tropic of Cancer*, has ruled portions of the Decency Act to be unconstitutional. As I write this, our elected representatives have passed the Child Online Protection Act, which will require some kind of adult verification or credit card number for one to enter any Web site that is deemed "harmful to minors." This will make the pornmeisters who offer free sites that draw income only from hits on banner ads ecstatic. Even if they only charge a quarter for access to their dirty pictures, they will become instant billionaires and stimulate the progress of e-commerce one hundred times more than every legitimate business that uses the World Wide Web.

Coming soon to a Web site near you will be an Internet rating system. Congress wants it, Internet porn hustlers want it, and parents think they want it because they believe such a system will be as effective as movie and TV ratings. I think that more people understand quantum mechanics than understand the TV rating system. The porn pushers want an Internet rating system because they feel it will inoculate them against potential lawsuits from parents or silk-suited lawyers looking to shift the blame for sex crimes from the perpetrator to anyone else.

I think that the best solution to the problem of keeping young people away from smut is for parents to simply talk to their kids about it. Nanny software won't work, and parents shouldn't abdicate their responsibility to a software pro-gram. Instead, they need to do what one of my friends did when he found his son's Zip disk chock-full of pornographic images. A professional photographer, he explained to his son that nudity, in and of itself, is not offensive, but that most of these images were clearly not artful. He tried to explain to his son the difference between art and smut—not any easy task. I'm sure it was difficult for both parent and child, but I can't help feeling they are both better from the expe-rience.

The Family and the Internet

If you haven't already discovered it yet, there is more to life than technology: There is family. Nothing is more important to me than my Dad, sisters, nieces

and nephew, and my daughter. I have deeply religious friends who hate the Internet, not because they actually ever accessed it, but because of what other people (who may not have even used it themselves) have told them about the Net. I have told them what's good about the Internet—e-mail for starters. My family and my wife's family live over a thousand miles away from us, and while we do write a few *snail mail* letters and send greeting cards, some people today just don't like to write. E-mail helps people who care about each other keep in touch, and receiving an e-mail message from my sister Kate or brother-in-law Jerry always cheers me up.

When uninformed people talk to me about the evils of the Internet, I mention one name: Denise. Denise is my grown daughter, whom I had not seen since she was five years old. I won't bother you with the details, which involve a messy divorce and my moving 1,800 miles away from my hometown. The last time I had heard anything about my daughter was more than ten years ago when my mother sent me a newspaper clipping announcing that Denise was getting married. As I got older and the reality of mortality set in, I decided to try to find my daughter and tell her about myself.

At first, I tried finding her by looking in the phone book in the town she used to live in, but that didn't work. She had moved, but I didn't know where. In true geek fashion, I tried using one of those directory CD-ROM packages that supposedly have the names, addresses, and phone numbers of everybody, everywhere in the known universe. I used all of the commercially available packages but couldn't find my daughter's name listed anywhere. When I went to trade shows, like MacWorld or COMDEX, I asked the companies that made those products to check using their latest versions, but she was never listed in any of them.

My search went on for several years and finally, in a moment of desperation, I wrote a letter to my ex-wife asking for Denise's address. It was the hardest letter I had ever written in my life, and, for whatever reason, I never received a reply. As a final resort, I decided to ask my friend, Mike, who is a private detective specializing in finding people—even those who don't want to be found. I left a message on his voice mail, but he was out of town, probably searching for somebody's lost love.

Before Mike got back from his road trip, a friend of my wife Mary told her about a Web site called *www.switchboard.com*. Together, Mary and I logged onto the site and typed in my daughter's married name, including her middle initial, and it showed two people with that exact name in two different states. Since I knew her husband's name, I entered her husband's name and got a match for one of the addresses.

Next, I wrote the second most difficult letter in my life to a child I had not seen in almost thirty years. I kept the letter short and kept it honest, dropped it in the box at the post office, and waited. And waited. A month later, a letter

The place to find a long-lost love or old Army buddies is *www.switchboard.com*. It can also help photographers looking for photo-related businesses that they may have heard about but could never find. Switchboard.com is a wonderful resource that only exists because of the World Wide Web.

appeared. In it were photos of Denise and her husband along with two grandchildren whom I never knew existed. By this time, it was close to Christmas, 1997, so my wife and I did some shopping for the grandkids, which thrilled us almost as much as the photographs that Denise later sent showing the kids playing with the toys.

Letters were sent back and forth between Denise and me and my wife, and I decided to make a trip back to the East Coast to see my father and sisters and hopefully meet with Denise. Instead of writing to respond to my letter about the upcoming visit, she called me late one Sunday night, and after almost thirty years a father and daughter spoke together. She cried, I cried—it was quite a moment. We made a lunch date to see one another in the small town where she lives.

When the time came for the lunch, Mary dropped me off at the restaurant

early; I didn't want to be late, in case she was early. It was the longest twenty minutes of my life and she was a little late. While I waited, I sat there, wondering if she would show up at all, and reliving every mistake I had made in my short relationship with her. She walked through the door of the restaurant looking just like the photograph she had sent me, and we hugged for the first time in a long, long time. After a lunch in which we both pecked at rather than ate our food, we compressed thirty years into an hour, and at the end of our non-lunch, she asked if I wanted to meet her children. Mary had returned and was waiting for me in the parking lot, and I introduced her to my daughter. We followed Denise to her home where we met her husband and my grandchildren. It was just a day after my granddaughter's birthday, so Mary and I had brought her a teddy bear as a gift. It was an afternoon that will live in my memory forever.

There are no fairy tale endings here: My daughter and I still live 1,800 miles apart, and I can only afford occasional trips back to see her, but the Internet helps. She now has an e-mail account and we occasionally correspond electronically. We may never have a *Father Knows Best* relationship, but because of the Internet she knows who her father is and I got to meet my grandchildren.

So, the next time somebody says that the Internet is the devil's playground, you tell them my story and remind them that the angels play there too.

Appendix A: Glossary of Internet Terms

The Internet uses a patois of computer, telecommunications, and made-up, whimsical, geeky terms that will send you running and screaming, looking for a dictionary trying to find out what FTP means. The following list of terms includes some imaging buzzwords that photographers navigating the Internet should know, along with bunches of acronyms that are needed to upload or download files to and from the World Wide Web. While not all-inclusive, it should help when reading this book or other books and magazines about digital imaging and the Internet.

ADSL: Asymmetric Digital Subscriber Line is the most familiar for home and small business users. It is called asymmetric because most of its two-way bandwidth is devoted to sending data to the user—often called *downstream* in the lingo of DSL. Using ADSL, up to 6.1 megabits per second of data can be sent downstream and up to 640 Kbps *upstream*. A portion of the downstream part of the connection can be used for voice communications, so you are really getting two lines for the price of one: one for data, one for voice.

AGENT: *See* Intelligent Agent or Spider.

ALPHA CHANNEL: Within Adobe Photoshop, this is a separate channel of the image that is tagged onto the traditional red, green, and blue channels containing a value that indicates the amount of transparency for each pixel. The alpha channel is where Adobe Photoshop stores transparency information.

ANCHOR: A spot on your Web site that is linked to places on the same Web page or on other Web pages.

API: Application Program Interface. A format used by a software program to communicate with another program that provides services for it. APIs carry out lower-level services performed by the computer's operating system. In Microsoft Windows, an API helps applications manage windows, menus, icons, and other graphic user interface elements.

ARCHIE: Archie is an acronym loosely based on the word "ARCHIvE." Until the World Wide Web came along, if you wanted to search the Internet, you only had a few choices: Archie, Veronica, and WAIS. Archie is an Internet utility that is used to search for file names. Over thirty computer systems on the Internet act as Archie servers and maintain catalogs of files available for downloading from FTP sites. On a random basis, Archie servers scan FTP sites and record information about the files they find. Several companies, such as Hayes, offer software that provide a menu-driven interface that lets you browse through Archie servers on the Internet. Archie can be reached at *archie.mcgill.ca* and *archie.sura.net.*

ARPANET: A computer network created in 1969 by the Advanced Research Projects Agency of the U.S. Department of Defense to enable scientists to communicate with one another. This was the real beginning of the Internet and consisted of four computers. By 1972 fifty universities and research sites had access to it.

ASCII: The American Standard Code for Information Interchange. ASCII is a standardized computer code for representing text data. The code has ninety-six displayed characters (characters you can see on the screen) and thirty-two nondisplayed characters (some of which you can see, others that you can't).

AT: The commands used to control any Hayes-compatible modem are typically called the AT Command Set and are so named because each command must begin with the letters AT, which stand for ATtention Code.

AVATAR: In Hindu mythology, the form taken by a deity when descending to earth. The *American College Dictionary* prefers a more down-to-earth use as a concrete manifestation or embodiment. Both definitions seem to fit the computer-related meaning popularized in the science fiction novel, *Hacker & the Ants,* which defines the term "avatar" to be a way of representing a user in a 2-D or 3-D virtual reality world.

BINHEX: Binary Hexadecimal is an algorithm for representing nontext Macintosh files (such as software, graphics, spreadsheets, and formatted word-processing documents) as plain text so they can be transferred over the Internet. The file-name extension *.hqx* designates a BinHex file.

BISDN: Broadband ISDN is built on fiber-optic technology that increases ISDN's potential to a top data transmission speed of 155,000,000 bps.

BITMAP: Graphics files come in three classes: bitmap, metafile, and vector. A bitmap (formerly known as a raster) is any graphic image that is composed of a collection of tiny individual dots or pixels—one for every point or dot on a computer screen. The simplest bitmapped files are monochrome images composed of only black-and-white pixels. Monochrome bitmaps have a single color against a background, while images displaying more shades of color or gray need more than one bit to define the colors. Images, like photographs, with many different levels of color or gray are called *deep bitmap*, while black-and-white graphics are called *bilevel bitmap*. A bitmap's depth is permanently fixed at creation. The screen shots that accompany this dictionary have a resolution of 72 dpi (dots per inch). No matter what I do, I can't change this. I can make them bigger, but not better.

BOOLEAN SEARCH: A search for specific data that gives you the ability to specify conditions and allows you to use one or more of the Boolean expressions, AND, OR, and NOT. (Don't let the term "Boolean" scare you. It comes from Boolean logic, in which an answer is either true of false, and was developed by English mathematician George Boole in the mid-nineteenth century.) An example of a Boolean search would be "find a photo lab that processes black-and-white film AND Kodachrome." Database programs typically allow you to make Boolean searches for data and so should a good Internet search engine.

BPS: Bits per second, sometimes called baud.

BRI: The Basic Rate Interface for an ISDN connection includes three separate channels—two B channels and one D channel—as standard. This means you can be talking on your telephone and surfing the Internet at the same time.

CCS: Cascading Style Sheets. This is an extension of HTML that allows styles, such as font color, to be specified in a HyperText document.

CERN: European Center for Nuclear Research was the original designer of the World Wide Web.

CDSL: Consumer DSL is Rockwell's trademarked version of DSL that is somewhat slower than ADSL (providing 1 Mbps downstream, and something less upstream), but it has the advantage that additional hardware, called a *splitter*, doesn't have to be installed at the photographer's location.

CD UDF: Compact Disc Universal Disc Format. A new disc format that defines a common scheme called "packet writing," established to assure the inter-

changeability of CD-ROM discs, and allowing CD-ROM drives to be integrated into computer systems so that they behave like any other removable media drive. CD UDF also creates a bridge between CD-ROM discs and the format selected for Digital Video (Versatile) Disc media. The CD UDF format was developed and proposed by the Optical Storage Technology Association (OSTA) by an alliance of companies, including Adaptec, Hewlett-Packard, Phillips, and Sony. More information can be found at OSTA's Web site: *www.osta.org.*

CGI: (1) Common Gateway Interface scripts are programs that run on a Web server to process all this activity and extend the capabilities of the server. Browser software enables computer users to view your home page. (2) Computer Graphics Interface is a device-independent graphics language that is used for display, printers, and plotters. It is an extension of another language. *See* GKS.

CHANNEL: As used in digital imaging, channels are similar to the plates or separations found in the commercial color printing process. In an RGB image, you will find separate channels for Red, Blue, and Green, along with a composite RGB channel. Adobe Photoshop and similar programs include a channels palette that allows you to look at—and manipulate, if you wish—each specific color layer. Channels are different from "layers." (*See* LAYER.)

CLIENT: (1) Within the context of the Internet, this is software that requests information. A WWW browser, such as Microsoft Internet Explorer, is often referred to as client software. (2) In more traditional (hardware) usage, a client is a computer—sometimes called a workstation—attached to a local area network (LAN).

COCOA: COmputations in COmmutative Algebra, a graphical programming language.

CODEC: COmpression/DECompression. Usually codec refers to a hardware product that produces compression and decompression for video—especially videoconferencing.

COMPUSERVE: A computer network, started and originally owned by tax accountants H&R Block and now owned by America Online, that can be accessed by subscribers to the service by using a modem. Using an online service lets you get up-to-date information as well as minor software upgrades (especially drivers for printers, scanners, and monitors) from the companies that produce these products.

CompuServe has a minimum monthly billing that includes a number of hours of access time. One of the fun places CompuServe can take you is its Photography Forum. (CompuServe calls sections of the network where people with common interests congregate, "forums.") A forum's message section allows you to post messages on what amounts to a community bulletin

board eliciting feedback and comments from photographers all over the world. If you want to keep it private, use e-mail. The libraries are places where members of the forum post images and shareware and/or freeware. You can also go to the online libraries listed to download information from the different conferences mentioned in the Newsflash. From time to time, conferences are held with experts available to answer your questions. These are live conferences and can include hundreds of electronically connected participants from all over the world. Some may ask questions and offer opinions, while others (called "lurkers") sit quietly and absorb what's being said. The first time you participate in a worldwide conference you will know what Buckminster Fuller meant by "global village."

Another forum—for pros only—is called the Photo Pro Forum and it has sixteen sections, including some reserved for members of the Professional Photographers of America (PPA) and the American Society of Media Photographers (ASMP), covering everything from darkroom techniques to cameras to stock photography and business matters.

Fuji Photo Film and Polaroid have forums, and there are tons of forums on Microsoft Windows and Macintosh-related subjects. Large software manufacturers, like Adobe, have their own forums where you can download updates that can fix any of your program's bugs, or you can just ask questions of experts about a given program. Smaller manufacturers, like Berkeley Systems, can be found in one of the Vendors forums that gather ten or so companies together. It would be hard not to find answers to your business or photography questions.

COOKIE: Originally a term associated with a network software component of UNIX, these are software entities that store information about a specific user—you—so that the next time this information is required, it is seamlessly provided. For example, if you access parts of the Web that require a separate password for entry, the cookie file saves it and, when requested, provides the information to a "smart" server or Web site, thus allowing instant access. Cookie files store information—originally provided by you—in a (generally) unreadable text file for future access. Netscape Navigator uses a COOKIE.TXT file for this purpose.

DCT: Discrete Cosine Transform. A bit-rate reduction algorithm that is used in JPEG image compression to convert pixels into sets of frequencies.

DDS: Digital Dataphone Service is an AT&T private line digital service that provides transmission rates from 2,400 to 56,000 bps. Not to be confused with a DAT (Digital Audio Tape) format used for creating data back-ups called Digital Data Service. Doesn't having two computer-related terms having the same initials make you wish there was an acronym czar?

DESPECKLE: The despeckle filter found in Adobe Photoshop (and other image

editing programs) detects the edges of an image—where significant color changes occur—and blurs a selection except the edges. This has the effects of removing noise while preserving detail.

DLL: Dynamic Link Library. Microsoft Windows (3.1, 95, and NT) use dynamic link libraries as a standard method for linking and sharing various functions of the operating system. When a program is launched through the Windows 95 Start menu, the program calls for and causes one or more DLLs to be loaded to assist the program with what it does. It could be sound support, graphics file translation, or, in short, any repetitive operation that might be shared by several applications.

DMA: A circuit on a computer's motherboard that provides direct access to a peripheral, like a removable media drive, bypassing the microprocessor chip to speed data throughput.

DNS: Domain Name System. A general purpose distributed, replicated, data query service used on the Internet from translating host names (where the computers/severs are) into internet addresses, such as *www.kodak.com.*

DOM: Document Object Model. This is a World Wide Web Consortium specification for the application program interface (API) for accessing the content of HTML and XML documents.

DSP chip: Digital signal processor chip.

E-ZINE: Electronic Magazine. (Sometimes referred to as "Webzine.") Current estimates place the number of purely electronic magazines (as opposed to electronic versions of traditional print media) on the World Wide Web at three hundred. One of the highest profile e-zines is *Slate,* edited by writer, pundit, and TV personality Michael Kinsley, and produced by Microsoft, but there are many others on the Web.

FAQ: Frequently Asked Questions. A term, often found on Internet home pages, that will lead you to an area containing the most frequently asked questions that visitors to the Web site may have. For the photographer, this is an excellent way to answer the number one question: How much will it cost? A FAQ section in your own home page is the perfect place to post your rate sheet and terms and conditions that address other potentially contentious questions such as ownership rights and charges for additional usage. Getting these sticky issues out of the way—even before sending, faxing, or e-mailing an assignment confirmation/estimate form—will make for smoother negotiations on an assignment or stock image purchase later on, and in future dealings with a picture buyer.

FITS: Functional Interpolating Transformational System technology used by the Live Picture image manipulation program. Under FITS, an image isn't stored pixel by pixel, but rather is stored as a mathematical formula that allows files greater than 100MB to be manipulated as quickly as 1MB images.

FreeDSL: is the name of a company (*www.freedsl.com*) that offers free ADSL hardware and setup with no monthly charge for service. In exchange, users must agree to provide personal information and to have a small navigational bar containing advertising that's always visible while they are connected. More information on how this freebie service works can be found at their Web site.

FreePPP: A control panel device needed to set up the PPP connection using the CompuServe local access number. FreePPP is commonly used for PPP dial-up and is not a CompuServe product. CompuServe's own PPP Utility will set up the FreePPP and MacTCP configuration and preferences for Internet access through CompuServe.

FlashPix: A new, open standard for digital imaging developed by a consortium of companies, including Eastman Kodak, Hewlett-Packard, Live Picture, Inc., and Microsoft. The format will use a hierarchical storage concept, allowing images to take less RAM and hard disk space than previous image-based graphics files. This will allow users to work with many on-screen images at the same time without overloading the computer's memory or adversely affecting performance. Edits will be easier, especially nondestructive edits, such as rotation, scaling, and color and brightness adjustments. This means that users will be able to experiment with changes and quickly undo them, without destroying original image data.

FTP: File Transfer Protocol is that part of the TCP/IP protocol that lets you send and receive files on the Internet.

FUZZY SEARCH: The least common type of search (in search engines) uses so-called "fuzzy" logic to look for data that is similar to what you are trying to find. (Fuzzy logic was originally conceived in 1964 by Lotfi Zadeh, a science professor at the University of California at Berkeley, while he was trying to program computers for handwriting recognition.) This is the best approach when an exact spelling may not be known or when you are looking for related information. If you're looking for information on the images of Jerry Uelsmann and don't know how to spell his name (I always have to look it up), you can type in "Ulesman," and a fuzzy search could lead you to the correct location.

G.Lite: Sometimes known as DSL Lite, this is basically a slower version of DSL. It's officially ITU-T standard G-992.2 and provides a data rate of 1.544–6 Mbps downstream and from 28–384 Kbps upstream.

GIF: (Pronounced like the peanut butter.) The Graphics Interchange Format developed by CompuServe is a completely platform-independent, compressed bitmapped file. The same file created on a Macintosh is readable by a Windows graphics program. Because some image and graphics programs consider GIF files to be indexed color, not all software reads and writes GIF files, but many do.

When CompuServe developed the format, it used the Lempel-Ziv-Welch (LZW) compression algorithms as part of the design believing this technology to be in the public domain. As part of an acquisition, UNISYS (formerly Univac computers) gained legal rights to LZW, and a legal battle has ensued. The way it stands now, reading and possessing GIF files (or any other graphics file containing LZW-compressed images) is not illegal, but writing software that creates GIF (or other LZW-based files) may be. In late 1994, CompuServe and UNISYS announced that royalties would be required on the GIF file format.

In response, developers worked to replace the GIF file format with an improved royalty-free format. A coalition of experienced independent graphics developers from the Internet and CompuServe formed a working group and proceeded to design the new format. The result is the PNG format.

GKS: Graphical Kernel System is yet another device-independent language for 2-D, 3-D, and raster graphics images. It allows graphics applications to be developed on one system and easily moved to another with minimal or no change. The CGI used on the World Wide Web is an extension of this language. (*See* CGI.)

GOPHER: A software tool that enables you to browse Internet resources. It was developed by programmers at the University of Minnesota—home of the *Golden Gophers*—and features a menu that allows you to "go for" items on the Internet, bypassing the typical complicated addresses and commands. You can navigate the Internet using Gopher by selecting the desired item from a series of lists and continuing through a series of lists until you locate the information you are seeking. While Gopher is a software program, Gopher sites are often called simply "gophers."

HDSL: High bit-rate DSL was the earliest version of DSL and is symmetrical in that an equal amount of bandwidth is available in both directions, which means that the maximum data transfer rate is lower than for ADSL.

HREF: HyperText reference. The address (*see* URL) of the destination of a HyperText link.

HTML: HyperText Markup Language, a format used on World Wide Web home pages on the Internet that uses multimedia techniques to make the Web easy to browse.

HTTP: HyperText Transport Protocol. The communications protocol used on the Internet—specifically the World Wide Web—to share information. The first part of any Web site address is: *http://*

IAB: The Internet Activities Board is ostensibly the Internet's governing body.

IDSL: ISDN DSL is really more similar to data rates and service at 128 Kbps than to the much higher rates of ADSL.

IETF: Internet Engineering Task Force, a subcommittee of the IRTF that works on specifications for new standards for the Internet.

IMAP4: Internet Message Access Protocol, version 4. A protocol that allows a client (your computer, for instance) to access and manipulate e-mail on a server. It permits manipulation of remote message folders, or mailboxes, in a way that is similar to a local mailbox. This is why I can log onto a computer in Germany and check the e-mail in my Juno account in the United States.

INDEXED COLOR: There are two kinds of indexed color images: those with a limited number of colors, and pseudocolor images. The number of colors for the first type is usually 256 or less. Pseudocolor images are really grayscale images that display the variations in gray levels in colors rather than shades of gray, and are typically used for scientific and technical work. CompuServe's GIF format creates files in indexed color. Before image enhancement programs like Adobe Photoshop can use GIF files, they have to be converted into RGB format.

INTELLIGENT AGENT: (sometimes just called "Agent") This is software (or hardware, too, for that matter) that has been taught something through the use of heuristic programming techniques. An agent can therefore be taught your preferences and then do something according to those preferences. It can, for example, know that you always log on the Internet in the morning and go to a certain Web site and look for new information about new photography products or film. Therefore it can be programmed to do that automatically as soon as you launch your Web browser. The possibilities are much greater than that, however, and the use of Intelligent Agents will be increasingly prevalent in both Internet and system software.

INTRANET: A private computer network that has the same look and feel as the World Wide Web and combines HyperText links with text-based information, animation, graphics, and video clips.

IP: Internet Protocol. This is the IP part of TCP/IP and is the protocol used to route data from its source to its destination over the Internet.

IPTSCRAE: (Pronounced "ipt-scray," like the pig-Latin word for "script.") IptScrae is a programming language that can be used to create special event-handlers, which can be attached to doors, hotspots, and props. IptScrae can be used to make online virtual reality environments like Robert Farber's *www.photoworkshop.com* an interesting place.

IRC: Internet Relay Chat. A system that allows users to interact in real time with other people connected to the same channel. Some pundits have likened IRC to Citizens Band Radio, and for years the Citizens Band Simulator on CompuServe has been a popular area for its subscribers.

IRTF: The Internet Research Task Force is a subcommittee of the IAB that investigates new technologies, which it then refers to the Internet Engineering Task Force.

ISDN: Integrated Services Digital Network is the international standard for trans-

mission of voice, data, and video at 64,000 bps over completely digital circuits and lines. Because this is a purely digital system, modems are replaced by simpler terminal equipment connecting computers to the telephone network. Two problems are standing in the way of widespread acceptance of ISDN: the high cost of terminal equipment and the high costs for telephone companies to upgrade their central office hardware and software to ISDN.

ISP: Internet Service Providers. Companies that offer direct access to the Internet through local or toll-free telephone connections, often at a flat ("all you can eat") rate.

ITU–T: International Telecommunication Union–Telecommunications Sector. The ITU-T is responsible for making technical recommendations about telephone and fax standards. It was previously known as CCITT (Comité Consultatif de Telagraphique et Telephonique).

JAVA: (Not an acronym.) Sun Microsystems' Java is an object-oriented programming language that uses the most useful features of other languages, yet remains easy to use. It was created to construct software for embedded systems in the electronics market, and originally began as a subset of the C++ programming language and other languages. It is different from traditional C-based languages because it is portable. Java 1.0 enables developers to write small applications (*applets*) that can be embedded in a Web site using a standard HTML tag and can transfer these *applets* from a server to a user's Web browser where they can be viewed on-screen.

JPEG: JPEG is an acronym for a compressed graphics format created by the Joint Photographic Experts Group, within the International Standards Organization. Unlike other compression schemes, JPEG is what the techies call a "lossy" method. By comparison, the LZW compression used by other processes, such as CompuServe's GIF, is lossless—meaning that no data is discarded during the compression process. JPEG, on the other hand, achieves compression by breaking an image into discrete blocks of pixels, which are then divided in half until a compression ratio of between 10:1 to 100:1 is achieved. The greater the compression ratio that is accomplished, the greater the loss of sharpness you can expect. JPEG was designed to discard information the eye cannot normally see, but the compression process can be slow.

LAP: Link Access Procedures are a family of ITU error-correction protocols.

LAYER: This is the digital equivalent of the clear Mylar, or "onionskin" paper, that artists place over a graphic element or photograph so additional images may be drawn or placed over the original design. In image-enhancement programs, like Adobe Photoshop, layers can be used for creating separate—and cumulative—effects for an individual picture. Layers can be manipulated independently, and the *sum* of the individual effects on each layer make up

what you see as the final image. Since the contents of a layer can be an object, layers are treated as different from channels.

LDAP: Lightweight Directory Access Protocol, a relatively simple protocol for updating and searching directories running over TCP/IP (Transmission Control Protocol over Internet Protcol).

LED: Light Emitting Diode. LEDs use less power than normal incandescent light sources.

LINUX: A shareware version of the UNIX operating system that has been designed to operate on PCs. The current version will run on 386 and faster machines and is available through download on the Internet. Another source is a series of Linux-based CD-ROMs from Pacific Hi-Tech: 800-765-8369.

MacTCP: Macintosh Transmission Control Protocol is a Control Panel that is bundled by Apple Computer as part of the System 7.5 (or greater) software package. MacTCP is Apple's implementation of the TCP/IP that is the official protocol of the Internet. If you have not upgraded to System 7.5 yet, this is just another reason that you should.

MASK: Many image enhancement programs have the ability to create masks—Live Picture has a class they call "stencils"—that may be placed over an original image to protect parts of it and allow other sections to be edited or enhanced. Cutouts or openings in the mask make the unmasked portions of the image accessible for manipulation while protecting the rest of it. Graphic artists who previously used Rubylith material to create masks will be glad to find that digital masks are part of their digital repertoire, too.

MCF: Meta Content Format is the file format that is used to describe MCF Information spaces (see *www.lightbulb.com/tech/mcf/mcffaq/index.html*).

MIME: Multipurpose Internet Mail Extension. This protocol was developed by the Internet Engineering Task Force for transmitting mixed-media (graphics, audio, video, etc.) files across TCP/IP networks like the Internet.

Newsgroups: All of the news that's found on the Internet is called NETNEWS, and a newsgroup is a running collection of messages on a particular topic.

NCSA: The National Center for Supercomputer Applications at the University of Illinois at Urbana-Champaign. Founded in 1985, NCSA provides supercomputer resources to universities and organizations and has a major World Wide Web site. Their main claim to fame was the creation of the Mosaic Web browser software that has mutated into several versions that are used by sources as diverse as NetCom, Microsoft, and CompuServe. The online world, being as acronym-riddled as the rest of computing, has another NCSA. This one, the National Computer Security Association, was founded in 1989 to create awareness about and provide a clearinghouse for computer security issues. When you say NCSA to most Webheads, they think of Mosaic and the first acronym.

NSFNET: National Science Foundations Network is a major link in the Internet that connects supercomputer locations and 2,500 scientific and educational institutions around the world.

OSTA: Optical Storage Technology Association, an international trade organization dedicated to promoting use of writable optical technology for storing computer data and images. See *www.osta.org.*

OLE: (Pronounced Oh-lay.) Object Linking and Embedding. A document protocol that Microsoft created for Windows 3.1 and Windows 95 that permits a document to be embedded within or linked to another one. When an embedded object (it can be a text, graphic, sound, or movie clip) is clicked, the application that created it is loaded—if it's on your hard disk—so that you can edit it. Any changes made to the embedded object only affect the document that contains it. If an object is linked instead of being embedded, the link is to an original file that is located outside of the original document. If you make any changes to the linked object, all the documents that contain that link are automatically updated the next time you open them. This is especially important in studio management spreadsheets where data, such as a photographer's film cost list, expense sheet, or hourly rates, are linked to another spreadsheet. OLE keeps track of all of these links and updates the linked master files as changes are made to the components.

PCMCIA: Personal Computer Memory Card International Association. The cards referred to in the organization's title are small, credit-card-sized modules that were originally designed to plug into standardized sockets of laptop and notebook-sized computers.

To date, there have been three PCMCIA standards: Type I, Type II, and Type III. The major difference between the types is the thickness of the cards. Type III are 10.5 mm thick, Type II are 5 mm thick, and Type I are 3.5 mm thick. The modules come in many applications that vary depending on the type and thickness. For example, there are PCMCIA cards for additional memory, hard disks, modems—you name it. PCMCIA has become such a mouthful to say that at COMDEX 95, manufacturers of these wonderful devices, have agreed on a new buzzword to replace it. If you see the term PC Card, what they really mean is PCMCIA.

PDF: Adobe's Portable Document Format is a cross-platform file format that can be created by Adobe's Acrobat (and other kinds of compatible software, including the new PageMaker), that preserves the fidelity of all kinds of documents including text, photographs, and graphics—across a wide variety of computer platforms, printers, and electronic distribution methods. It is yet another attempt at creating a "paperless" document system, and although it has been slow to catch on, it *has* been catching on.

Adobe Acrobat is a family of universal electronic publishing software

tools that allows users to create electronic documents that maintain the "look and feel" of the original—including all fonts and images—and can be distributed on electronic media, including the Internet, World Wide Web, CD-ROM, and online services. The free Acrobat Reader software lets users view, navigate, and print PDF files, and supports Windows 95, Widows 3.1, Windows NT, and Macintosh as well as DOS and workstation environments. Acrobat Reader software can be downloaded from Adobe's World Wide Web server at *www.adobe.com/software.html* and is also available from popular online services such as CompuServe and America Online. Adobe Exchange software is available for a wide variety of platforms for under $200 at popular computer retailers or mail-order firms.

PICT: An acronym without a strict definition, this time for a metafile file format. As a well-behaved metafile, PICT files contain both bitmapped and object-oriented information. Some people love PICT files because they are excellent for importing and printing black-and-white graphics, like logos. Others hate them because they don't always retain all of the information in the original image. I've had both experiences.

PNG: (Pronounced "ping.") Portable Network Graphics is the successor to the GIF format widely used on the Internet and online services, like CompuServe. In response to the announcement from CompuServe and UNISYS that royalties would be required on the formerly free GIF file format, a coalition of experienced independent graphics developers from the Internet and CompuServe formed a working group to design a new format that was called PNG.

Here are a few features of the file format: PNG's compression method has been researched and judged free from any patent problems. PNG allows support for true color and alpha channel storage, and its structure leaves room for future developments. PNG's feature set allows conversion of all GIF files and, on average, PNG files are smaller than GIF files. PNG offers a new, more visually appealing, method for progressive display than the scan line interlacing used by GIF. PNG is designed to support full file integrity checking as well as simple, quick detection of common transmission errors. And all implementations of PNG are royalty-free.

PORTAL (formerly Search Engine): Since the actual number of Web sites on the World Wide Web is big and getting bigger everyday, finding the Exacta Collectors home page might be impossible without a way to search for the word "Exacta." That's the function of search engines: You type in a word or words, and a list of Web sites whose descriptions contain those keywords appear.

PPP: Point-to-Point Protocol used by Macintosh computers for Internet access.

PROTOCOL: A communications buzzword that means that the computers on

both ends of a connection are operating under the same rules so that they can communicate without any problems.

QTML: QuickTime Media Layer used in Apple Computer's QuickTime video software.

RADSL: Rate-Adaptive DSL is an ADSL technology in which software determines the rate at which signals can be transmitted on a phone line and adjusts the delivery rate accordingly.

SEARCH ENGINE: Now called "portal." Since the actual number of Web sites on the World Wide Web is big and getting bigger everyday, finding the Exacta Collectors home page might be impossible without a way to search for the word "Exacta." That's the function of search engines: You type in a word or words, and a list of Web sites whose descriptions contain those keywords appears.

SDSL: Symmetric DSL is similar to HDSL, using a single twisted-pair telephone line and carrying 1.544 Mbps in the United States and Canada or 2.048 Mbps in Europe. Data transfer rate is the same in both directions.

SERVER: A shared computer on a local area network (or the Internet) that interfaces with a client in the form of Internet software and/or hardware. A server acts as a storehouse for data and may also control e-mail and other services.

S/MIME: Secure Multipurpose Internet Mail Extensions. *See* MIME.

SMTP: Simple Mail Transfer Protocol allows Internet users to send e-mail (electronic mail) by allowing computers to emulate a terminal connected to a mainframe computer. E-mail allows you to send a message electronically to another user who may be located anywhere in the world.

SOHO: Small Office/Home Office. An oh-so-clever marketing term created by the explosion of at-home workers produced by corporate downsizing and telecommuting. Since many photographers already had established at-home studios, we were among the first professional class to be SOHO users, long before the term was invented and popularized. SOHO computer users typically have less complex demands on their computer systems, in terms of volume of data processed, but actually make more demands on their system as far as power, functionality, and productivity. These requirements extend to using computers for telecommunications—including Internet access—as well as digital imaging and general business usage.

The original acronym, SOHO, was applied to the trendy artist district in New York City that is located South of Houston Street—hence SoHo. The popularity of this location and acronym has spawned imitations in other cities, such as SoMa—South of Market Street—in San Francisco, and LoDo—Lower Downtown—in Denver.

SPIDER: A term for Intelligent Agent, robot, or "crawler." In practice, it's soft-

ware that automatically explores the World Wide Web by retrieving a document and recursively retrieving some or all the documents that are referenced in it. This is in contrast with a normal Web browser operated by a human that doesn't automatically follow links other than online images and URL redirection. The algorithm used to pick which references to follow depends on the program's purpose. Index-building spiders usually retrieve a significant proportion of the references. The Lycos search engine has a software "spider" that searchers the World Wide Web for new Web sites that it then posts in its database of millions of home pages. Spiders have long been thought to be the most efficient form of an Intelligent *hardware* Agent and have been used in science fiction literature, such a Greg Bear's chilling *The Forge of God* and the Michael Crichton film *Runaway*.

TCP/IP: Transmission Control Protocol/Internet Protocol is the official protocol for the Internet. TCP/IP's big job is making sure that the number of bytes of data that starts at one place is the same number that gets to the other end. It was originally developed for UNIX computer systems but is standard on all computers.

TELNET: Originally developed for ARPAnet, Telnet is part of the TCP/IP communications protocol. It is a tool to allow you to log onto remote computers, access public files and databases, and even run applications on the remote host. When using Telnet, your computer behaves as if it were a "dumb" terminal connected to another, larger machine by a dedicated communications line. Although most computers on the Internet require users to have an established account and password, many allow you access to search utilities, such as Archie or WAIS. You don't have to buy any new software to access the Telnet function. Many browser software programs seamlessly integrate e-mail, FTP, and Telnet into Web browser activities.

THUMBNAIL: This is an old design industry term for "small sketch." In the world of digital photography, thumbnails are small, low-resolution versions of your original image. Since they are low resolution, they produce extremely small files. Thumbnails are often used on Web sites to show small images that a surfer can click on to see the image in a larger form.

TIFF: Tagged Image File Format. A bitmapped file format developed by Microsoft and Aldus. A TIFF file (.TIF is the extension used in Windows) can be any resolution from black and white up to 24-bit color. TIFFs are supposed to be platform-independent files, so files created on your Macintosh can (almost) always be read by a Windows graphics program.

TIN: While you can use your browser for accessing USENET newsgroups, there are dedicated programs, such as TIN—Threaded Internet Newsreader—that allow you to read newsgroup messages on the Internet.

UNIX: A multi-user, multitasking (doing more than one thing at the same

time), multiplatform operating system originally developed by Bell Laboratories for mainframe and minicomputers back in the bad old days of computing. UNIX is constantly being overhyped as "the next big thing." Its main popularity was in universities and large businesses and government agencies. Although there are many implementations of UNIX for both PCs and Macintosh, none have caught on in any great numbers.

This may be changing. Linux, a variation on UNIX begun by Finnish programmer Linus Torvalds, is catching on with many people, and Apple Computer is using UNIX-like underpinnings for the next release of its operating system.

URL: Uniform Resource Locator. The address of a page on the World Wide Web. It includes the appropriate protocol, the system, path, and file name, such as *www.li.net/~hsb60901.jpg*, where "www" is the system, "li.net" is the path, and "~hsb60901.jpg" is the file name.

USENET: USEr NETwork began in 1979 as a bulletin board that was shared between two universities in North Carolina. It has grown—in 1994, the daily volume exceeded 50MB of data—into a public access network maintained by volunteers on the Internet, that provides user news and e-mail services.

UUENCODE: UUencode software allows you to convert a binary computer file into ASCII form for sending across the Internet (or any other e-mail service), then converting it back to binary when it reaches its destination. In UUencoded form, a file may be visible and readable by your word processor, as ASCII text, but it will looks like gibberish on the screen. Some e-mail services, such as CompuServe, allow you to attach a binary (graphic, audio, or video clip) file to a message without ever affecting the message. The person receiving your now combined message can read your e-mail and then convert the file into its original, intended form.

V.90: A ITU-T standard modem serial line protocol that allows downloading speeds of up to 56,000 bits per second, with upload speeds of 33.6 kbps. V.90 modems are designed for connections that are digital on one end and have only one digital-to-analog conversion.

VDSL: Very High Data Rate DSL is a new technology that promises higher data rates over short distances, and a number of standards organizations are working on it.

VERONICA: Very Easy Rodent Oriented Netwide Index of Computerized Archives. Veronica locates gopher sites by chosen topics and prompts users to choose key words for searching, generating hundreds of references on the subject. A user can choose a reference and instantly view the information. There are a limited number of Veronica sites and a plethora of users. Veronica is a tool to help you find the Gopher servers containing information you need, and you can browse a Veronica menu just like you would a Gopher menu.

V.FC: V.First Class. A data standard created for 28,800 modems by Rockwell International before V.34 standards were finalized.

VIDEC: Connectix' proprietary Video Digitally Enhanced Compression technology that compresses video data at a 4:1 ratio with only slight loss in video quality, allowing users to get faster frame rates and add larger frame sizes.

VRML: Virtual Reality Markup Language, a specification for the design and implementation of a platform-independent programming language for the description of a virtual reality scene.

VRML+: A proposed extension to Virtual Reality Markup Language that will allow it to support real-time interaction with other people. It is not yet publicly available.

WAIS: Wide Area Information Server is a system to search Internet databases. You can do a keyword search using WAIS to retrieve all of the matching documents and then read them.

WEB BROWSER: A Web browser is a program that allows computer users to locate and access documents on the World Wide Web.

WEB CLIENT: A wirehead term for Browser. *See* Browser.

WEBZINE: *See* E-Zine.

WINSOCK: A software standard that provides a common interface between TCP/IP and Internet software for computers using the Windows operating environment.

WORLD WIDE WEB: One of the most popular aspects of the Internet, the World Wide Web has a set of defined conventions for publishing and accessing information using HyperText and multimedia. Apparently, the WWW contains everything you ever wanted to know about anything.

WYSIWYG: (Pronounced wissy-wig.) As Flip Wilson's Geraldine used to say— and it had nothing to do with computing—What You See Is What You Get. This term refers to the ability to view text and graphics on screen the same as they will appear when printed. While most programs, text as well as image processing, have WYSIWYG capabilities, not all do. Read the fine print when you think about purchasing any program. A GUI is useless unless the apps that run under it are fully WYSIWYG.

x2/DSL: The name of a modem manufactured by 3Com that is designed to support modem communications but is software upgradeable to ADSL.

XML: Extensible Markup Language. An initiative from the World Wide Web Consortium that defines an "extremely simple" version of Standardized Generalized Markup Language that is suitable for use on the World Wide Web.

YAHOO!: Despite its somewhat silly name, Yahoo! is the Honda Accord of World Wide Web search engines; it is the search engine that all of its competitors compare themselves to.

Appendix B: Some of the Companies Mentioned

Throughout the book, I have tried to provide the Web site address for different companies whose products are mentioned, but if you need additional contact information, you will find some, but not all, of that data in this appendix. Space limitations dictate that only some companies whose products might be of interest are listed here, although their URLs should appear at the appropriate place in the body of the book.

The phone, fax, and Web site addresses that appear here were current when the book was being finished. The world of digital imaging is constantly changing, so if some of the information does not appear current when you try to use it, take advantage of an Internet portal such as Yahoo! or Excite to find the latest contact information.

Acer Peripherals Corp., 2641 Orchard Parkway, San Jose, CA 95134. 800-733-2237; 408-432-6200; fax: 408-922-2953; *www.acerperipherals.com*

Adobe Systems, 345 Park Avenue, San Jose, CA 95110-2704. 408-536-6000; fax: 408-537-6000; *www.adobe.com*

Agfa Corporation, 200 Ballardville Street, Wilmington, MA 01887-1069. 978-658-5600; fax: 978-658-6285; *www.agfahome.com*

Aladdin Systems, 165 Westridge Drive, Watsonville, CA 95076. 408-761-6200; fax: 408-761-6206; *www.aladdinsys.com*

Alta Vista: *www.altavista.digital.com*

Apple Computer, 1 Infinite Loop, Cupertino, CA 95014. 408-996-1010; *www.apple.com*

Auto F/X Corporation, 31 Inverness Center Parkway, Suite 270, Birmingham, AL 35242. 205-980-0056; fax: 205-980-1121; *www.autofx.com*

Artec, Ultima International, 38897 Cherry Street, Newark, CA 94560. 510-739-0800; *www.artecusa.com*

Banana Software Inc., 29 Engle Road, Paramus, NJ 07652. 201-265-9855; e-mail: *alex@civ.com*

Beginner's Guide to HTML: *http://www.ncsa.uiuc.edu/General/Internet/WWW/HTMLPrimer.html*

Bender Photographic Inc.: *www.cascade.net/~jbender/index.html*

Better Light, Inc., 1200 Industrial Road, Unite 17, San Carlos, CA 94070-4129. 650-632-3680; fax: 650-631-2915; *www.betterlight.com*

Bogen Photo Corp., 565 East Crescent Avenue, P.O. Box 506, Ramsey, NJ 07446-0506. 201-818-9500; fax: 201-818-9177; *www.bogenphoto.com*

Bronica: *www.tamron.com*

Brother MFC7000FC, Brother International Corporation, 200 Cottontail Lane, Somerset, NJ 08875. 908-356-8880; fax: 908-356-4085; *www.brother.com*

Canon USA, One Canon Plaza, Lake Success, NY 11042. 800-423-2366; fax: 516-488-6700; *www.powershot.com*

Canon Computer Systems, 2995 Redhill Avenue, Costa Mesa, CA 92626. *www.ccsi.canon.com*

Casio, Inc., 570 Mt. Pleasant Ave., Dover, NJ 07801. 800-96-CASIO; 201-361-5400; *www.casio-usa.com*

Chimera: *www.chimeralighting.com*

CiNet's ShareWare.COM: *www.shareware.com*

CompuServe Inc., 5000 Arlington Center Blvd., P.O. Box 20212, Columbus, OH 43220. 800-848-8199; fax: 614-457-0348; *www.compuserve.com*

Connectix: *www.connectix.com*

CU-SeeMe (Cornell University): *ftp://gated.cornell.edu/pub/video/*

CU-SeeMe (White Pine Software): *http://goliath.wpine.com/cu-seeme.html*

Darkroom Online: *www.sound.net/~lanoue*

DejaNews: *www.dejanews.com*

Diamond Multimedia Systems, Communications Division (formerly Supra), Vancouver, WA. 360-604-1400; fax: 360-604-1401; *www.supra.com*

Digital Frontiers, 1019 Asbury Avenue, Evanston, IL 60202. 516-757-0400; fax: 516-757-2217; *www.phaseone.com*

EarthLink, Inc., 1430 West Peachtree Street NW, Suite 400, Atlanta, GA 30309. 404-815-0770; *www.earthlink.net*

Eastman Kodak, 343 State Street, Rochester, NY 14650-0522. 716-724-4679; fax: 716-724-0670; *www.kodak.com*

Equilibrium, 475 Gate Five Road, Suite 225, Sausalito, CA 94965. 415-332-4343; fax: 415-332-4433; *www.equilibrium.com*

Epson America, Inc., 3840 Kilroy Airport Way, Long Beach, CA 90806. 800-289-3776; 562-981-3840; *www.epson.com*

Excite: *www.excite.com*

Fuji Photo Film USA, Inc., 555 Taxter Road, Elmsford, NY 10523. 800-378-3854; *www.fujifilm.com*

Fujitsu: *www.fujitsu.com*

Granite Digital, 3101 Whipple Road, Union City, CA 94587. 510-471-6442; fax: 510-471-6267; *www.scsipro.com*

Hewlett-Packard Co., 3000 Hanover Street, Palo Alto, CA 94304. 800-752-0900; 800-387-3867; *www.hp.com*

GIF Converter: *www.kamit.com/gifconverter.html*

Heidelberg CPS, 80 Ruland Road, Melville, NY 11747-3170. 888-LINOCOLOR; *www.linocolor.com*

HotWired: *www.hotwired.com/frontdoor*

Hindsight, Ltd., P.O. Box 4242, Highlands Ranch, CO 80126. 303-791-3770; *www.hindsightltd.com*

Hyperzine, an online photographic magazine: *www.hyperzine.com*

Ichat: *www.ichat.com/ichat2/download.html*

Imacon, Inc., 4109 Clipper Court, Fremont, CA 94538. 510-651-2000; fax: 510-445-3988; *www.imacon-usa.com*

Info Products, 580 Division Street, Campbell, CA 95008. 800-777-3208; fax: 509-933-1896; *www.info-products.com*

Inset Systems, 71 Commerce Drive, Brookfield, CT 06804-3405. 800-374-6738; fax: 203-775-5634

Juno Online Services, LP, 120 West 45th Street, 39th Floor, New York, NY 10036. 212-478-0800; fax: 212-478-0700

JVC Company of America, 41 Slater Drive, Elmwood Park, NJ 07407. 201-794-3900; fax: 201-523-3601; *www.jvc.com*

Konica Corporation: *http://www.konica.com*

Kyocera Optic, Inc., 2301-200 Cottontail Lane, Somerset, NJ 08873. 800-526-0266; fax: 732-560-9221; *www.kyocera.com*

Largan, Inc., 2432 West Peoria Avenue, Building 9, Suites 1165 and 1166, Phoenix, AZ 85029. 877-4LARGAN; fax: 602-944-6226; *www.largan.com*

Leica Camera, Inc., 156 Ludlow Avenue, Northvale, NJ 07647. 201-767-7500; fax: 201-767-8666

Lycos: *www.lycos.com*

Macromedia, 600 Townsend, San Francisco, CA 94103. 415-252-2268; fax: 415-626-1502; *http://www.macromedia.com*

Magellan: *www.mckinley.com*

Marketwise Data Inc., 2860 South Circle Drive, Suite 2104, Colorado Springs, CO 80906. 719-579-0993; *www.market1.com*

Micrografx, Inc., 1303 East Arapaho Road, Richardson, TX 75081. 214-234-1769; fax: 214-994-6227; *www.micrografx.com*

Microsoft Corporation, One Microsoft Way, Redmond, WA 98052-6399. 800-426-9400; *www.microsoft.com*

Microtek Lab, Inc. (subsidiary of Microtek International, Inc.), 3715 Doolittle Drive, Redondo Beach, CA 90278-1226. 310-297-5000; fax: 310-297-5050; *www.microtekusa.com*

MegaVision, P.O. Box 60158, Santa Barbara, CA 93160. 888-324-2580; fax: 805-683-6690; *www.mega-vision.com*

Minolta Corp., 101 Williams Dr., Ramsey, NJ 07446-1293. 800-9-MINOLTA; 201-825-4000; fax: 201-818-3240; *www.minolta.com*

Mustek, Inc., 121 Waterworks Way, Suite 100, Irvine, CA 92618. 949-790-3800; fax: 949-788-3640; *www.mustek.com*

NEC Computer Systems, 339 North Bernardo Ave., Mountain View, CA 94043. 888-8-NECNOW; *www.nec-computers.com*

Netscape Communications Corp., 501 East Middlefield Road, Mountain View, CA 94043. 800-NETSITE; fax: 415-528-4120; *home.netscape.com*

NetCom, 3031 Tisch Way, San Jose, CA 95128. *www.netcom.com*

Netwriter Viewer By Paragraph International: *www.paragraph.com/netwriter /pictures*

Nikon Inc., 1300 Walt Whitman Road, Melville, NY 11747-3064. 800-526-4566; fax: 516-547-0362; *www.nikonusa.com*

Olympus Image Systems, Inc., Two Corporate Center Drive, Melville, NY 11747-3157. 800-347-4027; 516-844-5000; fax: 516-844-5339; *www.olympusamerica .com*

Online-PhotoWeb: *http://www.Web-search.com/photo.html*

Optical Storage Technology Association: *www.osta.org*

Pacific Image Electronics, 1830 West 208th Street, Torrance, CA 90501. 310-618-8100; fax: 310-618-8200; *www.scanace.com*

The Palace: *www.the palace.com*

Panasonic Communications & Systems Co., Two Panasonic Way, Secaucus, NJ 07094-9844. 800-742-8086; 201-348-7000; fax: 201-392-4441; *www. panasonic.com*

Pentax, 35 Inverness Drive East, P.O. Box 6509, Englewood, CO 80155-6509. 303-799-8000; *www.pentax.com*

Phase One United States, Inc., 24 Woodbine Avenue, Northport, NY 11768. 800-972-9909; 516-757-0400; fax: 516-757-2217; *www.phaseone.com*

PhotoBubble: Pentax, 35 Inverness Drive East, P.O. Box 6509, Englewood, CO 80155-6509. 303-799-8000; *www.pentax.com* and *www.omniview.com/ viewers/viewers.html*

Photo Electronic Imaging: Pentax, 35 Inverness Drive East, P.O. Box 6509, Englewood, CO 80155-6509. 303-799-8000; *www.pentax.com* and *www.peimag.com*

Photoflex, 333 Encinal Street, Santa Cruz, CA 95060. 800-486-2674; fax: 408-454-9600; *www.photoflex.com*

Photography & Digital Imaging Resource: *www.beStreetcom/~cgd/home/pholinks. htm*

PhotoWorks.com, 1260 16th Avenue West, Seattle, WA 98119-3401. 800-445-3348; *http://www.photoworks.com*

Plustek, 1362 Bordeaux Drive, Sunnyvale, CA 94089. 408-745-7111; fax: 408-745-7562; *www.plustek.com*

Polaroid Corp., 565 Technology Square, Cambridge, MA 02139. 800-225-1618; 617-386-2000. fax: 617-386-9339; *www.polaroid.com*

Relisys, 919 Hanson Court, Milpitas, CA 95035. 800-945-0900; fax: 408-942-1086; *www.relisys.com*

ResNova Software, Inc., 5011 Argosy Drive, Suite 13, Huntington Beach, CA 92649. 714-379-9000; fax: 714-379-9014; *www.resnova.com*

Ricoh Corporation, 475 Lillard Drive, Sparks, NV 89434. 800-225-1899; fax: 702-352-1615; *www.ricohcpg.com*

Rollei Fototechnic, 40 Seaview Drive, Secaucus, NJ 07904. 888-876-5534; fax: 201-902-9342; *www.rolleifoto.com*

Samsung Opto-Electronics America, Inc., 40 Seaview Drive, Secaucus, NJ 07904. 201-902-0347; fax: 201-902-1359; *www.simplyamazing.com*

Sanyo, 21605 Plummer Street, Chatsworth, CA 91311. 818-998-7322; *www .sanyodigital.com*

Second Glance Software, 7248 Sunset Avenue NE, Bremerton, WA 98311. 360-692-3694; fax: 360-692-9241

Scitex: *www.scitex.com*

Slate, an interactive magazine of politics and culture: *www.slate.com*

Sinar Bron Imaging, 17 Progress Street, Edison, NJ 08820. 908-754-5800; fax: 908-754-5807; *www.sinarbron.com*

Sony Electronics, 1 Sony Drive, Park Ridge, NJ 07566. 800-342-5721, 201-930-1000; *www.ita.sel.sony.com*

Storm Technology, 1395 Charleston Road, Mountain View, CA 94043. 650-691-6600; fax: 650-691-9825; *www.stormtech.com*

Studio Press, 4330 Harlan Street, Wheat Ridge, CO 80033. 303-420-3505

Symantec Corporation, 2500 Broadway, Suite 200, Santa Monica, CA 90404-3063. 310-453-4600; fax: 310-829-1826; *www.symantec.com*

Tamron/Bronica: *www.tamron.com*

TechSmith Corp., 3001 Coolidge Road, Suite 400, East Lansing, MI 48823-6320. 517-333-2100; fax: 517-333-1888; *www.techsmith.com*

Toshiba America, 9775 Irvine Blvd., Irvine, CA 92618. 800-457-7777; 949-583-3000; fax: 949-583-3545; *www.toshiba.com*

UMAX Technologies, Inc., 3561 Gateway Blvd., Fremont, CA 94538. 510-651-4000; fax: 510-651-8834; *www.umax.com*

Vivitar, 1280 Rancho Conejo Blvd., Newbury Park, CA 91320. 805-498-7008; fax: 805-498-5086; *www.vivitar.com*

US Robotics, 8100 North McCormick Blvd., Skokie, IL 60076-2999. 708-983-5001; fax: 708-933-5800; *www.usr.com*

Visioneer, 34800 Campus Drive, Freemont, CA 94588. 510-608-0300; fax: 510-608-0305; *www.visioneer.com*

Web Crawler: *Webcrawler.com*

Wolf Camera, 1706 Chantilly Drive, Atlanta, GA 30324. 404-633-9000; fax: 404-325-2248, *www.wolfcamera.com*

Yahoo!: *www.yahoo.com*

Zoom Telephonics, Inc., 207 South Street, Boston, MA 02111. 617-423-1072; fax: 617-423-3923; *www.zoomtel.com*

About the Author

Joe Farace's first published story about digital imaging appeared in the January 1990 issue of *Photomethods* magazine, when nobody even knew what to call this new technology. Was it digital photography, digital imaging, or pixography?

He is the author of more than twenty-one books, including *Capturing the Image* and *Printing the Image* for Silver Pixel Press/RotoVision. In addition, he wrote *The Photographer's Digital Studio* for Peachpit Press; *Digital Imaging: Tips, Tools, and Techniques for Photographers* for Focal Press; and *Plug-in Smart* and *Stock Photo Smart*, which are part of Rockport Publisher's *SmartDesign* series. Joe is also the author of several books about traditional photography, including *Better Available Light Photography* (with Barry Staver) from Focal Press, *Part-Time Glamour Photography, Full-Time Income*, and the *Magic Lantern Guide to the Canon Elan 7/7E*, published by Silver Pixel Press.

Joe was the original editor of *eDigitalPhoto.com* magazine, and he has published more than one thousand magazine articles about computers, photography, and digital imaging. He is Contributing Editor to *Publish* and *ComputerUSER* magazines and is a regular contributor to *Shutterbug* magazine, which publishes his monthly "Digital Innovations" and "Web Profiles" columns. Joe is Editor-at-Large for *The PRESS* and writes their monthly "Computer Tutor" column. His writing has appeared in publications including *DealerScope, DigitalImager, idn, Presentations, PEI, Professional Photographer, Video,* and many others.

Joe lives in northeastern Colorado with his wife Mary. You can visit his home page on the World Wide Web at *www.joefarace.com*.

Index

A

AcqURL, 52–53
ActiveShare, 67p
Ad Banner, 49
add-on, 5
Adobe Acrobat, 49
Adobe GoLive, 144
Adobe PageMill, 147
Adobe Photoshop, xiii, 47, 91–93, 99, 101, 123, 125p, 153, 171–172, 175, 184, 186–188, 191–193
Adobe Systems, 201
ADSL (Asymmetric Digital Subscriber Line), 183, 185, 190, 196, 199
Advanced Photo System, 63
advertising, 161
agent. *see* intelligent agent or spider
AGFAnet, 64
Agfa's home page, 64p
alpha channel, 184
America Online, 28–29
American Society of Media Photographers (ASMP), 187
anchor, 184
API (Application Program Interface), 184, 188
applet, 173, 192
Arbus, Diane, 103

Archie, 60, 62, 184, 197
ARCHIvE, 56, 62, 184,
ARPANET, 2–3, 184, 197
art, 93
ASCII (American Standard Code for Information Interchange), 75, 184, 198
AT, 184
AT&T WorldNet, 29
Auerbach, Gary, 138p, 138–142
AVATAR, 184
awards, 126

B

Babylon Translator, 53
@Back Up, 105–107, 106p
BaySpider, 174
BBEdit, 56, 127, 147
binary files, 75
BINHEX (Binary Hexadecimal), 75, 185
BISDN (Broadband ISDN), 24, 185
BITMAP, 185
BMP, 131
bookmarks, 39, 52
Boolean search, 78, 185
BPS (bits per second), 185
BRI (Basic Rate Interface), 24, 185
browser(s), x, 4–5, 28, 37–38, 107, 127, 132, 199

bookmarks and, 39
 cookies and, 69–70
 function of, 38–39
 information in, 39–42
 Java and, 39–41
 Netscape vs. Internet Explorer and, 43–45
 Opera, 45–47
 other, 45–47
 Plug-Ins, 47–52
 portals and, 41
 problems with, 43
 software, 15, 37–38, 117
 toolbars and, 41–42
business cards, 160
business forms
standard, 160–161
bytes, 2

C

Calendar Quick Plug-In, 49–50
camera clubs, 144
camera(s), 4p, 177
hardware, 149
Cameron, Julia Margaret, 103
CBM (Columbine Bookmark Merge), 50
CCITT (Comité Consultatif de Telagraphique et Telephonique), 192
CCS (Cascading Style Sheets), 185
CD UDF (Compact Disc Universal Disc Format), 185–186
CD-ROM, 186, 193, 195
CDSL (Consumer DSL), 185
CERN (European Center for Nuclear Research), 185
CGI (Common Gateway Interface), 118, 132–134, 186, 190
change form, 164
CHANNEL, 186
Clever Content, 128, 174
CLIENT, 186
clients, 126, 160
clipboard, 169
COCOA (Computations in Commutative Algebra), 186
CODEC (COmpression/DECompression), 186
color copiers, 169–170
COM (communications) ports, 17
communications, 10–13
Communications Decency Act, 178
companies, resources for, 201–206
compression systems, 125–126
CompuServe, 6, 12, 29–30, 30p, 154–155, 171, 186–187, 189, 192, 195, 198
computer(s), 105–107
Contextual search, 78
converter, 53
cookies, 69–70, 187
Copernic 2000, 53–54
copyright(s)
 no control over, 169
 protection, 171
 symbols, 171

D

darkroom
 advice for, 94
DAT (Digital Audio Tape), 187
data storage, 104
database management, x
Davidson, Bruce, 93
Day, Holland F., 93
DCT (Discrete Cosine Transform), 187
"DD Pouch," 48
DDS (Digital Dataphone Service), 187
desktop publishing, x
DESPECKLE, 187–188
digital copy stations, 169–170
digital imaging, 63, 65, 88, 91–93, 149
online services for, 63, 64–68
Digital Imaging Dictionary, The, x
Digital Satellite, 26–28
Digital Truth: Photo Source, 94
DLL (Dynamic Link Library), 188
DMA, 188
DNS (Domain Name System), 53, 188
DOM (Document Object Model), 188
domain name, 120, 134
domain(s), 10–12, 146
DOS, 195
"dot-coms," xiv
download, 5, 20, 60, 115, 153, 154, 172, 175
Download Accelerator, 54, 60
DSL (Digital Subscriber Line), 26–27, 185, 190
DSP (Digital Signal Processor Chip), 20, 188
Dynamic Link Libraries (DLLs), 2

E

Earthlink, 30–31
Eastman Kodak, 90, 130, 203
E. C. K. Mees, 90
e-commerce, 122–123, 178
e-mail, xi, 7, 37, 44, 47, 55, 104, 111, 113, 126, 144, 146, 150, 153, 166, 177, 179, 187, 191, 196, 198
 all about, 10–11, 68
 downside of, 73–75
 free sources for, 72–73, 73p
 good news about, 75–76
 junk, 34
 Juno Online Services and, 70
 signatures and, 72
 Simple Mail Transfer Protocol (SMTP) and, 3
equipment
 review of, 97
EquitySoft, 173
Excite, 62–63, 165p
EZ Prints, 65
e-zine, 103, 188

F

FAQ (frequently asked questions), 188
fax, 20–22, 74
Fetch, 135
FTP, (File Transfer Protocol), 3
FileMaker's Home Page, 127
files, xiii
filters, 90, 92, 94
fine arts, 114–115
FITS (Functional Interpolating Transformational
 System), 188
Flash Player, 52
FlashPix, 5–7, 189
flatbed scanner, 123
FPO (For Position Only), 111, 171
Free Software Foundation, The, 100
FreeDSL, 189
FreePPP, 189
freeware, 187
FTP (File Transfer Protocol), 60, 135, 184, 189,
 197
Fuzzy search, 78, 189

G

gallery, 122
GIF Converter, 203
GIF (Graphics Interchange Format), 5–7,
 124–127, 131, 141, 171–173, 189,
 190–192, 195
GIMP (GNU Image Manipulation Program),
 99–101
GKS (Graphical Kernel System), 190
Glamour Models, 95, 122
Glamour Portfolios, 154, 156p
G.Lite, 189
GNU (General Public License), 100p
Gopher, 190, 198
Go!Zilla, 50
graphic file(s)
 types of, 124–126
graphical user interface, xi
graphics file formats, xi, 5–7
Grizzley Bear Nature Photography, 96–98, 97p
GUI (Graphical User Interface), 61, 199

H

hacker, 115
Hacker Watch, 136
hardware, xiii, 15–19, 186, 196
Hayes Microcomputer Products, 20, 22, 62, 184
HDSL (High bit-rate DSL), 190, 196
helper applications, 47
Hindsight, 110, 110p
hit counter(s), 162–163
 styles of, 162, 163p
Home Page, 127, 129p, 133, 133p
 Claris, 129p
home page(s), x, 4, 5, 7, 37, 42, 63, 69, 85, 138,
 146, 152, 154, 159

basics, 117–118
browsers and, 39
building, 117–118, 127–134
contact information on, 122
fine arts, 114–115
gallery on, 122
maintaining, 161
online brochure for, 111–112
photographs displayed on, 123–124
photography, 85–88
portrait/bio on, 121
storefront on, 122–123
storyboarding, 120
hosts, 3
HotBot, 62–63
Hotmail, 73
HREF (HyperText reference), 190
HTTP (HyperText Transport Protocol, "http://"),
 x, 190
HyperText, 3–4, 7, 122, 185, 191, 199
HTML (HyperText Markup Language), 4–5, 40,
 118, 127, 131–132, 153, 162–163, 185,
 188, 190, 192

I

IAB (Internet Activities Board), 190
ICE (Intelligent Concept Extraction), 81
IDSL. see ISDN
IETF (Internet Engineering Task Force), 190
image files
 Web site and, 124
image-compression, xi
image-enhancement program, 124
image(s)
 loading time for, 127
 promoting and selling, 112–113
 search capabilities, 130
 size and resolution of, 171–172
ImageSafe, 173, 173p
IMAP4 (Internet Message Access Protocol, ver-
 sion 4.), 191
immersive imaging, 50
Indexed Color, 191
Instant Messenging, 12
Intelligent Agent, 191
International Standards Organization, 5
International Telecommunication Union (ITU),
 20
Internet, 146, 150, 152, 154–155, 157, 195. see
 also World Wide Web
 announcement of presence on, 159–160
 cable TV and, 25–26
 connection to the, 15
 copyright issues and, 169–176
 definition/history of, x–xi, 1–3
 distinction between World Wide Web and, xi
 domains, 10–12
 e-mail and, xi, 68, 70–76
 e-photofinishing services and, 65

family and, 178–181
good, bad, ugly of, 177–181
graphic file types and, 124–126
high-tech revolution and, ix
Intranet and, 7
Juno Online Services and, 70–72
marketing toolkit and, xv
netiquette on the, 12p
"NETNEWS" on the, 13
newsgroups and, 76–77
photographers and, 7–13, 63–68
pornography on, 178
product information on, 63
rating system for, 178
search engines and, 77–83
service providers and, x–xi, xiv, 28–34
SPAM and, 69–70
surfing, xv, 1, 5
technical specifications and, 63
Transmission Control Protocol/Internet
 Protocol (TCP/IP) and, 2–3
URL's and, x
years and, xiv
Internet Architecture Board (IAB), 3
Internet Corporation for Assigned Names and
 Numbers (ICANN), 11, 120
Internet Engineering Task Force (IETF), 3
Internet Explorer, 43, 45, 48, 52–53, 127, 169,
 174–175, 186
Internet Relay Chat (IRC), 12
Internet Research Task Force (IRTF), 3
"Internet Time," 104
Intranet, 7, 191
IP (Internet Protocol), 53, 191
IPIX, 50
IptScrae, 191
IRC (Internet Relay Chat), 191
IRTF (Internet Research Task Force), 190, 191
 Broadband, 24
 Web-sites for, 25
ISDN (Integrated Services Digital Network),
 23–25, 147, 190–192
 Broadband, 24
 Web sites for, 25
ISP (Internet Service Provider), x, xiv, 70, 119,
 128, 134, 135–136, 138, 142, 144, 147,
 150, 153, 155, 165, 174, 192
 choosing a, 34–35
 e-mail and, 10–11
 finding, 28–34
 other, 32–34
ITU-T (International Telecommunication Union-
 Telecommunications Sector), 192, 198

J
Java, 39–41, 60, 173–174, 192
JPEG (Joint Photographic Experts Group), 5–7,
 114, 124–127, 130p, 131, 153, 171–173,
 176, 187, 192

Juno Online Services, 32–33, 70–72, 71p, 128,
 191, 203

K
Kaltman, Len, 122, 154
 Web site for, 112, 112p
Kodak. see Eastman Kodak
Krieger, Herman, 151–154

L
LAN, 146
Landscapes/Cityscapes, 140
LAP (Link Access Procedures), 192
LauraWave Smart Compress Lite, 54–55
Layer, 192
LDAP (Lightweight Diretory Access Protocol),
 193
LED (Light Emitting Diode), 18p, 193
letterhead, 160
Lightware, 115, 116p
Link Check Watch, 136
links page, 89, 118, 153
LINUX, 193
loading time, 127
Lycos, 79–80, 80p, 166p, 166–167, 197, 204
Lynes, George Platt, 93
Lyon, Danny, 93
LZW (Lempel-Ziv-Welch), 5–6, 190, 192

M
Macintosh, xiii, 6
Macromedia, 5
MacTCP (Macintosh Transmission Control
 Protocol), 193
Magellan, 80–81, 81p, 166
The Magic Floppy, 104–105, 105p
mailing lists, 160
Mapplethorpe, Robert, 93
Markerink, Willem-Jan, 89–90
marketing, 137, 144
 worldwide, 10
MASK, 193
Massive Dev Chart, The, 94
Mauskopf, Norman, 93
MCF (Meta Content Format), 193
MediaDepot, 107p, 107–108
Microsoft Network, 31
MIME (Multipurpose Internet Mail Extension),
 75–76, 193
modem(s), xi, 17p, 153
 basics of, 19–21
 cable, 25–26
 choosing the right, 21–22
 configuration of, 22
 fax, 22–23
 Hayes compatibility, 22
 internal/external, 16–19
 PC Card, 19
 Smart, 20

speeds of, 20
telephone capability of, 22
transmission speed of, 20
Moose Peterson, 148–151
"Moose" polarizing filter, 148
multimedia, 5

N

National Association of Photoshop Professionals
(NAPP), 101–102
Nature Photographers on the Web, 103–104
NCSA (National Center for Supercomputer
Applications), 193
Net. *see* Internet
NETNEWS, 193
Netscape, 48, 52–53, 153, 163, 204
Netscape Communicator,
download size and speed of, 43–44
fully integrated search function and, 44
Netscape Navigator, 38p, 127, 130, 169,
174–175, 187
Network Termination Devices, 24
newsgroups, 76–77, 193
Nikon's Web site, 8p
nonphotographic
products and services, 8–9
NSFN (National Science Foundations Network),
194
NSFNET, 2–3

O

OLE (Object Linking and Embedding), 194
online auction, 8
OnLine-PhotoWeb, 89
Opera, 45–47
order forms
online, 132
OSTA (Optical Storage Technology Association),
186, 194

P

Palm Pilot, 43
Paper Direct, 160
passwords, 60
PC Card. *see* PCMCIA
PCMCIA (Personal Computer Memory Card
International Association), 19, 194
PDF (Adobe's Portable Document Format), 149,
194–195
Peterson, Moose, 148–151, 149p
photo essays, 151–152, 154
Photo Essays of Herman Krieger, 151–154, 152p
Photo Travel, 91
photographer(s)
assignment, 114
changing communication of, ix
classifications of, xii–xiii
commercial, xii
do it yourself, 118–119

e-zines for women, 103
fine art, 114–115
glamour, 154
importance of internet to, 7–13
landscape, 98, 142
nature, 96–98, 103–104, 142, 148, 150
online storage for, 107–108
portrait, xii, 114, 121
procrastination of, 119
questions to, 138
stock, 113, 143, 154
Web sites for, 85–108, 86–88, 89–104
wildlife, 151
photograph(s)
copyrighting, 169–176
digital, 67, 123–124
glamour, 132, 154
graphics file formats and, 5–7
products and services for, 7–8, 64–68, 115
secure storage for, 107–108
Web site, 123–124
photography
experimental, 96
glamour, 95p, 132
infrared, 89–91
as a passion, 141
stock, 113, 155
technical, 94
travel, 91
ultra-violet, 90–91
photojournalism, 151
Photoshop, 48, 144, 147
PhotoSource International, 88p
PhotoWorks.com, 65–66
home page for, 66p
PICT, 131, 195
pixel, 5, 124, 170, 185, 188
PixSafe, 128, 173
Platinum Photography, 138–142
platinum printing, 138
Plug-Ins, 47–52, 92, 100, 171, 177
Plugsy, 55
PNG (Portable Network Graphics), 5–7,
124–126, 190, 195
Polaroid Image Transfers, 140
portals, 41, 77, 166, 195. *see also* search engine
Portraiture, 140
PPP (Point-to-Point Protocol), 195
Prodigy, 31
Professional Photographers of America (PPA), 187
protocol, 195–196
publishing, 93

Q

QTML (QuickTime Media Layer), 196
QTVR (QuickTime Virtual Reality), 148
Quick View Plus, 55
QuickTime, 50–51

R
RADSL (Rate-Adaptive DSL), 196
RAM (Random Access Memory), 6, 70, 189
RealPlayer, 51
real-time messaging, 44
RGB, 191
Ritts, Herb, 93
Ronald Warunek: Fusionist, 96

S
Sammon, Rick, 92p
scanners, 144, 147, 149, 152
SDSL (Symmetric DSL), 196
search engine(s), 9, 41, 77–83, 128, 130, 146,
 163, 164. *see also* portal
 additional information for, 81–83
 comparison of popular, 78–81
 Excite, 165–166
 list of, 82
 Lycos, 166–167
 types of, 78
 workings of, 77–78
 Yahoo!, 163–165
SearchLynx, 110, 110p
 Clever Content, 174
server(s), 16, 37, 134–135, 196
secure, 115, 115p
shareware, 171, 187
Sherlock, 55–56
Shockwave, 5, 51p, 51–52
Shutterbug, 143
sidebar, 44
silver-based technology, 88
Simple Mail Transfer Protocol (SMTP), 3
S/MIME (Secure Multipurpose Internet Mail
 Extensions). *see* MIME
SMTP (Simple Mail Transfer Protocol), 196
software, xii, xiii, 173, 186, 192, 196
 client, 37–38
 document retrieval system of, 61
 downloading, 60
 free, 100
 helper application for, 47
SOHO (Small Office/Home Office), 196
South Dakota State Parks, 97–98
SPAM, 34
 how to avoid, 69–70
spider, 167. *see also* Intelligent Agent
splitter, 185
SSL (Secure Sockets Layer), 115
stock photography, 113, 155
storefront, 122–123
storyboard, 120
studio(s)
 computers in, x
Stufflt Deluxe, 56–57, 75–76
Sweet, Tony, 142

T
taglines, 162
TCP/IP (Transmission Control Protocol/Internet
 Protocol), 2–3, 7, 76, 189, 191, 193, 197,
 199
Telnet, 60–61, 197
theft, 169
 digital, 169–176
 non-digital, 170
Thumbnail, 197
TIFF (Tagged Image File Format), 197
TIN (Threaded Internet Newsreader), 77, 197
Tom Zinn, 145p
Tony Sweet Photography, 142–145, 143p
toolbar, 54
Transact, 115
Travelocity.com Web site, 9p
TrellixWebb, 127
Twelvetrees Press, 93
Twin Palms, 93

U
Ulead Systems, Inc., 66
Ultimate Photoshop, 91–93
UNIX, 135, 197–198
upload, 135, 144
 download vs., 5
URL (Uniform Resource Locator), x, xv, 38–39,
 53, 81, 83, 86–87, 104, 120, 128, 136,
 141–142, 146, 153, 160–161, 164–167,
 190, 197–198
URL Filter, 49
UseNet, 13, 76–77, 198
UUcode, 76
UUencode, 198

V
V.90, 198
VDSL (Very High Data Rate DSL), 198
Veronica (Very Easy Rodent Oriented Netwide
 Index of Computerized Archives), 62,
 184, 198
V.FC (V. First Class), 199
VIDEC (Video Digitally Enhanced Compression),
 199
virtual gallery, 140, 141, 149
virtual tours, 145
VRML+, 199
VRML (Virtual Reality Markup Language), 199

W
WAIS (Wide Area Information Server), 60–63,
 184, 197, 199
@Watch, 136
watermark(s), 171
 digital, 175p, 175–176
Web browser. *see* browser
Web Client. *see* browser
Web server. *see* server

Web Shepherd, 136
Web site(s), 4–5
 advertising, 161
 assignment shooters', 114
 bio/portrait on, 122
 construction of, 118–119, 127–134
 construction software for, 127
 copyright issues for, 169–176
 design, 119
 domain names and, 120, 134
 establishing parameters for, 113
 fine arts and, 114–115
 free, 128
 gallery and, 122
 graphic file types and, 124–126
 hit counter on, 162–163
 "hit meter" on, 111
 hosting, 134–136
 linking of, 118
 links pages and, 88
 maintenance of, 144, 147, 150, 153, 155, 159
 marketing yourself on, 109–111, 144
 online brochure and, 111–112
 online order forms and, 132–133
 Photo Request, 161
 photographs displayed on, 123–124
 photography and imaging manufacturer for, 86–88
 proper working of, 136
 resources for, 201–206
 server transference of, 134–135
 step-by-step construction of, 128–134
 stock photography and, 113, 155
 storage/security and, 107–108
 storefront at, 122–123
 storyboarding, 120
 text of, 126, 128
 time spent on creating, 118
 updates on, 119
Web Utilities, 52

Web Zapper, 135, 135p
Webmasters, 39–40
Webzine, 89, 102, 188. see also E-Zine
Winsock, 199
Witkin, Joel-Peter, 93
WJ's Home Page, 89–91
word processing, x
World Wide Web (WWW), ix, 195, 197–198, 199. see also Internet
 browsing, x, 5, 28, 37–38,
 data storage and, 104
 description/designer of, 3
 designing graphics for, 127
 distinction between Internet and, xi
 e-zines for women and, 103
 Juno Online Services and, 70–72
 marketing yourself on, 109–111
 multimedia aspects of, 5–7
 opinion vs fact on, 86
 other uses of, 59–60
 photographic e-zines and, 102–104
 photographic manufacturers and, 65
 pornography on, 177–178
 search engines and, 77–83
 utilities, 52
web sites on, 4
Wratten and Wainwright, 90
WYSIWYG, 127, 131–132, 199

 X
x2/DSL, 199
XML (Extensible Markup Language), 188, 199

 Y
Yahoo!, 77, 79p, 82, 137, 148, 199, 206
 listing information on, 164–165, 164p

 Z
Zinn, Tom, 145
ZIP, 76

Books from Allworth Press

How to Shoot Stock Photos That Sell, Third Edition
by *Michal Heron* (softcover, 8 × 10, 224 pages, $19.95)

The Photographer's Guide to Marketing and Self-Promotion, Third Edition by *Maria Piscopo* (softcover, 6¾ × 9⅞, 192 pages, $19.95)

The Photographer's Assistant, Revised Edition
by *John Kieffer* (softcover, 6¾ × 9⅞, 256 pages, $19.95)

Mastering the Basics of Photography
by *Susan McCartney* (softcover, 6¾ × 9 7/8, 192 pages, $19.95)

The Photojournalist's Guide to Making Money
by *Michael Sedge* (softcover, 6 × 9, 224 pages, $18.95)

Historic Photographic Processes: A Guide to Creating Handmade Photographic Images by *Richard Farber* (softcover, 8½ × 11, 256 pages, $29.95)

Creative Black-and-White Photography: Advanced Camera and Darkroom Techniques by *Bernhard J Suess* (softcover, 8½ × 11, 192 pages, $24.95)

Travel Photography, Second Edition
by *Susan McCartney* (softcover, 6¾ × 10, 360 pages, $22.95)

Re-Engineering the Photo Studio
by *Joe Farace* (softcover, 6 × 9, 224 pages, $18.95)

The Digital Imaging Dictionary
by *Joe Farace* (softcover, 6 × 9, 224 pages, $19.95)

Business and Legal Forms for Photographers, Revised Edition
by *Tad Crawford* (softcover, 8½ × 11, 224 pages, includes CD-ROM, $24.95)

ASMP Professional Business Practices in Photography, Fifth Edition
by *the American Society of Media Photographers* (softcover, 6¾ × 10, 416 pages, $24.95)

Pricing Photography: The Complete Guide to Assignment and Stock Prices, Second Edition by *Michal Heron and David MacTavish* (softcover, 11 × 8½, 152 pages, $24.95)

The Business of Studio Photography: How To Start and Run a Successful Photography Studio by *Edward R. Lilley* (softcover, 6¾ × 10, 304 pages, $19.95)

Please write to request our free catalog. To order by credit card, call 1-800-491-2808 or send a check or money order to Allworth Press, 10 East 23rd Street, Suite 510, New York, NY 10010. Include $5 for shipping and handling for the first book ordered and $1 for each additional book. Ten dollars plus $1 for each additional book if ordering from Canada. New York State residents must add sales tax.

To see our complete catalog on the World Wide Web, or to order online, you can find us at *www.allworth.com*.